PRAISE FOR *CAMILLE PISSARRO*

"Cézanne hailed him as the first Impressionist, and from these pages Pissarro certainly emerges as the most beguiling. Faced with every manner of obstacle—from financial woes to anti-Semitism to the destruction of his paintings during the Paris Commune to an inhospitable art world—Pissarro held his own, ceaselessly experimenting with new subjects and styles. Anka Muhlstein has done him proud. Lithe, incisive, and sparkling, this is a model biography."

—Stacy Schiff, author of *Cleopatra:
A Life* and *The Revolutionary: Samuel Adams*

"On rare occasions, a biography introduces you to an artist whose life reminds you of all the joy and beauty on offer to those who seek them, along with all the hardship the seeker must transcend. Camille Pissarro is such a character, and Anka Muhlstein's exquisite portrait of him is such a revelation."

—Judith Thurman, National Book Award–winning author of
Isak Dinesen: The Life of a Storyteller

"With the skill only a master biographer can muster, Anka Muhlstein paints a portrait of a beloved artist as you have never seen him before. Pissarro emerges at the crossroads of identities and experiences, a true man of the world. The book is remarkable for Muhlstein's trademark depth of scholarship, but most of all for her depth of insight."

—James McAuley, author of *The House of Fragile Things:
Jewish Art Collectors and the Fall of France*

"Anka Muhlstein's life of Pissarro is a story about devotion. We see the young man travel from his native Saint Thomas in the Caribbean and create himself as a French painter in the shared adventure of Impressionism, holding fast to his vision through poverty, vilification, and family sorrow. A noble tale of art and friendship, in Muhlstein's telling, as dappled and subtle as Pissarro's own paintings. When I reached the final pages, my heart was full."

—Rosanna Warren, author of
Max Jacob: A Life in Art and Letters

"Here is life-writing at its most vivid and engrossing. Pissarro emerges as heroic in his artistic dedication and collegial generosity—a patriarch and saint among the painters of modern life. Muhlstein's portrait pulses with all the particulars of a mighty life and career. Her Pissarro is irresistible."

—Benjamin Taylor, author of *Proust: The Search*

"Muhlstein deftly traces the life of Camille Pissarro from its Caribbean origins to Paris and the turbulent center of radical Impressionism. Drawing on the artist's correspondence, she illuminates with acute sensitivity his Jewish background, long years of struggle and loss, equanimity, devotion to family, constant work—as well as his extraordinary artistry and role as father figure to his younger Impressionist friends."

—Susan Grace Galassi, coauthor of
Picasso's Drawings, 1890–1921: Reinventing Tradition

"The 'father of Impressionism'—Camille Pissarro—emerges from this intimate account, written largely from his correspondence, as a dedicated and independent artist and a greathearted man. Anka Muhlstein has written a fine, fast-paced, readable account of a crucial figure in cultural history."

—Peter Brooks, author of *Seduced by Story:*
The Use and Abuse of Narrative and *Balzac's Lives*

PRAISE FOR
MONSIEUR PROUST'S LIBRARY

"This gemlike exploration of the literary underpinnings of *À la recherche du temps perdu* reveals a Marcel Proust who did not so much read books as 'absorb' them." —*The New Yorker*

"With *Monsieur Proust's Library*, Anka Muhlstein has added another volume to the collection of splendid books about Proust. A woman of intellectual refinement, subtle understanding, and deep literary culture...Muhlstein is an excellent provisioner of high-quality intellectual goods." —*Wall Street Journal*

"[Muhlstein] here turns her attention to Proust's enthusiasms, antagonisms, and literary influences...sensitive to nuances of style and echoes of older standard French authors."
—Edmund White, *New York Review of Books*

PRAISE FOR *THE PEN AND THE BRUSH*

"The close friendship, interaction, and parallelism between writers and artists in nineteenth-century France are the subject of Anka Muhlstein's *The Pen and the Brush*...The subject is enormous, and might threaten to go off in every direction. What about photography? And book illustration? And sculpture? What about poets and pictures, both real and imaginary? Anka Muhlstein wisely limits herself to prose writers, and to five who speak to her most clearly: Balzac, Zola, Huysmans, Maupassant, and—a slight chronological cheat—Proust. The result is a personal, compact, intense book that provokes both much warm nodding and occasional friendly disagreement." —Julian Barnes, *New York Review of Books*

"Endlessly enjoyable...It may take a certain courage to offer the 21st-century reading public a compact cultural history of 19th-century France, seen through its major writers and painters and the currents which washed and swirled between them. This is not mainstream. Muhlstein, however, is a confident guide."
— *The Guardian*

PRAISE FOR *BALZAC'S OMELETTE*

"This effervescent volume celebrates Balzac's use of gastronomy as a literary device and social critique." —*The New Yorker*

"Fabulous...worth nibbling on, as prelude or accompaniment to the pièce de résistance, *The Human Comedy*."
— *New York Times Book Review*

"*Balzac's Omelette*...is a charming and modest little book."
— *New York Review of Books*

"Muhlstein uses Balzac as a guide to the French culinary scene of the 19th century in a literary analysis that is original, delectable, and entirely readable." —*Washington Post*

"An absorbing and insightful portrait of Balzac...and of the role that food played in 19th-century France."
— *Wall Street Journal*

CAMILLE PISSARRO

CAMILLE Pissarro

THE AUDACITY OF IMPRESSIONISM

ANKA MUHLSTEIN

Translated from the French
by Adriana Hunter

OTHER PRESS
New York

Production editor: Yvonne E. Cárdenas
Text designer: Patrice Sheridan
This book was set in Chaparral Pro and Gil Sans
by Alpha Design & Composition of Pittsfield NH

2 4 6 8 10 9 7 5 3 1

Library of Congress Cataloging-in-Publication Data
Names: Muhlstein, Anka, author. | Hunter, Adriana, translator.
Title: Camille Pissarro : the audacity of impressionism / Anka Muhlstein ;
translated from the French by Adriana Hunter.
Description: New York : Other Press, [2023]
Identifiers: LCCN 2023000620 (print) | LCCN 2023000621 (ebook) |
ISBN 9781635421705 (hardcover) | ISBN 9781635421712 (ebook)
Subjects: LCSH: Pissarro, Camille, 1830-1903. | Painters—France—Biography.
Classification: LCC ND553.P55 M84 2023 (print) | LCC ND553.P55 (ebook) |
DDC 759.4 [B]—dc23/eng/20230609
LC record available at https://lccn.loc.gov/2023000620
LC ebook record available at https://lccn.loc.gov/2023000621

Pour Louis,
Comme toujours et pour toujours

Contents

Introduction

Camille Pissarro was a most unusual man. Granted, most artists are, but Pissarro knew that he was even more out of step with the France of his day than his peers. "I have a rustic, melancholy temperament, I look coarse and wild," he acknowledged.[1] Later, he added, "too serious to appeal to the masses and too distant from exotic tradition to be understood by dilettantes. I am too surprising, I break away too often from accepted behavior."[2] Settled in France from the age of twenty-five but born in the Caribbean, he was not French, and what is more he was Jewish. He never hid this fact and knew that it was not without significance. He saw himself as an interloper in French society even though he was a founding member of the new school of French painting, was affectionately nicknamed the father of Impressionism by his peers, was a close friend of Monet, a longtime associate in Degas's and Cassatt's experimental work, a support to Cézanne and Gauguin, and a comfort to Van Gogh, and was backed throughout his career by the great Parisian art dealer Paul Durand-Ruel. Nevertheless,

a sense of being set apart, different, and hard to classify persisted, and this is what drew me to Pissarro.

He portrayed himself four times in thirty years, and his self-portraits help us form an impression of his gravitas, his calm, and the intensity of his gaze, but he also left a fifth portrait, a more detailed, more complex, and often unexpected one, the portrait constituted by his correspondence. Reading a person's correspondence is a little like eavesdropping. We are breaking and entering into the intimate world of someone who has let their guard down. The more sustained the exchange, the more personal it is, and the deeper and more nuanced the letter writer's self-portrait becomes.

Camille Pissarro left a vast accumulation of letters, most of which were brought together in five volumes and edited by Janine Bailly-Herzberg.[3] Although not exhaustive, these volumes are certainly enough to give an idea of a painter's life in the nineteenth century and, more specifically, of the audacity of the Impressionist adventure. But what I found most interesting about this correspondence was the self-portrait that emerges from it. Given that most of Pissarro's letters are to his children, the tone is utterly unconstrained. Pissarro did not use the familiar *tu* form when addressing his fellow painters, even those he had known as a student. He always showed his peers a courtesy not far removed from reserve, but abandoned all restraint particularly in his exchanges with his eldest son. The question of religion recurs frequently over the pages. During a period of despondency, this resolute atheist admits that his origins have left their mark on him: "To date,

no Jew in this country has produced art, or rather heart-felt, disinterested art, I think that this could be one of the reasons I'm having no luck."[4]

This is a curious remark insofar as he never inter-jected political or religious messages in his art. He good-naturedly admitted that for a Hebrew he was far from biblical. He felt that painting should be neither literary or historical, nor political or social, but only the expression of a feeling. The fact remains, though, that he was fully conscious of the consequences of his lineage. He confesses to sometimes feeling like an outsider in France. Being not only Jewish but also foreign necessitated a degree of cau-tion that did not come naturally to him. This man who consistently demonstrated bravery in his artistic choices, who was never slow to develop or change his style, or to admit his mistakes, without ever giving way to the pres-sures of public demand; this man whose personal life was characterized by an absolute refusal to accept family or social conventions; this man still knew he must never openly take part in the political battles of his time. The threat of expatriation enforced on him a reserve that he never waived. Being very sensitive to social injustice, he did whatever was within his means to support anarchist publications but never made public *Les Turpitudes sociales* (Social turpitudes), a series of striking caricatures about suffering among the working class. And, although he openly sided with the Dreyfusards, he did not play such an active role in their struggle as did many of his peers, in-cluding Eugène Carrière, Edouard Vuillard, and the Swiss Félix Vallotton.

All his energy was concentrated into his art, his children's artistic education, and the fight to have modern art recognized. He was exceptionally hardworking and left a considerable body of work—more than fifteen hundred oils, not to mention the pastels, watercolors, and drawings—as well as being a gifted teacher whose four sons all went on to be respected artists. He had a tremendous talent for attracting and working closely with artists as diverse as Degas, Cézanne, Gauguin, Signac, and Seurat. Whenever the opportunity arose, he refused to comply with the demands of official art, and he alone with Degas participated in every Impressionist exhibition, serenely braving the insults and jeers because he was convinced of the validity of his experimental work.

Perhaps it fell to him, with his particularly independent spirit, to adopt a system that encouraged freedom and autonomy. "Make your plans with no rules, or at least with none that you find offensive," he advised his son.[5] With this he was arguing for a new tradition, a modern one that granted artists the ability to invent, to keep reevaluating their own work, and to justify their reputation as "fierce revolutionar[ies]."[6]

I

Saint Thomas–Paris–
Saint Thomas Round Trip

Camille Pissarro was born in 1830 in Saint Thomas, one of the three main Virgin Islands in the archipelago of the Lesser Antilles, a tiny island measuring twenty kilometers long by four wide that was under Danish rule at the time. It is difficult now to imagine how strategically and economically important these three islands—Saint Thomas, the even smaller Saint John, and the larger Saint Croix—once were. Positioned at the intersection of various maritime routes, they gave vessels from Europe and Africa access not only to Central America but also to North and South America. The port of Saint Thomas, Charlotte Amalie, was so sought-after that it was said to be "the place that led to everywhere else."[1] The port's commercial advantages were such that, over the centuries, it elicited covetous attention from the French, the English, the Dutch, and the Danes.

The Spanish, led by Christopher Columbus, had been the first Europeans to land on these islands, in 1493. Disappointed by the absence of gold or silver mines, they did

not stay long, but the inhabitants did not survive this violent irruption and the propagation of unfamiliar germs. The islands remained uninhabited other than by bands of pirates who attacked Spanish galleons laden with precious metals on their return to Seville and Cadiz. After several fruitless attempts thwarted by opposition from the Spanish, the English, and the French, in 1672 the Danish West India Company secured permission from the king of Denmark to found a colony on the then deserted island of Saint Thomas. Almost as soon as it was established, this colony attracted British, French, Dutch, and Jewish emigrants who lived on the neighboring islands. They were fleeing the repercussions of the European war between the Dutch Republic on the one side and England and France on the other, and were seeking protection from Denmark, which had remained neutral. These newcomers set up the first cotton and sugarcane plantations, and the corollary of this was the importation of enslaved Africans. A slave market was swiftly put in place, and colonizers from other islands came here for slaves. In 1673 the population of Saint Thomas ran to 100 whites and 100 blacks; in 1715 it was inventoried at 565 whites and 4,187 blacks.

Over the course of the next century the economy in Saint Thomas changed. Charlotte Amalie expanded, and the island's triangular trade became so substantial that the inhabitants deemed it more lucrative to leave sugarcane cultivation to colonizers on the nearby island of Saint Croix, which Denmark had bought from France in 1733, and devote themselves entirely to the slave trade.[2] The English seized the island during the Napoleonic wars, but

in 1815 they signed an accord with Denmark, which took back possession of the island that same year and made it a free port. A great variety of import-export companies—large and small, English, French, Italian, Spanish, and German—set up shop, and the atmosphere on the island became more cosmopolitan. The tenor of the population altered too. The cruel practice of slavery continued on Saint Croix, where 90 percent of the population was enslaved, but declined in Saint Thomas, where sugar cultivation was gradually phased out.[3] There was, however, still a considerable number of slaves in domestic service.

Camille Pissarro's mother, Rachel Pomié Manzana, was born in Saint Thomas in 1795. Nothing is known about her family's history. Her parents or grandparents, who were Sephardic Jews, had left France at the end of the eighteenth century, initially to set up home in Saint-Domingue and then in Saint Thomas in 1791. Meanwhile, Camille's father, Frédéric Pissarro, was born in France, and his paternal grandfather, a Portuguese Sephardic Jew, in Braganza. Portugal, like Spain, had been persecuting Jews since the sixteenth century, and the constant threat of the Inquisition forced many to live as Christians while practicing their true religion in absolute secrecy. These Marranos, as they were known, fled Portugal at the first opportunity; which is how, in 1769, the Pissarros managed to reach Bordeaux, a city that was very open to overseas trade and had been welcoming and protecting Portuguese Jews since the reign of Henri II. On payment of a tax, they secured the

right to practice their religion openly and to exercise whatever trade they chose.

Portuguese Jews constituted the most flourishing Jewish community in eighteenth-century France. They specialized in industry and, in particular, the processing of commodities from the colonies. The Gradis, the most prosperous family in the *naçao* (the Sephardic community), had a monopoly on sugar; and the Da Costas on chocolate, which was introduced to France by the Jewish community in Bayonne. Other opportunities for accruing wealth were offered by banking, outfitting ships, insurance, and most significantly, by trading in slaves and freight heading for colonies in the Americas.[4]

Joseph Gabriel Pissarro settled in Bordeaux's trading community and married a local Jewish woman, Anne-Félicité Petit. When their son, Frédéric, was born in 1802 he was entirely French because Jews had been emancipated in 1791. The family prospered and, like many Jewish families, extended its activities over the Atlantic.

As part of this expansion, Joseph Gabriel's brother-in-law Isaac Petit set sail for the West Indies and settled in Saint Thomas, joining one of the most populous and complex Jewish communities in the New World. The first synagogue on the island was built in 1796; it was destroyed by fire in 1804. A second synagogue was erected in 1812 but was very soon outgrown and was replaced by a third. In 1823 the town was ravaged by fire, and the Jews had to build yet another new place of worship. It was completed in 1833 and this synagogue is still standing. It has kept its original furnishings and the custom of spreading sand

over the floorboards as a reminder of the days when the Marranos had to stifle every sound during their services; it is one of the two oldest synagogues in the Americas.[5]

The Jews in Saint Thomas were not a homogenous group. A Sephardic element that had originated in Bordeaux and Bayonne and was intermingled with Spanish and Portuguese immigrants lived alongside families of Dutch extraction formerly based in Curaçao and a small number of Danish Ashkenazi Jews. At the time, Jews constituted one-quarter of the white population, a population that had always been extremely diverse. (A 1688 census noted that inhabitants with European roots came from eleven different countries.) The population included American and Danish Protestants, as well as a sizable Roman Catholic faction. Saint Thomas and its trading activities drew in a good many Venezuelans and other Central Americans. The official religion was the Lutheran church, as in Denmark. It goes without saying that the great majority of inhabitants were black. The phasing out of plantations had given some of them the opportunity to live as free men either because they had been released from slavery or, more commonly, because they had bought their freedom. They earned their livings as craftsmen, shopkeepers, or clerks. An 1834 decree from King Frederick VI gave citizenship to all free blacks, along with the same rights and privileges as white inhabitants. But it took one final slave rebellion on the island of Saint Croix for slavery to be abolished at last in 1847.

When he arrived on the island in about 1810, Isaac Petit married Esther Manzana Pomié. Esther died young,

and, true to Jewish tradition, Isaac then married her younger sister, Rachel, who was some twenty years his junior. They set up home in Charlotte Amalie to take advantage of the three-way trading arrangements between Europe, the United States, and Latin America. Isaac Petit soon found himself running an extremely lucrative warehouse for a variety of goods. The business was flourishing when he died in 1824. Pregnant with a fourth child, distraught, and unable to run the company, Rachel turned to her late husband's family. The business was too profitable to be left to founder, so the French family swiftly sent out someone to help the widow: young Frédéric Pissarro, Isaac's nephew, whom the latter had in fact appointed as the executor of his will.

His aunt's welcome went beyond his expectations. In the spring of 1825 she was pregnant again and gave birth to a son, Félix, causing a scandal in the community. It may have been common for an uncle to marry his niece, but for a nephew to seduce his aunt (even if only by marriage), and especially when she was seven years his senior, was deemed inadmissible. Rachel and Frédéric took no heed of this. Furthermore, Félix's birth coming so soon after the arrival of Isaac's last child proved that they had contravened the Jewish law stipulating that a man may not have relations with a woman who is breastfeeding a newborn. The synagogue therefore did not grant them permission to marry. They proceeded regardless and exchanged their vows in a private house before a minyan, a group of ten adult Jews that was essential for the recitation of prayers and hence for any religious ceremony. The young couple

announced they were married in the newspaper, but the synagogue in Saint Thomas did not accept this fait accompli and refused to recognize the marriage; it even went so far as to run a large-display notice in the same newspaper, the *St. Thomas Tidende*, to state categorically that the synagogue's authorities, the Rulers and Wardens of the Synagogue, did not accept it.[6] The synagogue in Copenhagen supported this decision. By contrast, the civil administration recorded the marriage, but the Petit family in Bordeaux, concerned that they might lose their business to a Pissarro nephew, announced that they were against the union. It was a complicated matter, and the dispute continued for eight years.

The synagogue finally yielded in 1833 after the king of Denmark intervened, having been asked to settle this thorny question once and for all. In the meantime, three more sons had been born, Moïse Alfred in 1829, Jacob Camille in 1830, and Aron Gustave in 1833.

As a result of this long controversy, the children attended neither the Hebrew school nor the Christian school. The scandal caused by their parents' union was not confined to the Jewish community. There is no doubting that the tiny white community was hungry for malicious gossip, and the Pissarro boys would not have been comfortable alongside children from these families. They took classes at the Moravian school, where lessons were taught in English by missionaries, and where most of the students were black children.[7] The school had been founded to convert and educate them. It was here that Camille acquired a perfect knowledge of English along with an unusual self-assurance

and immunity to prejudice in the world around him. He also escaped the intolerance typical of many small religious communities. The Pissarro boys would certainly have been excused from religious instruction given by the missionaries, but, bearing in mind the synagogue's attitude toward their parents, it is not at all clear whether they received any Jewish instruction. Camille Pissarro never made any mention of a Bar Mitzvah. His parents remained attached to their respective fathers' tradition, but their circumstances did not facilitate passing it on.

The Pissarros lived over the shop, which was usually crammed with merchandise, in a house that stands to this day. It has been named the Camille Pissarro Building and is now a gallery. When Camille was a child, it must have felt very small for Rachel's eight children. She was helped by two slaves and other servants, but her capricious moods provoked frequent storms. Within the family, the day-to-day language was French. English was spoken mostly for business affairs; Danish, which was used only for settling administrative matters, was not common. The father of the family, Frédéric, remained in close contact with his parents, brothers, and cousins who had stayed in France; and Rachel considered herself French, even though her family had settled in America in the course of the previous century. When the time came to complete the boys' education, it was decided as a matter of course that they should go to boarding school in Paris where their paternal grandparents had moved from Bordeaux.

Camille was eleven when he set out on a sailing ship for Le Havre with his older brother Alfred. They would spend

six years as boarders at Savary School in Passy, which was then practically in the countryside. Savary boarding school dated back to the ancien régime and, like many similar institutions, had abandoned central Paris in favor of fresh air. Of course, the great majority of masters and pupils were Roman Catholic, and once again the Pissarro boys found themselves, if not in an awkward situation, at least in the unusual position of receiving no religious instruction. This decision of their parents and grandparents can first be explained by the fact that there were no Jewish boarding schools in Paris at the time. Besides, the boys had never been subjected to Jewish authorities; and lastly, the family probably considered that the instruction at Savary would better prepare them for French customs should they ever decide to settle in France. In any event, Camille and his brother Alfred do not appear to have suffered during their time at the boarding school.

The curriculum of classical education was balanced between humanities and sciences, and the masters regularly took their pupils to the Louvre. Camille was therefore introduced to art when he was very young, and if his father's complaints are to be believed, he showed only a tepid interest in mathematics. One of the greatest etchers of the time, Charles Meryon, had attended the school a few years before the Pissarro boys and was always grateful to the headmaster Auguste Savary's younger brother for introducing him to drawing. This same Mr. Savary, who had a good reputation as a painter, took an interest in Camille, encouraged him, invited him to visit his studio, and—although he himself never worked *en plein*

air—particularly recommended that he should always pay close attention to the natural world and draw as many coconut trees as possible during his vacations. But because the crossing took about three weeks, it seems unlikely that the children could go home to their parents over the summer. Their grandparents and one of their uncles, Moïse, who had a large family of his own, took them in. In 1847, having completed their education, they left their boarding school, where they had made a good impression. Many years later, one of Camille's sons, Lucien, met a "very friendly old spinster," Mlle. Picard, who remembered his father in Passy and had even kept a few sketches of her parents that he had drawn for her.[8]

Back in Saint Thomas, Camille and Alfred started working, though with little enthusiasm, alongside their father. The business was growing, and they were actively involved, but their thoughts were elsewhere. They had had a taste of another life, a life spent visiting museums and galleries, going to concerts, and discovering how huge Paris was and how varied its neighborhoods. Alfred could think only of playing the violin, and Camille of drawing. Two cousins shared their frustration and were hatching plans to escape. One of them, Jules Cardoze, longed to write novels; the other, Raoul Pannet, dreamed of living an artist's life in Paris.

Whenever he could get away, Camille spent time strolling through the streets and along the docks. He had clearly not forgotten his French teacher's advice and studied people and things around him: a few sketches of young children playing in the street date from this period, as well

as a more detailed drawing of a woman patching an item of clothing. But the most accomplished drawing was of a coconut tree. He regretted having so little time to himself and was mostly kept busy overseeing the unloading of cargo and keeping the accounts for his father's warehouse. He found these responsibilities crushingly boring. Deliverance came in the form of a traveler, a Danish painter called Fritz Melbye who landed in Charlotte Amalie in 1851.

2

Rudderless Adventure
in Venezuela

Fritz Melbye, a tall handsome Dane, had come to Saint Thomas in search not of a fortune but of new landscapes. It would surely not have been long before he noticed a young man who paced the docks, sketchbook in hand. The two artists quickly became acquainted. Melbye enjoyed a freedom that must have appeared boundless to Camille. His training had begun alongside his brother Anton, a pupil of Corot, who painted seascapes and whose work was highly valued in France. Another brother, Vilhelm, who also painted seascapes, lived in England. At twenty-three, Fritz had enough self-confidence to leave Denmark. He never returned. He set off to discover the Americas with sufficient resources to roam the New World, encouraged by his artist family who set no constraints on his travels. What is more, his travels were justified by a mission entrusted to him by the Danish government: to inventory indigenous plants.

He was only four years older than Camille, but when their paths crossed he had considerably more experience.

His work had already been exhibited in Copenhagen, and he had no trouble selling his American landscapes, which seemed so exotic to his fellow countrymen and which he regularly dispatched back to Europe. The two artists, whose common language was English, were soon inseparable. They were always seen together, often drawing somewhere around the harbor. Camille made the most of his friend's advice and of the example he set. He was encouraged by the fact that Fritz could survive off his painting. Within no time Charlotte Amalie and the surrounding area could no longer satisfy their curiosity and they made plans to leave Saint Thomas and explore Venezuela. Despite his impatience, Camille did not allow himself to act on impulse. His brother Alfred was in France at the time, and he knew that his father needed one of his sons there to ensure that the business ran smoothly. He would have to wait for Alfred's return, then. He resigned himself to waiting. This patience and readiness to find a compromise, to take into account other people's needs, and to respect family responsibilities—all unusual qualities in a young man as passionate as he was—are the most endearing aspects of his personality.

A letter from Fritz dated April 1852 and sent from the nearby island of Saint Croix gives details of the preparations for their adventure. Camille must, he advised, stock up on materials: paints, canvases, pencils, and paper might not be easy to find along the way. Camille had no trouble getting hold of them—the Pissarro firm sold everything! At last, in October 1852, the two young men boarded a French ship due to stop over in La Guaira, the port of

Caracas, where they found lodgings in an inn. Years later,
Pissarro was intoxicated by memories of this departure
and allowed himself some liberties with the details when
he wrote to his friend Eugène Murer, a colorful character
who was a great admirer of the Impressionists (and who
will be mentioned again below): "As a paid assistant in
Saint Thomas in 1852 I dropped everything without a mo-
ment's thought and fled to Caracas to break the cable that
tethered me to bourgeois life.... I don't think I would have
any hesitation if I had to do the same thing again."[1]

The frustration of being unable to spend hours on end
painting and drawing in Saint Thomas had been a decisive
factor in his desire for escape, and from the moment he
was free he never stopped working. He produced hundreds
of works on paper in the two years he spent in Latin Amer-
ica. Many examples of them can be seen in the Caracas
Museum of Fine Arts, in private collections in Venezuela,
and at the Olana State Historic Site in Hudson, New York,
which houses an archive that Melbye entrusted to his
friend the famous landscape artist Frank Church, before
he traveled to China, where he died in 1869.

The two artists frequently set up their easels side by
side. Melbye gave snippets of advice to the younger man,
but Camille appears to have found his own eye at a very
early stage, and during his time in France he had acquired
sufficient technique and ability to give him the freedom
to be creative without copying his companion. Despite his
lack of experience, he was not unduly influenced by Mel-
bye. Besides, they did not always view the object of their
interest in the same way. Melbye's mission required an

accuracy in the depictions of plants that does not appear in Camille's work. It is not that the latter neglected the details of a flower or a leaf, but he was primarily interested in the overall structure of a drawing and had already stopped prioritizing line over color.

Their concepts of landscapes were different too. Let us take as an example a watercolor of Camille's that depicts the small harbor of La Guaira. As he always would, he put a number of figures in the scene: a woman carrying a large earthenware jar on her head; a man on a donkey, talking to a child; a couple in the distance in conversation, and another out for a walk. Camille would never lose this partiality to the human aspect of a scene. After a trip to Arques in the Pas-de-Calais at the end of his life, he wrote to his son: "the countryside doesn't suit me. It's mostly sweeping when what I'm after is little nooks."[2] Melbye, on the other hand, liked sketching vast expanses that would serve as frameworks for larger paintings. Nevertheless, Camille certainly benefited from their close working relationship and enjoyed this unstructured connection between peers, which, as we shall see, he re-created throughout his life.

Having exhausted the possibilities around the small port, the two young men set out for the capital, Caracas. Camille had already spent nearly six years in the great city of Paris, but nothing could have prepared him for a city like Caracas, an agglomeration of 250,000 inhabitants with origins all over the world, their forefathers having mixed freely with the indigenous population. The European element, mostly descended from Spanish colonizers, may well have been a minority, but it dominated political and

intellectual life and had imposed Spanish as the country's official language, along with some of its old-world institutions. The citizens of Caracas took pride in having a university, a theater, and even an academy of drawing and music that was sufficiently modern in its outlook to make time for teaching Daguerre's photographic techniques. Camille explored the extensive stocks of the city's bookshops, which often included rich pickings of French publications. One shop sold beautiful engravings by François Gérard, Horace Vernet, Léon Cogniet, and Louis Girodet, painters whose works Camille would almost certainly have seen in Paris. The city's grandest hotel, the Posada Europa, opened its lounges for concerts during which a violinist from the Paris Opera played with Venezuelan musicians. It was there that Pissarro discovered Chopin, Offenbach, and Bellini. In no time the musicians had adopted the two painters and even suggested that they contribute to a reenactment of a Venetian banquet, complete with a choir. But what made them happiest was the backdrop provided by daily life in Caracas, a scene characterized by perpetual motion.

At first light, peasants arrived at the market on donkeys and set out their produce; as soon as it was all sold, noisy celebrations, complete with singing and dancing, began in the multitude of taverns. Come evening, the smallholders set off back to their fields. Alongside this, there was the endless political agitation of a country that had wrenched its independence from Spain at the turn of the century but had failed to find any viable equilibrium.

This turbulent climate did not stop the two travelers from settling in comfortably. They rented a house near

Plaza Major and set to work. A colored pencil drawing by Pissarro shows them in a well-furnished studio, cluttered with canvases, with just one portrait visible among many landscapes. A little boy is drawing under the watchful gaze of Camille, who is probably giving the child a lesson. The prospect of earning a living without abandoning painting was exhilarating. The two painters were not short of students, and they were sought after for portraits. Their rapport never wavered throughout their stay here. Although Melbye was more experienced than Camille at the time, it is difficult to interpret theirs as a student-teacher relationship. In the considerable archive that Melbye left at Olana, their landscapes and small-scale oils are not always easy to attribute to one or the other. Throughout his life, Camille would maintain similarly loose partnerships based on reciprocal influence with fellow artists. In fact, when many years later he worked alongside Cézanne, Gauguin, Degas, and Seurat, it would be difficult to establish who was the master and who the student. In Pissarro's mind there was no hierarchy. Any exchanges with his colleagues were always typified by equality. He was quite indifferent to discrepancies in age. This taste for freedom in human relationships, which would be so manifest in his attitude toward his own children, constantly evolved.

Over the course of this trip in his youth, Pissarro identified what he liked to paint and what went on to interest him his whole life: markets, animated groups of people, and occupations rather than faces. He was drawn to everyday

scenes, usually out of doors: women washing clothes in a stream or cooking a meal on a brazier, always with other figures in the background. One of the most accomplished drawings, a sepia entitled *Danse de carnaval*, is so exuberant, so vigorous that the beat of the music seems to emanate from it. Already, he was not striving to prettify, be sentimental, or make any political judgment. He painted what he saw. He was very comfortable speaking Spanish, having learned the rudiments in Saint Thomas, and he became friends with a group of Venezuelan painters who, like him, recognized Melbye's technical superiority. These artists—Mariano Palacio, Rafael Herrera, and Miguel Romer—went on excursions together and discovered the natural wonders of tropical forests and spectacular waterfalls. Sketches of Camille made by his friends show him happy and focused. He is very handsome, relaxed-looking, and already sports a Van Dyck–style beard.

These would be his only years of true freedom, far from family constraints and free of any financial worries. "When I was young, like everyone else I was left to my own devices, in a foreign country, free, absolutely free, and I was lucky never to meet with difficult circumstances," he wrote to his son nearly fifty years later.[3] It is worth pointing out that he produced nearly six hundred sheets of drawings and a significant number of very varied oil paintings during this period.

This thoroughly happy and rewarding life was interrupted when he received a letter from his brother Alfred: their younger brother, Gustave, had just died, aged twenty, and their mother was being submerged by grief and

depression. She had already lost three children in infancy. This latest blow was a crushing one. Alfred described her sobbing, pacing the corridor outside Gustave's bedroom, as if hoping he would reappear. She was in no state to support or console her other children, and Alfred ended his letter by insisting that Camille return home because he, Alfred, so desperately needed a friend. The pain and loneliness were killing him. This was the first glimpse of Rachel Pissarro's character and her emotional fragility, which would weigh so heavily on her children. Not a word about their father in Alfred's letter. Responsibility for Rachel's frame of mind seemed to fall more on her children than her husband. Camille had broken ties with bourgeois life, but not with family.

Nevertheless, having learned that his mother intended to leave Saint Thomas and move permanently to France, he stayed on in Venezuela for a few more months. He struggled to resign himself to ending such a successful sojourn, but in the meantime, he and his father reached a compromise. He would return to Saint Thomas and replace Alfred, who had left for Paris, where he hoped to have several months of well-deserved vacation. Camille committed to working for his father for a year. Then he would be free to leave and try his chances as an artist in Paris. And so he left Caracas in August 1854 and resumed his position in the family business, while still maintaining contact with Melbye.

Meanwhile, his mother and two half sisters had left the island in favor of Europe. The eldest, Emma, had recently married Phineas Isaacson, a merchant from a Jewish Saint

Thomas family of English origin who had set up a company
in England with offshoots in Saint Thomas. She intended
to make her home in London while her mother and sister,
Delphine, would stay in Paris. This wholesale move was
justified: Camille's father anticipated that steamboats,
which were making the Atlantic crossing in ever greater
numbers, would reduce the strategic importance of the
islands, meaning his business would need to adapt. The
port of Charlotte Amalie was too small for large modern
boats to maneuver. It was becoming clear that this stop-
over would soon be dropped, so it was useful to establish
strong ties in Europe. On a personal note, Rachel had a
rather abstract nostalgia for France, given that she had
never lived there, but she was glad to leave the island and
the devastating memories of Gustave's death, briefly leav-
ing behind her husband and one of her sons.

So it was that Camille was left treading water in Saint
Thomas for a whole year. When at last he could set sail for
Europe he never regained the freedom of the young bach-
elor who had embarked on a Venezuelan adventure three
years earlier. Family commitments would weigh heavily on
him his entire life, and a more serious apprenticeship as
a painter would show him just how much work there was
for him to do.

3

Paris
One-Way Ticket

Camille Pissarro arrived in Paris in October 1855. In fact, he first landed in Southampton and intended to spend a few days in London, but there was a letter from his sister Emma waiting for him. She begged him to come to Paris as a matter of urgency. Their sister Delphine was dying; their mother, Rachel, was stricken, and Emma herself, overwhelmed by the demands of four young children, needed help. Her husband, Phineas Isaacson, was in London, and her aged grandparents constituted her only support, and rather shaky support at that. "We are alone here without a man to help us."[1]

The era of responsibilities was beginning. Camille did not hesitate: he left for Paris immediately. Room was made for him in the family apartment on the rue Notre-Dame-de-Lorette. This was in the heart of the neighborhood that attracted painters and writers, but this choice of location is more readily explained by the fact that very close by, on the rue Lamartine, was the Portuguese Jews' synagogue.

The Portuguese Sephardim had settled in Paris before the Ashkenazim but were fewer in number and for a long time had had access only to oratories rather than a true synagogue. Having their own place of worship was so important to them that, when the large Ashkenazi synagogue on the rue de la Victoire was built in 1874, they refused to join it and remained independent.

Not much could be done for the unfortunate Delphine, who died in December, but it was clear that Rachel—transplanted into a city with more than a million inhabitants and thrown into a frenetic pace of life—needed help. Luckily, the Pissarros were well-off; the smooth running of the household was ensured by a nanny, a chambermaid, a cook, and a kitchen girl. The paternal grandparents were well used to life in the capital and explained Parisian customs to them. Camille was very soon able to have a life of his own, a life entirely governed by his passion for art.

In 1855 Paris under the Second Empire was in a state of effervescence. There was construction in progress everywhere. Baron Haussmann was transforming the city, dismantling the ancient maze of streets, creating wide arterial roads, and razing slums to the ground. The whole center of Paris—comprising a warren of insalubrious and overpopulated streets—was opened up. The city that Pissarro discovered was more like the Paris we know now than the one he had known during his first stay. One of his most famous views of Paris, painted late in his life in 1898, is of the avenue de l'Opéra, one of the newly laid roads intended to link the grand boulevards to the Louvre and the rue de Rivoli.

Not only were the capital's appearance and daily life changing but its artistic life was also evolving. Honoré de Balzac died in 1850, just as Emile Zola moved to Paris from Aix-en-Provence; Eugène Delacroix and Jean-Auguste Dominique Ingres were at the height of their careers but had only a few years left to live. By contrast Camille Corot was in full possession of his faculties and—along with his peers Jean-François Millet, Charles-François Daubigny, and Narcisse Diaz—was launching plein air painting in the forest of Fontainebleau around Barbizon. Edouard Manet and Edgar Degas were beginning their apprenticeships, Manet in Thomas Couture's studio, Degas at the Ecole des Beaux-Arts, the national school of fine arts. Jacques Offenbach was creating a new genre, operetta, which would enjoy resounding and lasting success; meaning that a German Jewish immigrant to France would come to define the high spirits and frivolity of the Belle Epoque.

This was a far cry from Saint Thomas and Caracas. Camille surrendered happily to an exciting atmosphere so perfectly matched to his own tastes that he never felt the need to return to the Americas and does not appear to have missed the sunshine, the light, or the ocean there. Bouts of bitterly cold weather (it was –11°F in Paris in the winter of 1879) made no difference to him. On the other hand, he complained all his life about spikes of "torrid" heat through which he suffered in Île-de-France, and he never joined Paul Cézanne or Claude Monet on their frequent trips to work in the south of France. He always preferred Normandy's soft, damp tones and the effect

that rain had on the city, and did not allow himself to be influenced by his dealer Paul Durand-Ruel, who often reminded him that sun-drenched paintings were more likely to tempt buyers. He personally liked wintry hues. In a letter, he told his friend the critic Théodore Duret: "There's nothing *colder* than strong summer sun, quite at odds with the colorists, nature is colorful in winter and cold in summer."[2] He never renounced this way of seeing things. "I can't bear summer," he admitted to his son Lucien in 1893, "with all its monotonous green, its dry distant expanses where you can see everything, the torment of stifling heat, the sluggishness and sleepiness...artistic feelings come back to life in September and October."[3] During his twilight years, in 1901, convinced that there were more flowers in fall than in springtime, he wrote to one of his last dealers, Bernheim-Jeune, about his painting *Autumn in the Meadow at Eragny*, saying that its trees "are decked in dead leaves that burst out like flowers in the sunlight."[4] Hardly surprising then that he never wanted to return to the tropics.

Paris certainly provided the young man with stimulating possibilities but also, by great good fortune, he had arrived a few days before the end of the Exposition Universelle world's fair. Four years earlier, London's Great Exhibition—the first in a series of fairs and exhibitions that would punctuate the nineteenth century—had been an astounding success with its six million visitors. But that exhibition had been devised primarily to glorify industrial art and English manufacturing. In Paris, fine arts had been given such prominence that a temporary

building had been erected on avenue Montaigne to exhibit some five thousand works. Ingres and Delacroix dominated the collection with forty-three and thirty-five paintings respectively. Pissarro later said that he spent at least four days viewing everything. He enjoyed discovering the landscape painters Daubigny, Théodore Rousseau, and Diaz, and most particularly Corot. Forty years later he still remembered him affectionately: "Old man Corot sure did some beautiful little things... a couple of willow trees, some water and a bridge like the painting at the World's Fair, what a masterpiece! Happy are they who see beauty in modest surroundings where other people see nothing; everything is beautiful, what matters is being able to interpret it."[5] Another young man, Paul Durand-Ruel, who would have a decisive impact on Pissarro's life, also spent a long time at the exhibition. But if their paths crossed, they did not speak to each other.

Ingres and Vernet each had a long gallery on either side of a vast salon devoted to Delacroix. The latter's work "opened [the future dealer's] eyes to the triumph of living art over academic art."[6] But the crowd favored Vernet and his large battle scenes. Edmond Duranty, one of the few critics to support young artists, regretted the fact that the general public preferred evocations of Greece, Rome, the Middle Ages, and the sixteenth, seventeenth, and eighteenth centuries rather than illustrations of contemporary life.[7] Academic art still eclipsed new talent. Which is why Gustave Courbet—furious that *A Burial at Ornans* and *The Painter's Studio* had been rejected—did not exhibit at this official site. Instead, with financial help from his

collector and patron Alfred Bruyas, he built the Pavillon du Réalisme out of brick and wood just a few meters from the exhibition hall and displayed some forty of his own works there. Ingres may have thought that Courbet's art was mired in mud, but Pissarro was struck by its power and his choice of subjects. He certainly did not think a peasant or a stonebreaker unworthy of being observed.

Pissarro lost no time in getting to work and completed some views of Saint Thomas, so-called exotic scenes that were likely to attract buyers. More significantly, he tried to establish himself by contacting Anton Melbye, the elder brother of his friend Fritz. Anton Melbye was a recognized figure in the Paris art world. He regularly exhibited at the Salon, and his seascapes had an official customer base that included the emperor. He greeted Camille kindly, made room for him in his studio, and even employed him to paint his skies when he was short of time. Added to this, Melbye bought eleven oils from Pissarro over the next few years. These early works stayed in Melbye's possession until his death in 1875. Shortly after that they were bought by a great Danish collector, John Hansen, and were not sold until Hansen's widow died in 1967, most of them going to Danish connoisseurs. Of more immediate importance to Camille, Melbye introduced him to Corot—proof that young Camille was already being taken seriously.

Corot had achieved notoriety but still retained great simplicity and was unusually generous toward young artists. He closely studied the drawings that Pissarro brought him, showed him his own work, and even gave him a drawing, *Le Martinet near Montpellier*. Sometime later, he

introduced Camille to two landscape painters, Antoine Chintreuil and Jean Desbrosses, both of whom were enjoying a degree of success. During their conversations, Corot encouraged him to "do a lot of painting to make it feel familiar," in other words, work the whole time.[8] In gratitude and as a mark of his admiration, Pissarro would call himself Corot's pupil when he presented his canvases to the Salon. Truth be told, Camille Pissarro was nobody's pupil, but he understood the import of Corot's fundamental advice that landscape painters should work out of doors and not huddled up in studios: go out for a walk, he would say, the muse is in the woods.

Forsaking memories of coconut trees and coves in the tropics, Camille set out to explore the area around Paris. His father had accepted his choice of career but wanted him to enroll at the Ecole des Beaux-Arts. Camille balked at the idea of being shut away in a studio copying plaster casts, but he was aware that he had never worked with nude models and that there was no improvising in these basic academic skills. He therefore chose private instruction. One of his masters, a German called Henri Lehmann, had been a favorite pupil of Ingres. He was a fashionable portraitist whose sitters included Chopin, Liszt, Gounod, and Stendhal; he also painted the ceiling of a room in the Palais de Justice and the Senate room in the Palais du Luxembourg in Paris. Lehmann later took on Georges Seurat as a pupil. He had the intelligence to leave the newcomer Pissarro free to work as he pleased.

Partially relieved of his family obligations by his father's arrival, Camille left Paris in the summer of 1856

to live and work in Montmorency, where he took lodgings with a Jew, M. Nouri, who ran the bathhouse. This respite did not last long. His father needed to return to Saint Thomas and his mother's mental health was still a problem, which meant that Camille had to return to the family apartment. One of the refrains scattered throughout his letters to his brother and father is "*Maman* is calmer," which implied that most of the time the household was ravaged by her explosive outbursts. Pissarro senior understood that, in these circumstances, Camille desperately needed somewhere quiet to work, particularly as he'd had to surrender his bedroom to his young nieces. And so he granted him the wherewithal, some four hundred francs every three months, to rent a studio.

The young man then embarked on a classic student life. Fritz Melbye came to spend a year in Paris, and thanks to him, Camille became friends with a number of Danish artists and briefly shared a studio with David Jacobsen. He often saw his two cousins, reconstituting their little gang from Saint Thomas days. One of them, Jules Cardoze, had a fine talent as a draftsman. We have him to thank for the first portrait of Camille at work in Paris. Cardoze later made a name for himself as a novelist. The three of them spent lively evenings dancing and flirting with pretty girls. In 1892 Camille still fondly remembered one of them, Mlle Jenny Berliner, "pretty, graceful and very alluring. We played little games, it was delightful."[9] Pissarro often saw friends from the Americas: the painter Rafael Herrera, who had arrived from Venezuela, and the Puerto Rican painter Francisco Oller. The latter, whom he

had met at the Académie Suisse, a large studio where the young artists often met to work, was a pupil of Couture and of Courbet. It was not long before this band realized that no one lived in Paris without going to cafés. Brasserie Andler in the Latin quarter was favored by Courbet, who presided over a table where the conversation could center on politics and social injustice just as readily as on art. Conversations became heated especially when Courbet was joined by the socialist Jules Vallès and the anarchist Pierre-Joseph Proudhon. Pissarro listened and pondered.

When Courbet abandoned Andler, leaving behind an unpaid bill of three thousand francs, the painters transferred to the Brasserie des Martyrs at the foot of Montmartre in New Athens, their favorite neighborhood. Beyond the brasserie's vast dining area there were billiard tables in a covered courtyard. Even more important for all these young men so eager for discussion, there were couches, which meant that they could exchange opinions in comfort. Monet admitted that he had wasted many an hour drinking beer and flirting with girls whom he entertained by sketching caricatures of the bourgeois clientele. Pissarro appears not to have been bored either, judging by a photograph of him dressed as a Venezuelan gaucho.

More significant, he felt sufficiently sure of himself to submit a painting, a landscape painted in Montmorency, to the 1859 Salon, four years after he had arrived in Paris. He presented himself as a pupil of Anton Melbye and of Corot, which was something of an exaggeration, but it was customary to name a master and Corot did not protest.

The painting was accepted—to the jubilation of the Pissarro family.

Camille's father was understandably relieved by this first recognition of his son's talent. The importance of the Salon in artistic circles at the time cannot be overstated. It was the only platform in Paris where novice painters could exhibit their work, potentially sell it, and be noticed by critics. The Salon's power was all the more implacable because there were no other spaces to show. Everything happened at the Salon during the annual exhibition in the Louvre's Salon Carré, which gave the event its name. The institution dated back to the ancien régime. Its objective then had been to put on public display works by the latest Académie prizewinners and, from 1817 onward, prizewinners from the Ecole des Beaux-Arts. The system gradually became more democratic. In 1850 a jury made a selection from submitted works, but the Académie des Beaux-Arts, along with studios run by its members and artists who had received acclaim in previous Salons, still had a powerful influence. To all intents and purposes, official art locked out innovative painting, and this monopoly would bar the way for the Impressionists a few years later. The fact that this same jury had turned down Millet, Manet, Whistler, and Fantin-Latour meant little to Pissarro senior. What mattered was that it had recognized Camille's talent.

The sheer number of canvases exhibited was so huge—the caricaturist Cham suggested hanging paintings from the ceiling like hams—that the work of an unknown such as Camille was usually hung at the very top of a panel and was therefore almost impossible to see. His painting,

which was very small and depicted a donkey by a farm-yard, was deemed to have "pretty coloring and great veracity" by the editor of *L'Art dans la rue et l'art au Salon*. No one else noticed it, apart from Zacharie Astruc, a very young critic heading for a great career as an editor, journalist, and chronicler of Paris life. Unfortunately, this was not enough to encourage sales, so the young painter remained dependent on his father. At this point his father returned definitively from Saint Thomas and moved to a house on the rue de la Pompe in Passy with his wife, their daughter Emma and her five children (the last of whom was born in 1861). He hoped that this neighborhood, which was almost out in the country, would better suit Rachel, whose frayed nerves had been exacerbated by the noise and bustle on rue Notre-Dame-de-Lorette.

Camille did not live with them. He spent winters in Paris, often sharing a studio with his Danish friends in the ninth arrondissement, which was so popular with artists. Ary Scheffer, one of the most fashionable painters during the Second Empire, lived on the rue Chaptal in a charming house, which is now the Musée de la Vie Romantique. Vernet, who was much admired for his military paintings, lived on rue de Tour-des-Dames, and the satirist Henri Monnier was neighbors with Gustave Moreau on the rue de La Rochefoucauld. Writers, musicians, and other painters soon followed their example. Over the course of the century, this neighborhood between the boulevard de Clichy to the north, the rue des Martyrs to the east, the rue Saint-Lazare to the south, and the rue Blanche to the west was home to Alexandre Dumas, Georges Sand, and Zola;

Chopin and Bizet; Monet, Renoir, Degas, and Toulouse-Lautrec. These writers, musicians, and painters constituted a "republic of arts and letters," which justified the sobriquet New Athens.

In summer Pissarro escaped to the suburbs of Paris or to Normandy, a way of life that required constant moving as he arranged either to rent a room or to share a studio with a friend. His father was still giving him his four-hundred-franc allowance, and Anton Melbye bought a few paintings from him, but he was often short of money, and his father would then give him a supplement or his sister would help him out. When Camille was in Paris, his father often reminded him to come and join the family, particularly for Jewish holidays. The fact that he had to explain to Camille the importance of Yom Kippur, one of the holiest days in the Jewish calendar, proves how neglected the young man's religious education had been. It is clear, however, that Camille distanced himself from religious practices without this having an effect on his relationship with his parents. What did bring about a crisis, though, was love.

4

A Mother, a Wife,
and a Rather Different Family

Rachel Pissarro had always had servants, whom she treated with the harshness of a former slave owner.[1] There is little doubt that notions of equality barely occurred to her. So when her son announced that he was in love with her kitchen maid, Julie Vellay, that Julie was pregnant, and that he intended to marry her, she exploded with rage. Who knows what irritated her most: the little serving girl's total penury, her lowly origins, her Catholicism, or her inability to spell? Any one of these features would have been enough to disqualify the girl. Together they were inconceivable. Camille could not have made a worse choice. Julie vanished, either because she was driven out or because she fled, and Madame Pissarro remained mistress of her territory—if not of her son's heart. The decision that Camille had to make was all the harder because he valued family ties and was still financially dependent on his parents, but his commitment to Julie was unshakable.

Camille was both conciliatory and resolute. Gauguin, who was an amateur graphologist, detected "a combination

of obstinacy and gentleness" in the handwriting of this young man who was as passionate as he was principled.[2] Being devoid of any bourgeois prejudice, Camille did not bow to his mother's will. He loved his Julie and he wanted her. Julie herself showed some backbone. Instead of returning to her village with her tail between her legs, she managed to find work with a florist so she would not be dependent on Camille. She lived alone for a few months while Camille made his arrangements. The Pissarro parents (who were outraged by this far from dazzling match with a Christian) and their son (who was determined to defend his decision) refused to yield to one another, but paradoxically, neither faction opted to break off all contact.

The fact that Julie went on to miscarry did not persuade Camille to review his stance. Quite the opposite. The young couple very soon set up home together on rue Neuve-de-la-Bréda (now rue Clauzel), a street that led onto rue des Martyrs, so it was in a neighborhood that they knew, and they lost no time making another baby. The child was born in 1863 and was named Lucien. There was no baptism or circumcision. His birth certificate was signed by two friends: the painter Antoine Guillemet and Alfred Nunès. Guillemet was a shrewd, cheerful fellow who enjoyed a handsome lifestyle thanks to an allowance from his father, who was a wine wholesaler in Bercy. The Nunès family was connected to the Pissarros through the Isaacsons (Camille's sister married an Isaacson). Granted, Alfred Nunès liked Camille's painting, but what is interesting about this choice is that it shows how Camille was keen to stay within his family's orbit.

It is impossible to imagine a greater contrast than the one between Camille Pissarro and Julie Vellay. Camille had extensive experience of the world. He had lived in the mixed-race societies of the Caribbean and Latin America, among blacks, Native Americans, and European Jews, Protestants, and Catholics; he spoke French, English, and Spanish fluently, had some knowledge of Danish, and felt comfortable in a variety of social settings and in different countries. Julie came from a family of small farmers in Grancey-sur-Ource near Dijon in Burgundy and had never left her village until she found work as a servant in Paris. Camille read extensively—the French, English, and American press as readily as novels and poetry. When they were in London, Monet gave him a book by Edgar Allan Poe that he was fond of. When Camille described people, he often referred to Balzac characters. A blustering wheeler-dealer cousin of his, for example, was a Gaudissart. His correspondence with novelists Zola, Octave Mirbeau, and Joris-Karl Huysmans and with the journalist and critic Félix Fénéon is proof that he was a part of the intellectual set in Paris, and he found it all the easier to be a part of this set because writers of his day were passionately interested in art and they all published critiques of the Salon. Right through to the end of his life, Camille demonstrated a curiosity for how young writers' work developed. Not impressed—and justifiably so—by Colette's first efforts, he wrote to his son in 1902: "as for *Claudine in School* and the other [book], *The Indulgent Husband*, I'm not keen. It's quite accurate with a sort of sweet Parisian feel, but I think it's aiming too intentionally at the pornographic angle."[3]

Julie, on the other hand, could only just read and write. In fact, her spelling, which was virtually phonetic, left so much to be desired that her children redacted many passages in her letters before archiving them, to avoid highlighting her ignorance. But Camille did not mind at all, he liked her as she was. What better proof of their physical connection could there be than the birth of eight children over a period of twenty years? Camille was always faithful to her and grateful for the resolve she showed in adversity.

Their family relationships were unusual. For ten years Madame Pissarro refused to acknowledge the young woman's very existence, although she regularly saw her son and, later, welcomed her grandchildren into her home. Never did she mention Julie's name. Camille continued to accept his parents' help and gave his mother psychological support whenever she succumbed to neurasthenia. He even went so far as to do shifts with his brother Alfred, spending the night by her side when their father, as frequently happened, was called back to Saint Thomas to oversee business matters. Meanwhile, Alfred himself was on friendly terms with Julie and, bizarrely, wrote to her with news of her terrible mother-in-law when the latter was struck down with cholerine, an infection that was common during outbreaks of cholera.[4]

It is worth mentioning that, in these artistic circles, parents frequently disapproved of their sons' choices, and that painters and writers led far from conformist lives. Zola lived with Alexandrine Meley for five years before his mother allowed them to marry, and then, toward the end of his life, he remained with his wife but had a second

household with his mistress; Cézanne did not dare admit his liaison with Hortense Fiquet to his father, or even the birth of their son, for fear that his allowance would be cut off. These relationships were not necessarily formalized by marriage. Monet had a son with his model, Camille Doncieux, before he married her (in a ceremony not attended by his father); he later had a long affair with a married woman. Renoir had two children with his model, Lise Tréhot, and neither of them gave any thought to marriage. The fact remains that Julie would have preferred to be married and often had to claim that she was when visiting friends. "To avoid gossip," their friend Piette wrote before they stayed with him on his estate, "Julie will have to be passed off as your wife. It's stupid but necessary."[5] In this instance, this was not even as a concession to strict parents but to avoid shocking the very conservative locals.

Pissarro was thirty-one and certainly did not need his parents' permission to marry. Yet he did not do so. And when his father died in 1865, he saw his mother all the more frequently, because she left distant Passy and moved back to the ninth arrondissement, where Pissarro often came to work with a friend or to stock up on painting supplies. He had in fact left Paris after his first child was born, and he and Julie had set up home in Varenne-Saint-Hilaire on the outskirts of the city in order to save money. They never returned to central Paris, except for brief stays, and moved again several times before settling in Pontoise for a number of years. Camille almost certainly missed the ready contact he had had with his friends when he had lived in Paris (although, thanks to trains, the distances

were now shorter), but life in this semi-rural setting dotted with rather sleepy villages appealed to him and inspired him—as is demonstrated by the beautiful peaceful landscapes from this period that were exhibited at the 1864 and 1865 Salons. What truly transformed him, though, were the births of his children. Two years after Lucien was born, a little girl, Minette, came along. He recognized how fully fatherhood anchored him and charged him with a whole new energy and determination, which were further bolstered by Julie's support.

It might seem natural that Julie would have acted as his model, but he made very few portraits of her, not least because she did not like taking the time to pose. Idleness was alien to her. She only ever appears with a task in hand or a child in her arms. She was a woman of unwavering loyalty, courageously enduring long years of hardship, and sometimes abject poverty, and proving adept and inventive when it came to feeding her family. Always hospitable, she never refused to take in a friend passing through. "She's always so welcoming to people," Camille would write to his son a few years later, in anticipation of a visit from Seurat and Signac.[6]

At the time, the household was surviving on eighty francs a month, a pitiful sum considering that a dancer in the corps de ballet at the Paris Opera complained of earning only two hundred francs a month. True, she had expenses for her toilette that the Pissarros were spared. In an 1895 letter to his son Georges, Camille referred to this period when he walked barefoot or in wooden clogs except when he went to Paris, but his wife and children ate their

fill thanks to Julie's vegetable garden and to the chickens and rabbits she raised.[7]

Julie must have been quite an astonishing person. She is hard to pin down because she did not express herself clearly and was not given to introspection. The most remarkable thing, though, is that Camille respected her judgments on the subject of painting: he did not always accept them (she often criticized him), but he wanted to know what she thought. Their son Lucien, who had a difficult relationship with Julie, also minded about her opinion and, at the time of one exhibition, asked Camille: "What does *Maman* think about your exhibition. I'd be glad to hear her thoughts, which don't miss the mark sometimes."[8] There is something impressively insolent about that "sometimes" at the end of the sentence, but the fact remains that Julie's opinion mattered in this family of artists.

Her ability to form true friendships with her husband's fellow artists is not insignificant. Monet asked her to be godmother to his son and remained friends with her after Camille's death; and, unlike Madame Zola, Julie always willingly welcomed Cézanne, who took malicious delight in shocking any gathering with his appearance and language. Most importantly, she seems to have been sufficiently self-assured to stand her ground with her husband. Her assertiveness surprised Henri Matisse, who spent time with the Pissarros as a very young man at the beginning of the twentieth century. He believed that Mother Pissarro, as he called her, did not understand much about her husband's art but this did not stop her criticizing it. "You did some pointillism, then you stopped

doing it. Why? Either it was good or it wasn't. After you stopped doing it, you thought that was a mistake. You don't know what you want."[9] She clearly had no knowledge of the experimentation, studies, and thought processes that caused Pissarro's work to evolve. Subtlety was not her strong point, and her directness often hurt her husband and sons, but there is no denying that in the first ten years of their lives together she was confronted with unusually insulting personal circumstances, which makes a certain hardening of character unsurprising. Camille, meanwhile, amiably adopted her family.

Julie had two sisters. The Pissarros saw more of one of them, Félicie, who was burdened with an alcoholic husband, and they often invited the couple's daughter, Nini, to stay with them to spare her the fights that ravaged her parents' home. Pissarro liked to paint her and often depicted her busy with domestic chores, perhaps sweeping the floor or washing the dishes. She is the person carefully cutting a slice of bread in *The Pork Butcher*, a bustling market scene that Pissarro struggled with until it occurred to him to substitute the young girl for his original choice of an old peasant woman. He also frequently took in another niece, Marie, who was consumptive and—according to him—lived surrounded by brutes.[10] Pissarro liked playing the benevolent paterfamilias, and we will see later how affectionately he cared for his sister Emma's children, when she died young and they had to suffer their irascible father's authority.

He appears to have negotiated a variety of different situations all the more easily because he always positioned himself on the periphery. Even his nationality could not

be established indisputably. Was he French thanks to his father's nationality or Danish by his birth? Regulations in Denmark and France were different, and the question was never clearly resolved. But because he was over twenty-five when he arrived in France, the problem of his military service was never raised by the authorities at the time. The question of nationality would arise much later when he struggled to spare his sons the four years of compulsory military service, which was the common fate of all male French citizens, even if this meant setting them up abroad and risking their being busted (to use an equivalent of his expression *pincé*) every time they visited France. Years later, during the Dreyfus affair, these actions earned him sarcastic remarks from Renoir, who derided Pissarro's children as "citizens of nowhere who avoided military service everywhere."[11]

This aversion to following every letter of the law indicates a degree of ambivalence in Pissarro's relationship with France. Granted, his immersion in the French heartland—which was precipitated by his union with Julie—demonstrates an obvious liking and curiosity. The French countryside inspired him, as did rural scenes and village markets. What is more, although he signed his first works Pizzarro, in 1855 he definitively adopted the more French (rather than Spanish) spelling Pissarro and had his official records altered to reflect this.

There are, however, no signs that Pissarro burned with desire to be a Frenchman. Staying to one side and keeping his distance came naturally to him, perhaps because his family had always been difficult to classify. His father was

French, his mother was born in the Caribbean but had a Danish passport, and as we have seen, they fought long and hard to have their marriage accepted. All this created unusual circumstances even in Saint Thomas's far from homogenous society. Once in France, the family—with the exception of Camille—developed links with the Jewish diaspora rather than with French society. Emma, Camille's eldest sister, married an English Jew, and his brother Alfred married a young woman whose Ashkenazi family had put down roots in the Alsace region several generations earlier. And although he had abandoned any form of religious practice, Camille described himself and thought of himself as Jewish. Even though he discussed it very little, he knew that French society did not view Jews as entirely French. In fact, it is clear that when the freethinker Camille was settled in the Normandy village of Eragny with his family, he and his children were yet again slightly set apart and seen as "different" by their neighbors. Perhaps this was because the locals were astonished that anyone could earn a living by pushing an easel out into the fields and daubing a canvas with color or that anyone did not send their children to catechism. In any event, only Julie had easy relationships with their neighbors.

It would be wrong to picture Pissarro as isolated. He had his own cosmopolitan family with members settled in Haiti, Montevideo, London, and Minneapolis, and with whom he was in regular correspondence.[12] More significantly, he had the adopted family consisting of his painter friends, a family that respected and supported him.

5

The Group

"I'm so glad to see that you're finally beginning to feel you have the support of a group. It's the only way anyone can achieve anything; being isolated in a big city like London is death!" Pissarro wrote to his son Lucien, who was struggling to find recognition in England, thirty years after his father arrived in Paris.[1] Pissarro certainly never forgot how much his painter friends' support had encouraged him and how useful their solidarity—despite inevitable artistic divergences—had been for breaking into the Parisian scene.

At the outset, Pissarro's group comprised a dozen or so artists, including Monet, Renoir, Cézanne, Degas, Bazille, Sisley, and Berthe Morisot. Later, he grew close to Gauguin, Mary Cassatt, Caillebotte, Seurat, and Signac. We recognize the names of all these painters who are now the glory of museums all around the world, but in the 1860s they were at best unknown, at worst considered mad.

How did this collection of unknowns manage to meet in the vastness of Paris? Particularly as they all came from

very different places and backgrounds. Claude Monet was the son of a merchant in Le Havre who was always extremely harsh and inflexible toward him; it was thanks to his aunt's generosity that he was able to follow the advice of Eugène Boudin, whom he had met at a stationery store that provided material for painters and engravers in Le Havre. Boudin noticed the the young man's drawings, which the owner of the store had pinned on his walls, and encouraged him to go to Paris, have some instruction in art, and meet other artists. Paul Cézanne was from Aix-en-Provence and had a terrible relationship with his banker father who grudgingly agreed to send him to Paris to try his chances. Alfred Sisley had been born in Paris, and with a father who traded in silks from England, his family had benefited from the flourishing black market between France and England under the empire; Sisley's father soon grasped there would be no point in opposing his son's vocation. Auguste Renoir was Parisian too, but from such humble origins—a tailor father and a seamstress mother—that he had to earn a living from a very young age. At thirteen he was taken on as an apprentice in a porcelain factory and swiftly proved adept at decorating cups and plates; in the evenings, he attended drawing classes. Frédéric Bazille had a quite different experience, reluctantly studying medicine. He was far more drawn to painting than to physiology and eventually swapped his white coat for a painter's apron. His father, a Protestant senator in Montpellier, supported him generously even though he regretted seeing him abandon his medical career and would have preferred him to choose a more reliable

profession. Edgar Degas, like Pissarro, had transatlantic family ties, his mother having been born in New Orleans. His paternal grandfather had left France for Naples during the French Revolution, but his father had settled in Paris to run a branch of the family bank. Degas himself was Parisian. To his father's distress, he abandoned his legal studies in favor of classes at the Ecole des Beaux-Arts. Berthe Morisot, the only woman in the group, was a regional prefect's daughter. Her mother was Fragonard's grandniece, which perhaps explains why she alone among her peers was encouraged from the start in her ambitions as a painter. It is striking how quickly the members of this group identified and then supported one another.

A poet needs just a table, a pen, and some paper, but a painter must have canvases, paints, brushes, pencils, and models, and all these were expensive. Luckily there was an unusual institution in Paris, the Académie Suisse, which was neither Swiss nor an academy but simply a large studio near the quai des Orfèvres. It was founded in 1808 by Charles Suisse, a former model for Jacques-Louis David. His face may be familiar because, as a gesture of friendship toward Delacroix, he agreed to pose for one of the artist's earliest paintings, *The Barque of Dante*, in 1822. He was so good at holding a pose that Delacroix used him to represent Dante and, with highly exaggerated features, one of the damned clinging to the boat. Father Suisse, as he was known, was not mercenary. For an average of ten francs a month, artists could work in his premises all day right up to ten o'clock in the evening. A male model would sit for three consecutive weeks and was replaced by a woman in

the fourth week. No teaching was offered, and there was often a lot of noise, but plenty of greats—Delacroix, Corot, Courbet, and Manet—honed their skills here.

Pissarro had been coming here since he first arrived in Paris. He did not allow himself to be impressed by novices who "did everything well straightaway and casually, not going into any depth."[2] But he noticed the concentration of one young man of not yet twenty, and he admired his brushstrokes. His name was Claude Monet. Their friendship was reciprocal and instant. They lived in the same neighborhood, Pissarro on the rue de Douai and Monet on the rue Pigalle, and they agreed to go painting *en plein air* together, first in the streets of Montmartre and then in the fields around Champigny-sur-Marne or the forest in Fontainebleau. "That was when I met Pissarro," Monet remembered in 1900, "who didn't yet think of himself as a revolutionary and just worked in Corot's style. It was an excellent example: I did the same."[3]

It was also at the Académie Suisse that, in 1862, Pissarro met Cézanne, freshly arrived from Aix-en-Provence, a wild boy who was eccentric, often furious, and incredibly stubborn. Zola, Cézanne's best and oldest friend, once said of him: "Proving something to Cézanne would be like persuading the towers of Notre Dame to dance a quadrille. He might say yes, but he wouldn't budge a single inch."[4] Other artists brought along by Monet soon joined this initial nucleus.

The moment his work was exhibited at the Salon, Pissarro stopped studying with Lehmann as his father had insisted. He was convinced that only constant drawing, particularly from memory, would help develop his

techniques. Monet, yielding to his family's wishes, had en-
rolled for classes with Charles Gleyre, a Swiss who advo-
cated a return to antiquity. Gleyre was not much to look at,
and according to the Goncourt brothers (although it has to
be said they were always malicious), he could be taken for "a
man made of wood, looking like a second-rate laborer, with
the intelligence of a drunken painter and a boring, lacklus-
ter mind."[5] According to Renoir, Gleyre did not teach his
students much, but at least he left them in peace. Monet,
who was less submissive, could not tolerate Gleyre's end-
less lecturing and became truly exasperated when Gleyre
criticized his nudes. Gleyre insisted on idealization, find-
ing realism repellent: "You see a thickset fellow and paint
him thickset. If his feet are huge, you show them as they
are. It's all so ugly. Remember if you will, young man, that
when executing a figure, one should always think of antiq-
uity. Nature, my friend, is all very well as part of a study,
but there's nothing of interest in it. Don't you see, it's all
down to style!"[6] This modest and generous man—he did
not ask his pupils for payment, settling for a contribution
to the rent and to the sitters' fees—does not appear to
have had any lasting effect on his students. Did he not
keep reminding them that landscapes were a decadent art
when all these young men were so eager to go off painting
in the countryside? But if Gleyre was neither cheerful nor
warm, he certainly attracted excellent individuals. It was
in his studio that Monet met Bazille, Renoir, and Sisley.
And he was keen to introduce them to Pissarro.

Monet left Gleyre's studio after only a few weeks and
had no trouble rallying all his friends around himself and

Pissarro. They, like him, found beauty in the quotidian and wanted to paint what they saw. They were bored by academic art such as Ingres's and gradually deserted the various studios and courses. But they were too intelligent not to acknowledge that they needed to learn reliable techniques if they were to paint in their own way, and so they headed to the Louvre, "the book that taught us to read," to use Cézanne's expression.[7] There they joined Manet, Degas, and Morisot. They had to ask for permission from the Copyists' Bureau before they could set up their easels next to the painting of their choice in the Louvre's galleries. They could be granted three different cards: artists' cards, pupils' cards, and work permits. Pissarro had had his artist's card since 1861. Manet had secured a pupil's card as soon as he turned eighteen; Degas received his in 1853 when he was twenty-one, and he renewed it every year for fifteen years.

It was in these galleries that they came to know each other. Manet was struck by a young man who worked with passion, studying by turns a Poussin and a Holbein. It was Degas. They struck up a conversation and could not fail to notice the skill and diligence of a young woman who was frequently spotted at her easel. This was Morisot, a pupil of Corot. She knew Henri Fantin-Latour, who then introduced her to Manet who, by happy chance, was copying the portrait of Hélène Fourment on a day when she was studying a painting in the Marie de Medicis cycle in the Rubens room. They started chatting. The group of friends was expanding. Five years later, in 1869, Manet asked the young woman artist to pose for *The Balcony*. He took a

great deal of interest in her work, but she was very independent and was infuriated when he suggested he could correct and retouch her paintings, although this had no impact on their friendship. They became even closer when she married his brother Eugène in 1874.

Pissarro was the oldest member of the team, and they really were a team, enjoying working side by side. Frustrated by official taste and the reluctant attitudes of the teachers, these young painters, who were on the brink of founding their own school, helped, corrected, and encouraged one another. At the end of his life, Pissarro explained their process to his son; it consisted of observing nature with their own modern temperaments. He had always been convinced that the arts were each intimately linked to their own era, without implying a rejection of schools that had come before. "We now have a general type that our great modern artists bequeathed to us, so we have a modern art tradition; I'm minded to follow it by altering it to fit our individual point of view.... Surely our predecessors, David, Ingres, Delacroix, Courbet and Corot—the great Corot—have left something for us?"[8] Incensed by the Salon jury's refusal to exhibit their work, the young Turks put together the Salon des Refusés (the rejects' salon), which, with the consent of Napoleon III, opened in 1863 in the Palais de l'Industrie that had been built for the 1855 World's Fair.

Visitors guffawed. Manet's *Le Déjeuner sur l'herbe* elicited the cruelest quips. Flaubert's friend Maxime du Camp gave a crushing review in the *Revue des Deux Mondes*: "This exhibition which is both pathetic and grotesque is one of

the most peculiar one could wish to see…affording as much laughter as the farces at the Palais-Royal."[9] But Pissarro and his friends were not rattled and continued to paint in the countryside, benefiting from two inventions that were essential to the development of Impressionism: tubes of paint and railways. The first freed them from the need to mix pigments to obtain colors (a process that could be done only in the studio) and the second facilitated all their excursions.

In an interview in 1904, Renoir explained the advantages of working alongside his friends; otherwise, he claimed, you might think everything you did was good. You don't criticize your own work.[10] He could not have expressed it more accurately. Artists of his generation loathed academic teaching, and it had been replaced by a very free system that encouraged them to work together and judge one another. The only valid teaching, therefore, was to be had from their peers and from the Louvre. Over this period, it is sometimes hard to distinguish between criticism and advice, particularly as the young gang spent so much time together. At the first opportunity they escaped for weeks at a time to the Barbizon area, drawn, like their predecessors, to the beautiful scenes in the forest of Fontainebleau. Monet and Pissarro joined Renoir and Sisley, who had taken rooms at the Auberge de la Mère Antoine in the tiny village of Marlotte. It is here, thanks to Monet, that Renoir met Corot. A little later Monet asked Bazille to meet him in Chailly, also in the forest of Fontainebleau, and Bazille told his father in a letter that Monet "who is quite good at landscapes" had given him

advice that helped him a great deal.[11] Thanks to his medical knowledge, Bazille in turn helped Monet when he injured his leg and had to keep to his bed. Courbet came calling on them at the auberge, and Bazille introduced them both to Corot.

The relations between them were equally close in Paris. Bazille, who was always extremely generous to his fellow painters, was happy to share his studio on rue Visconti. "Since my last letter," he wrote to his mother, "there have been developments on rue Visconti. Monet arrived out of nowhere with a collection of magnificent paintings that will be enormously successful at the Exhibition. He will be staying with me until the end of the month. With Renoir, that makes two struggling painters I'm housing. It's a real infirmary. I'm delighted, I have plenty of room and they're both most cheerful."[12]

Zola gathered his group of friends together at his home every Thursday evening: "I've started up my Thursday receptions again. Pissarro, Baille, Solari, and Georges Pajot come every week to moan with me and complain about how hard times are."[13] And Cézanne, of course, when he was in Paris. Zola did not restrict himself to artists: Philippe Solari may have been a sculptor, but Zola's childhood friend Georges Pajot was a police officer, and Baptistin Baille an astronomer at the Paris Observatory who went on to teach optics and acoustics at the School of Physics and Chemistry.

Berthe Morisot did not enjoy the same freedom as these young friends. It was impossible for her to join them on their expeditions to the country or their evenings in

cafés. But her family was happy to welcome them into their home, at least those who dressed appropriately. Manet, Degas, and Renoir, all still unmarried, were regulars in the Morisots' living room. There were endless comings and goings.

All these artists were independent spirits; they refused to comply with the conventions of official painting and they relished discussion. When they were not out in the open, they met in cafés. Night falls early in Paris once summer is over. They could not work in the dark, but cafés were well lit and heated. I have mentioned Brasserie Andler and the Brasserie des Martyrs. A little later, the Café Guerbois on rue des Batignolles (now the avenue de Clichy) became the favorite meeting place for painters and writers. Manet, whose studio was nearby, was bound to be there surrounded by admirers and friends. In 1909 Monet remembered that it was Manet who invited him

to go meet him every evening in the Batignolles café where he and his friends got together to chat when they left their studios. That's where I met Fantin-Latour and Cézanne, and Degas who arrived soon after from Italy, the art critic Duranty, Émile Zola who was just starting out as a writer, and a few others. I myself took along Sisley, Bazille and Renoir. Nothing could be more fascinating than these conversations, with their constant clashes of opinions. We kept one another's minds in suspense, encouraging one another to persevere with genuine, impartial research, and stocked up on provisions of enthusiasm which sustained us for weeks

on end until the idea took a definite form. We always came away toughened, more determined, our thoughts sharper and clearer.... Cézanne sometimes came to the Café Guerbois where our group met after the 1870 war [the Franco-Prussian War]. He always dressed in [a] careless way, and kept his pants up with a red belt like a workman....

Cézanne would cast a wary eye around the group when he entered. Then, opening his jacket and giving a thrust of his hips worthy of a zinc roofer, he'd haul up his pants and theatrically adjust the red belt at his waist. Next, he'd shake hands with everyone in turn. But if Manet was there, he would doff his hat and, speaking through his nose, say, "I won't shake your hand, Monsieur Manet, I haven't washed for a week." He clearly couldn't give a fig for Manet. But Manet paid him in kind.[14]

Pissarro tried to be there as often as possible, particularly on Thursdays when the greatest number of group members would gather, and if his wife and children were well he would spend the night at his mother's because he had been living in Pontoise since 1866. With his long beard that turned white very early and his thoughtful expression he had something of the patriarch about him and was greeted with a friendly "good evening, father Abraham." Pissarro had neither Degas's mordant wit nor Manet's elegance, nor Renoir's high spirits. He came to listen rather than to shine. The atmosphere was not the same as in their earliest meetings in the Brasserie des Martyrs. The young

people had aged, they worked hard. Depending on the Salon's response to their work in any given year (occasionally accepting it but more often rejecting it), they struggled to put across their way of seeing things. "M. Pissarro is an unknown whom no one will likely talk about," Zola wrote, explaining that Pissarro's serious, austere painting, his rigorous pursuit of truth and accuracy, and his strong, acerbic will were unlikely to appeal to the wider public.[15]

While they waited for success, Pissarro and his friends found some comfort in getting together even if their heated discussions meant they fell out from time to time, at least temporarily. Degas and Manet sometimes quarreled so vehemently that they reclaimed paintings they had given each other. The most appalling insult was when Manet mutilated a painting that Degas had given him of Manet listening to his wife, Suzanne, play the piano. He slashed off a whole strip of the painting, removing Suzanne's face and hands.

One of the most hotly debated issues was the question of subjects. Gods and goddesses, allegories, religious martyrs, battle scenes, or great moments in history bored them. There was no point in inserting a nymph in a landscape when the eye was drawn to a passing peasant. Contemporary life and modern towns provided much more interesting subjects. Unlike his older predecessors such as Courbet, who gave his peasants and parish priests a social significance, Pissarro did not paint to translate any political idea, despite his constant preoccupation with

social problems. Once a subject had attracted his attention, he never questioned whether it deserved to appear in his painting. He held out for a form of painting that he described as nonliterary. The raison d'être of a literary painting is to tell a story, but a painter's painting is based on feeling—in other words, on how things are seen.[16] This same concept was shared with Monet and the whole group: Degas did not make crude or cruel images of prostitutes to condemn the way they were exploited.

Their discussions were more specific and technical when they were all in agreement—on the importance of Japanese art, for example. A couple who had lived in Japan, Monsieur and Madame Desoye, opened a shop on the rue de Rivoli. The Japanese prints they exhibited were particularly admired by painters and engravers. There were other finds here too, such as kimonos, fans, and china. There are traces of this craze in Degas's 1868 portrait of James Tissot posing under a painting depicting Japanese women. Manet put a Japanese screen behind Zola and an image of a Japanese man in full costume pinned on the wall to his left. Monet painted his wife standing against a background of Japanese fans and swathed in a blazing red kimono that features a terrifying samurai, and this bears testimony to his enthusiasm for the lively colors favored by these exotic artists. Pissarro put a Japanese fan in his daughter Minette's hand for his 1873 portrait of her. But first and foremost, he was interested in Japanese engravers' elegance and techniques. Along with Degas and Cassatt, he would refine his own technique a few years later, and remained captivated by this art for the rest of his life.

"Hiroshige is a wonderful impressionist," he wrote to his son in 1893. "Monet, Rodin and I are enthused by him. I'm pleased to have created the effect of snow and flooding, these Japanese artists validate my commitment to our visual aims."[17]

Japanese art would become increasingly influential and popular over the course of the century, to the extent that department stores started introducing Japanese displays, spurred on by Hayashi Tadamasa, a translator in the Japanese delegation to the 1878 World's Fair. Tadamasa moved to Paris, opened a store at 65 rue de la Victoire where he sold Japanese objets d'art and prints, and became one of the most intelligent intermediaries between Japan and his adopted country. As an ambassador for culture, he did not stop at bringing Japanese art to the attention of Parisian buyers; he was passionately interested in contemporary painting and built up a superb collection of Impressionist works. It was to him that Pissarro turned in 1900 when he was trying to buy Japanese paper that could not be found in Paris.

But unanimous agreement was rare among the artists, and tempers flared easily. They were divided on the fundamental question of plein air painting. Manet, Fantin-Latour, and Degas thought the idea of painting in the woods and meadows ridiculous. Degas gave his opinion on the subject with his usual verve: "Painters who set up their easels out of doors should be shot." He was not interested in nature. Whistler, among the anti–plein air

faction, expressed his opposition most clearly: "These pic-
tures...cannot be anything else than large sketches, a bit
of floating drapery, a wave, a cloud that one sees for a mo-
ment then it disappears—the true tone has to be caught
in flight just as one shoots a flying bird. But the public
demands a finished product."[18] Convinced that the play
of light, the exuberance of ever-shifting colors, and the
fragile delicacy of morning mist could not be re-created
in a studio, Pissarro, Monet, Renoir, and Sisley would not
have contradicted him. It was precisely these ephemeral
effects that they sought, although they were still feeling
their way. Remembering the impassioned debates of his
youth, Pissarro admitted to his son Lucien: "I did not re-
alize...how profound a movement we were instinctively
pursuing. Its time had come."[19] A few years later the move-
ment would have a name: Impressionism.

In 1867 all of the friends were rejected by the Salon:
Pissarro, along with Renoir, Monet, Sisley, and of course,
Cézanne, whose work shocked the jury still more violently
than that of his peers. How could they sell their work if no
one saw it? Bazille tried to set up an exhibition with his
friends and described his plan in a letter to his mother:
"And so we have decided to rent a large studio every year
to exhibit as much of our work as we wish. We will invite
painters whom we like to send paintings. Courbet, Corot,
Diaz, Daubigny and many others whom you may not
know have promised to send canvases and are very much
in favor of our idea. With people like them and Monet,
who is better than all of them, we're bound to succeed.
You wait, people will be talking about us."[20] The plan was

never realized for lack of funds, and Bazille had to admit their defeat: "We need to be accepted into the bosom of the organization whose milk we haven't suckled, and which disowns us."[21] But the seed of the idea to set up a group exhibition had been planted.

Exacerbating his professional difficulties, family problems plagued Pissarro. Since his father's death in 1865, the family's equilibrium had collapsed. Frédéric Pissarro appears to have been an eminently sensible man. In matters of religion, he showed no sign of being particularly pious or intransigent. It seems Camille's lack of piety did not upset him unduly, and when he told his son not to forget to come for dinner for Yom Kippur, this was for family rather than religious reasons. And—incontrovertible proof—he bequeathed equal sums to the synagogue and the Protestant church in Saint Thomas. Did he want to signal his refusal to adhere exclusively to the synagogue? Can we see this as a sign of gratitude for the support the Protestants gave him during his long battle with the synagogue at the time of his marriage? The fact remains that he favored neither community over the other. He left no instructions regarding the running of the business in Saint Thomas, which was his widow's sole source of revenue. At Camille's request, one of the Petit uncles (a member of his father's maternal family) assumed that task. The emotional fallout was not so easily resolved. Emma, the eldest daughter, lived in England and, although she still contributed a great deal, responsibility for the widowed Rachel's welfare fell

on the two sons, Camille and Alfred. And this mother of theirs was not easy to please.

She left Passy and moved to boulevard des Martyrs (a continuation of the present-day rue des Martyrs beyond the boulevard de Clichy), which was in the neighborhood that Camille frequented when he was in Paris. He often left paintings in his mother's apartment in the hope of being able to show them to potential buyers, but he rarely spent the night there because he was reluctant to leave Julie alone in the country with two small children. His mother complained constantly about his absence: "You're never here when I need you" is a running theme in her letters from this period. She could have made life easier for herself if she had finally accepted Julie's existence, but she still obstinately refused to do this, thereby adding a painful complication to her son's life. Emma wrote from London: "I worry about her because she doesn't know how to make herself happy."[22] How right she was.

The aging Rachel suffered not only from her own sour character but also from various physical ailments. A doctor had to be found for her, and Camille turned to Dr. Paul Gachet, whom he had met several times without truly becoming friends. The young doctor, who had come to Paris from Montpellier, was passionate about painting but, unlike Bazille, did not abandon his profession and produced paintings and engravings as an amateur. He therefore enjoyed spending time with the group of artists who met regularly to vilify official art, and despite his modest means he built up a noteworthy collection over the years. According to Pissarro's son Paul, Camille came to know him

better in the studio of a mutual friend, Armand Gautier, a painter from Lille who had come to Paris as a very young man to enroll at the Ecole des Beaux-Arts. A few conversations were enough to convince Camille that Gachet had the patience and talent to treat his mother. It was a happy choice: the doctor won the trust of old Madame Pissarro, and she liked to open up to him about her woes, the lack of news from her children, her sad life, and the injustices of fate. "I could not be more worried. I'm sick because I can't sleep or eat from being so worried. I know how good you are to us and am therefore counting on you to visit soon,"[23] she wrote to him. And he was a constant source of support to Camille, as a doctor and a collector but also, from 1872, simply as a friend and neighbor. I am tempted to add "as a fellow artist" in that Gachet took up engraving in earnest and often invited Pissarro to use his studio.

Gachet believed in homeopathy, in other words administering diluted substances that—in concentration—would cause the same symptoms as the ailment. Camille adopted the method enthusiastically. He always refused to consult more traditional doctors, often with catastrophic results. One characteristic of Pissarro's family letters is how passionate he was about prescriptions and medical advice, which were accompanied by detailed descriptions that many readers would prefer to be spared about his correspondents' various evacuations. His trust in Gachet was complete, as was his authority over his children in medical matters.

It was during this period, in 1866, that Pissarro moved his household to Pontoise. He stayed there until 1869, when he rented a house in Louveciennes. Pontoise was an old town some twenty-five kilometers northwest of Paris; it stood on two rivers, the Oise and the Viosne, and provided a wealth of opportunities for landscape artists. The possible subjects were many and varied. Even the different crops in the surrounding fields intrigued Pissarro. He was particularly drawn to cabbages—despite taunts from the critics who thought the vegetable too vulgar to be painted! The town's market provided still more subjects, including a pig market. He had been interested in market scenes since his time in Caracas, and they never failed to inspire him throughout his career. Pontoise also had the advantage of attracting other artists. Daubigny had a house in Auvers, a nearby village, and had had a studio built on a boat to paint from life all the bustle of activity on the river Oise. Morisot often came here in summer. The elderly Honoré Daumier—who had been born under the First Empire and whom Pissarro admired unreservedly—rented a house in the area. Next door to Pissarro lived a remarkable woman, Maria Deraismes, with whom he later struck up a friendship. She was a very active feminist and the first woman to be admitted to a freemason lodge in France; in 1876 Pissarro painted her in the garden of her beautiful house "Les Mathurins."

Another advantage was that Paris was little more than an hour away by train. This was a recent development; the railway bridge that spanned the Oise had been completed in 1863. Pissarro, who rented a number of different houses

in Pontoise, could finally live more comfortably with his wife and children and could easily work either inside or out of doors. He put his energies into making the most of this situation, while still retreating to Paris in the winter months. This change of location was rewarding, and some of his most beautiful landscapes date from these years.

Daubigny became a member of the Salon's jury in 1866, and with Corot's support he promoted his young fellow artists. Manet, Monet, Degas, Bazille, and Pissarro were all accepted. Only Cézanne, who was still far too shocking for the majority of the jury, was refused. Pissarro won the votes of critics whom he respected, notably Zola who stressed the honesty of an artist who refused to prettify. Zola admired what he called Pissarro's "heroic simplicity, ... his ability to capture the modern countryside where man had left his mark, digging up the soil, carving it and blemishing its horizons.... It would be terribly banal if it weren't so terribly impressive. The painter's temperament has drawn a rare poem of life and strength from an ordinary truth." But Zola was well aware that the public balked at Pissarro's seriousness and austerity. He himself bought a painting—a barge on the Oise, the first of a series of about twenty views from the banks of the river—and gave a glowing critique of the paintings on show:

> There are two marvels at the Salon this year. But they have been hung so high that no one can see them. Mind you, had they been on the picture rail people might not have paid them any more attention. This work is too strong, too simple, too frank for the crowds.... Camille

Pissarro has been waiting nine years for success, and still it does not come. Never mind! If one recognized critic were to say tomorrow he had talent, that would be enough for the crowds to admire him. Everyone has their sixty minutes of acclaim; but what not everyone has is his powerful craft as a painter, his accurate, honest eye. With these fine qualities, once circumstances shine a light on him, he will be accepted as a master.[24]

Odilon Redon, a respected Symbolist artist, also commented on the austerity and intensity that emanated from these paintings. The two works, the "marvels," were *Jallais Hill, Pontoise*, which is now in the Metropolitan Museum of Art, and *The Hermitage at Pontoise*, which can be seen at the Guggenheim in New York. *Jallais Hill* depicts two elegant women, their faces obscured by their hats, walking uphill on a path that overlooks a hamlet. On the other side and taking up the whole upper part of the canvas is a hillside divided into green and brown strips of cultivation, under a big cloud-filled sky. And emerging beyond the ridge is the bell tower of the Saint-Maclou church, with tall poplar trees towering over it. The lack of detail and the indistinct mass of foliage signal the work of an Impressionist. An astonishing play of light that emphasizes the different shades of green dominates the whole painting. The subject for *The Hermitage at Pontoise*, the second painting exhibited at the Salon, is an unexceptional everyday scene: two women have stopped to chat on a dirt road, one of them has her young daughter in tow. Two children are playing on the grass, and peasants in the distance go

about their chores, but the eye is drawn to the expansive landscape in the background, all its charm derived from the delicacy of the color palette.

Despite these favorable articles, Pissarro was still not selling enough to free him of dependence on his mother. Granted, he was in touch with Pierre Firmin Martin, always called Père Martin, an intriguing character who had started out in life as a wine merchant, then opened a bric-a-brac shop and took an interest in the Barbizon painters at a very early stage. He was one of the first people to display Pissarro's paintings. "He bought them for 40 francs, hoped to get 80, and when he couldn't achieve that, which was often the case, he would settle for a price of 60, satisfied with a profit of 20."[25] Forty francs was a laughable sum. Pissarro needed to earn at least ten times that every month to support his family. In a very precise letter to Cézanne, who was preparing to leave Aix-en-Provence for Paris, Zola concluded that 125 francs a month was barely enough for a bachelor.

Nevertheless, Pissarro did not allow himself to be discouraged, and he continued to work with prodigious energy. He was accepted by the Salon again the following year and had gained enough confidence to complain about the positioning of his painting. "I would like to draw your attention to a joke that the art handlers have played on me by hanging my painting in a room that is not labeled with my initial letter and more specifically by hanging it over a door at an impossible height. I cannot attribute this

decision to the organizers, these gentlemen will feel, like me, that it is bad enough for an artist to be at the mercy of some jury, without then being subjected to the judgment of the handlers who hang the paintings!"[26]

The year 1868, marked by Pissarro's first favorable reviews, was darkened by the death of his sister, Emma Isaacson. Camille traveled to London for the funeral, leaving his brother, Alfred, with his mother who was "in a truly pitiful state."[27] The ties between the French and English branches of the family were strengthened in their grief. Camille grew very close to his nieces, particularly the two younger girls, Esther and Alice, who frequently suffered from their father's ill temper. It was then agreed that the eldest, Amélie, would go to Paris to console her grandmother and perhaps remain by her side. She lightened Camille's load at a time when he was spending less time in Paris because, in 1869, he decided to leave Pontoise for Louveciennes. He found a large yellow house on the route de Versailles to rent from a Monsieur Rotrou. The house features in an 1870 painting that belongs to the Clark Museum in Williamstown, Massachusetts.

Monet and Renoir lived in nearby villages, Monet in Saint-Michel and Renoir in Voisins, where his parents had bought a house. Louveciennes, where madame du Barry had settled after the death of Louis XV, lies some thirty kilometers west of Paris, next to the forests of Marly and Saint Germain-en-Laye and overlooking the river Seine. There was no lack of subjects, and the three friends often painted the same scenes. Various streets in Louveciennes adorn the walls of museums in Paris, Washington, New

York, Chicago, San Francisco, Houston, Dallas, London, Berlin, Madrid, Copenhagen, Moscow, Johannesburg, Tokyo, and Edinburgh, among others, thanks to their interpretations by Pissarro, Monet, Renoir, and Sisley.

The banks of the Seine provided further possibilities, particularly la Grenouillère, a huge boat that had been converted into an open-air café and moored to a pontoon on an island in the Seine, a few kilometers from Louveciennes. Parisians came there to lunch, to rent row boats for gliding up and down the river, and to enjoy the weekly dance. The island had such luxuriant vegetation that it was nicknamed "Madagascar on the Seine." Its visitors' behavior was so unfettered that a municipal decree required the wearing of bathing suits, and a contemporaneous guide specified that the site was not recommended for priests. Artists, on the other hand, were very welcome.

The three companions set up their easels there and worked to capture the reflections and vagaries of light on the water and foliage. Renoir and Monet, closer in their choice of subjects, combined elegant figures with more working-class types to convey the cheerful atmosphere of the place, and they both painted the Camembert, a tiny and perfectly round adjacent island with just one tree growing out of it, like a parasol. Pissarro, meanwhile, was more down-to-earth, more interested in the reality of the rural surroundings than his companions were, and he painted from a little farther back, focusing on the structure of the countryside. Being eminently intellectual, he saw plein air painting as only one aspect of the work. He explained this at length in an 1892 interview: "I don't

paint my work directly from nature; I do this only for stud-
ies, but the way the human mind unifies the vision can be
found only in the studio. That is where our initially dispa-
rate impressions are coordinated, where they add weight
to one another to bring out the true poem in the country-
side. Outside you can grasp the beautiful harmonies that
instantly captivate the eye, but you cannot interrogate
yourself sufficiently to assert your private feelings in the
work. It's in pursuit of this intellectual unity that I put all
my efforts."[28]

These sessions, which generated a series of canvases
that are now universally admired, did not bring an end
to the three artists' total penury, however. Renoir would
sometimes bring Monet bread given to him by his mother
to serve as an evening meal. "There isn't food every day. But
I'm still pleased because, in matters of painting, Monet is
good company. I'm hardly doing anything because I don't
have much by way of colors."[29] Fifty years later, Monet
and Julie Pissarro recalled the day when Monet had ar-
rived at the Pissarros' house famished and hoping for a
bite to eat with them. Julie had just two eggs, a sprinkling
of flour, and not a sou in her pocket. She borrowed some
milk from her neighbor and made pancakes. Monet never
forgot them.

Monet was not only hungry but also afraid that his
paintings would be seized, so he entrusted them to Pis-
sarro at this time. With no paints, he could not work
and—just like Renoir—was dependent on Bazille's help.
But Bazille's resources were running dry, and Monet found
himself completely up against the wall when his mistress,

Camille, gave birth to their first son, Jean. As a gesture of gratitude Monet asked Bazille to be the godfather and, as a gesture of friendship, he asked Julie Pissarro to be godmother. The more expedient Renoir abandoned the children he had with his model, Lise Tréhot, during this period of destitution.[30] At the time, Pissarro was reduced to painting window blinds to earn enough to feed his family. There were still no sales.

Whistler's warning that the public would insist on more polished pictures proved right, and nothing seemed to attract buyers, not even a glowing article by Théodore Duret, an upper-class gentleman who traded cognac and became an energetic champion of the new painting style, praising Pissarro's sensitivity and his ability to communicate a sense of space or of loneliness. It is true, Duret added ironically, that he lowered himself to painting cabbages and lettuces and that, "for followers of great art, there is something degrading in such subjects, something that debases the dignity of painting."[31] Alfred Pissarro interceded with their mother to persuade her to give Camille a monthly allowance, but the sum of some one hundred francs (which, besides, was dispensed irregularly) was barely enough to keep alive a family of four. And they were soon to be five, because Julie was pregnant when war between Prussia and France broke out on July 19, 1870.

6

War, Exile, and
a Fortuitous Meeting

War, which could easily have been avoided, was declared on July 19, 1870. To the astonishment of the population who had been reassured by France's generals that her army was prepared to fight down to the last gaiter button, there followed a succession of defeats: the French were crushed by the enemy, and Napoleon III surrendered at Sedan on September 2, 1870. Imprisoned by the Prussians, he was stripped of power on September 4. The creation of the French Republic was announced the very same day. But the war continued: Paris was besieged, and German troops pushed deeper into French territory, bypassing the capital. Pissarro and his family left Louveciennes in late August, abandoning his paintings and work tools, to take refuge with the painter Ludovic Piette, who had been a close friend since his time at the Académie Suisse. His mother had fled Paris for Saint Valery-en-Caux, to the north of Rouen and some thirty kilometers from Dieppe, where there were regular ferries to England. She stayed there

with her granddaughter Amélie Isaacson until November that year.

Pissarro was welcomed like a brother by Piette and his wife, Adèle Lévy, after an interminable journey covering three hundred kilometers: a twelve-hour train journey from Paris to Mayenne, then a long wait before they crammed themselves into a carriage that took them to Montfoucault, finally reaching the Piettes' beautiful family home. Like the Pissarros, the Piettes' household was Jewish and Roman Catholic: Piette, a Catholic who shared Pissarro's agnostic views, had married a Jewish woman. Adèle had not been received warmly by her in-laws and understood all too well Julie's awkward situation, rejected by Madame Pissarro while pregnant with her third child and still not married. Adèle could not fail to extend much needed emotional support to Julie. The Pissarro children were very familiar with the house, having spent several vacations there. They were reunited with toys from earlier trips, and their ebullience charmed the Piettes who were pained to have no children of their own. On previous visits the two men had gone out to paint all day, but they were now too anxious about the situation to clear their minds, so they turned to manual work. Manpower was in short supply, and Piette was only too happy to have Pissarro's help in the fields and in his large orchard. This would have been a period of respite for Camille if his exchanges with his mother all through October had not been so trying.

As a forty-year-old Danish citizen, Pissarro had no military obligation to France, and it never occurred to him to volunteer to defend the empire. But when the republic

was announced—a regime he had hoped for with all his heart—he was briefly tempted to enlist. His mother was panic-stricken at the thought and pleaded with him to do nothing:

> I beg you, my dear son, don't do anything rash
> remember that I have enough sadness; you're not
> French so don't endanger yourself unnecessarily. It's
> sad for me at my age to have only two sons and both of
> them far way leaving me with no protector. Don't ever
> think we are happy and cheerful here. Besides thinking
> about how the whole population is suffering is enough
> I would say to make us sad. What's more we don't know
> how long we shall be staying here if we receive some
> money. All in all a lot to think about. What to do. My
> God!!!!!! (Aren't you familiar with a grandmother's
> lamentations?)"[1]

This grandmother could sometimes make fun of herself, but her sense of humor never lasted long. A few days later, she returned to her subject: "Put the Republic to one side and think of your entourage." In her mind, she alone constituted his entourage, and her letter concluded with this reproachful question: "If by misfortune anything should happen to you, what would become of me?"[2]

In the event, Camille's military aspirations did not last long. He had never held a rifle: what sort of soldier would he have made? How could he abandon Julie and the children—particularly as, if he were killed, Julie would not inherit his rights to the business in Saint Thomas, the

family's only reliable source of income? Even putting aside this consideration, the question of marrying Julie—who was about to bring their third child into the world in such troubled times—reared its head with increased urgency. It was the subject of unpleasant discussions between mother and son when Camille wrote to Rachel yet again to ask for her permission to marry. These were pointless discussions that highlighted the stalemate in which Camille found himself, torn between his commitment to Julie and respect for his mother's wishes.

It was not only a question of money. True, he was still dependent on the help his mother gave him, but there were other elements at play. Pissarro was keenly aware of his responsibilities. He was thoughtful, conciliatory, and conscious of what he owed his father; I picture him troubled by the thought of falling out with his mother and abandoning the well-being of such an emotionally fragile woman entirely to his brother. I also imagine that he could not resolve himself to cut all ties with this family unit. Being an atheist was one thing, rejecting your family quite another, particularly for a man who knew he was an outsider in French society. In a letter to Monet he called himself an intruder, and he used the same word in a letter about artistic differences addressed to Théodore Duret, one of the first critics to recognize his talent: "Surely anyone would expect diverging views when they turn up like an intruder and plant their little flag in the middle of a brawl?"[3] Lastly and quite simply, his affection for his mother and his compassion for this woman who had lost two daughters since arriving in France encouraged him to

be indulgent with her. Nevertheless, one could have imagined that—driven by an equally pressing moral obligation to his companion and a desire to offer her some comfort at such a worrying time—Camille might have married Julie in secret while they were staying with the Piettes, but the fact that the banns of marriage had to be read outside the town hall in the residence of one of the fiancés made this solution impossible.

And so negotiations between mother and son continued by letter all through October. Camille needed to secure only the old lady's consent in principle, but she remained stubborn and illogical. At one point she agreed to allow the marriage but then went back on her decision the following day, explaining her reasons in a long letter dictated to her granddaughter:

My dear son, I replied to your letter yesterday, I can tell you I was filled with sorrow. The request you made of me caused me a great deal of it, it's making me sick, and now when I am already so sad and still ailing is not the time for me to be exposed to such emotions. As a mother, wanting to please you and without thinking, I said yes. It worried me sick all through the night and I made up my mind to write you to tell you that this consent deeply distresses me, and so I am relying on you and if you have any regard for me, you will return the letter, for I wrote it without thinking sufficiently on a matter of such importance. . . . Your brother knows nothing of all this. I have not even written him on the subject. It is I alone who beg you, . . . but do me the

pleasure of returning the letter and not making use of it. You can be sure I shall keep my word.... If you don't want to see your mother in despair for the rest of her days, you will restore my peace of mind because a son can do this for his mother.

Adieu, my dear son, I'm relying on you to set my mind at rest.

Tenderly, from your mother who loves you."[4]

Never once did she mention the name Julie. Never once did she ask for news of her, even when Julie gave birth on October 21, though she was not miserly in dispensing grandmotherly advice about the baby. Distressingly, the child, a girl called Adèle, survived only three days, to the immense sadness of the whole Piette household, and she was buried in the Piette family vault. But still not a word of consolation from the grandmother. On the other hand, Rachel did suggest a solution: Camille should go to London with his little family (she would finance the trip), and there he could marry Julie without her consent and, more significantly, without anyone present. It can be assumed that this compromise was devised so that no relations or Jewish friends should learn about, let alone be tempted to celebrate, such a shocking union.

In fact, Rachel left France before Camille did. She took a ferry in November to join her son Alfred, who had arrived in England a few weeks earlier with his wife and child. They moved into neighboring houses, not far from the Isaacsons in the London suburb of Norwood, which was attractive for its rural feel but was within easy reach

of the city center thanks to the railway. Perhaps a more decisive factor in their choice was the presence of a fairly sizable Jewish community. An old institution, the Jews' Hospital, founded in 1795, had transferred here from central London. The huge Jacobean-style building constructed in Norwood in 1866 was less a hospital then a hospice for elderly Jews and a school-cum-orphanage that could accommodate 220 children.

Pissarro was shaken by the ever more menacing news, the severity of the siege of Paris, and the relentless fighting less than two hundred kilometers from Montfoucault, particularly around Orléans (the Prussian army had surrounded Paris to the north, the east, and the west), and, conscious that they must not outstay their welcome with the Piettes, he waited for Julie to be sufficiently recovered from her delivery. They left Montfoucault at the start of December, six weeks after Julie had given birth, and sailed for England from Saint-Malo. Old Madame Pissarro had found lodgings for them just minutes from her own. A few months later, Pissarro settled on a more convenient neighboring house (demolished in 1977), not far from the Crystal Palace, which had originally been erected in Hyde Park for the 1851 Great Exhibition but had then been dismantled and rebuilt in Norwood a few years later.

Pissarro surely knew that he would be reunited with Monet in London (Monet had left France back in August of that year, leaving his wife and son in Trouville), but he did not yet know that Bazille had been killed on November 28,

1870. Bazille, promoted to sublieutenant, had volunteered with a Zouave regiment in a high-risk position. He wrote to his commanding officer with heartbreaking optimism: "As for me, I'm quite sure I shan't be killed, there are too many things I want to do in life."[5] He fell the following day at Beaune-la-Rolande, near Orléans, in a battle so unequal and murderous that 8,000 Frenchmen were killed or wounded while the Germans lost only 850 lives. Bazille had been one week short of his twenty-ninth birthday.

Other friends survived. Renoir was mobilized but, having suffered a serious bout of dysentery, did not see active combat; Degas enrolled in the National Guard; Manet was called up and served in the same unit as Degas. Cézanne evaded the police pursuing him as a draft dodger. He took refuge in Estaque, a small fishing port west of Marseille, in a house that belonged to his mother—"When the military police arrived, his mother would tip him off and he escaped through a back door into the scrubland with a basket of provisions."[6] Then, he took refuge in his father's house in Jas de Bouffan in Aix-en-Provence. Zola was exempted from military service, as he was his family's only means of support, his mother being widowed. He was not accepted by the National Guard because of his myopia and had left Paris for Marseille. The group had certainly scattered far and wide.

What could have been a tough ordeal for Pissarro in fact proved a productive period. It is worth pointing out that his ability to adapt to life in England was helped considerably

by the fact that he spoke English. Now that he, Julie, and the children were settled in a house very close to Rachel's and to his brother, the custom of regular visits was resumed—but Julie was still excluded. The grandchildren occasionally came to visit their grandmother, but Camille most often came alone. As he had in Paris, he often met other members of the family at her house. Julie's name remained taboo for all of them.

In their eyes she did not exist. It is not hard to imagine the young woman's loneliness and distress. Barely recovered from childbirth, still weeping over her infant's death, she also had to endure the effects of Madame Pissarro's fury. Not only could she not speak a word of English, she also claimed to feel assaulted by the peculiar noises that passed for that language. And she got lost in the fog. Going to the market and running her household were exhausting and difficult for her. The English Christmas complete with the famous pudding ablaze on every dining-room table and brightened by twinkling Christmas trees delighted Camille but struck her as all the more bizarre because Christmas trees were not yet a tradition in France. They were in fact introduced just after the Franco-Prussian War by Alsatians who chose to move to France. But what pained Julie most was that the Pissarro family remained inflexible about her.

When Camille and Julie, who was by then pregnant again, were finally married the following June in the registry office in the neighboring town of Croydon, not one relation attended the ceremony. The witnesses were Alexandre Prévost, a painter and engraver who lived in

London, and a shoemaker, Charles Lecape, whom Prévost brought with him from London. Camille knew not to be overwhelmed by such a problem, infuriating though it was, and he had set to work immediately after his arrival.

In this respect he was similar to Monet, whom he had contacted as soon as he arrived and who admitted to being "bored to death" whenever he was not obsessively painting. Camille made the most of this period of exile not only to explore other landscapes but also to study English painting. Painting—and selling—were vital because, it goes without saying, he had arrived with an empty purse but also because, the moment he started working, he was happy. It would be difficult to overstate the importance of this source of inner serenity, which allowed him to weather trials that would have overwhelmed a weaker character and which explain his attitude toward his children (as we shall see). He lost no time in putting on his wooden clogs as protection from the cold, to the astonishment of passersby, and setting up his easel to paint *Fox Hill, Upper Norwood*, a painting that now hangs in the National Gallery in London. He liked the surrounding countryside. Being sensitive to the charms of its multicolored houses and abundance of subjects, he was constantly tempted to break off from a walk to start painting. He was familiar with the theme of the approach to a village, but what was new was the railway and how it transformed the landscape.

Comparisons are often made between a painting of Turner's, *Rain, Steam and Speed—The Great Western Railway*, which was exhibited at the National Gallery while Pissarro was in England, and Pissarro's own *Lordship Lane*

Station, but whereas Turner emphasizes the violence of the engine's irruption, Pissarro by contrast highlights the peaceful coexistence of this modern invention with traditional countryside. There is nothing hostile about his locomotive pulling a peaceful slow train, whereas Turner's meteoric contraption strikes fear in the heart. In France, Pissarro had already been incorporating mills and factories into his landscapes, eschewing a sentimental or romantic view of the countryside while conversely underlining his fascination with the modern world. He revisited the theme of English trains nearly thirty years later in *The Train, Bedford Park*, and here again, the train is more reassuring than menacing. He continued to amalgamate trains with landscapes, sometimes so subtly, as in *Route d'Auvers sur les rives de l'Oise, Pontoise*, that it takes a moment to notice the unexpected smoke and the succession of carriages in the distance.

When the weather was very bad, which happened frequently (the winter of 1870–1871 was particularly cold in England), he often went to the British Museum, the National Gallery, or the South Kensington Museum (now the Victoria and Albert Museum), sometimes taking his son Lucien into London, and he enjoyed showing him the paintings that he liked. He later berated Lucien for not remembering the Turners they had seen together, but the child was only eight at the time. Turner had bequeathed his paintings to the National Gallery on condition that two of his works be hung alongside two landscapes by

Claude Lorrain. If Pissarro was alone, he sometimes spent evenings with painter friends at the Café Royal, which was run by some French people. Among the regulars he was happy to meet up with Daubigny, who had always been a supporter of his.

Another welcoming place was the home of the respected painter and engraver Alphonse Legros who, at Whistler's instigation, had left Paris in 1863 to settle in London, where he taught at the South Kensington School of Art. He was well acclimatized to England, had an English wife, and proved generous toward French exiles, extending particular help to Durand-Ruel in setting up his London gallery. Many years later, Pissarro remembered lunches at Legros's house with Monet. He had fond memories of what could have been a difficult period, further proof that he always refused to be crushed by circumstances. Pissarro was admirably resilient. Inertia and self-pity were alien to him. During these months of exile, he did not succumb to fretting about the future, but he did little to soften Julie's bleak loneliness. When he wasn't painting or taking care of Lucien, he immersed himself in English art.

One of Pissarro's characteristics was his curiosity: the British Museum's Holbeins and bas-reliefs captivated him as much as English landscape artists such as Turner and Constable. Many years later he became friends with the English painter Wynford Dewhurst and told him how he remembered this period: "In 1870 I ended up in London with Monet. [We] were very enthusiastic about London landscapes....We visited [the] museums of course. Turner's oils and watercolors and the Constables...certainly

influenced us. We admired Gainsborough, Lawrence, Reynolds etc. but were more struck by the landscape artists who were more in keeping with our experiments in plein air work, in light and short-lived effects. Of the modern painters, we were very interested in Watts and Rossetti."[7]

Paul Signac also relates that in 1886 Pissarro mentioned how thoroughly dazzled he and Monet had been by Turner's "delicate and magical" colors, how they admired his representations of snow and ice, and had discovered that he managed to communicate the whiteness of snow "not with solid white but with a mass of varied touches applied alongside one another."[8] Pissarro never forgot what he owed the English painter. In an 1892 letter to the critic Noël Clément-Janin, he corrected the critic about the way he understood the artistic evolution of the Impressionists, once again highlighting Turner's importance: "We have nothing in common with Th. Rousseau, Harpignies, Bastien-Lepage.... Our journey begins with the great English painter Turner, [and continues with] Delacroix, Corot, Courbet, Daumier, etc."[9] In an interview with Paul Gsell for *Revue Bleue*, he explained: "[Turner] was perhaps the first who knew how to make colors blaze with a natural brilliance."[10] For Pissarro, these months of exile were therefore a period of intellectual fermentation and of increased activity, given that he completed about fifteen canvases whereas he had been unable to work at the Piettes' house. But commercial success still eluded him.

Like Monet he was stung by the Royal Academy's refusal to show their work. His bitter letter to Duret from

the end of his time in England bears witness: "It's only when abroad that we can grasp how beautiful and big and hospitable France is, what a difference here where we garner only contempt, indifference and even rudeness among our fellow painters, jealousy and the most self-serving disapproval—there is no art here, it is all about business. As far as sales are concerned, I have achieved nothing, except with Durand-Ruel who bought two small paintings from me, my painting doesn't attract anyone, no one at all. This problem dogs me wherever I go."[11]

Duret replied by return of post, assuring him of his active support: "Your letter arrived only this morning.... I shall be traveling to London, and I hope you will still be there when I arrive.... I should very much like to have some of the canvases painted during your stay in England. Would you be so kind as to choose and set aside one or two canvases. Whatever the dimensions, large or small, prepare whatever best pleases you and has the most originality and flavor sui generis. You know how I admire these qualities."[12] Duret not only came to see Pissarro's paintings in Durand-Ruel's gallery, but he also visited him in Norwood and bought a painting from him, and brought along a "charming young man" employed by his father's cognac business who bought *Street in Upper Norwood*, which now hangs in Munich's Neue Pinakothek.

In June 1871 Pissarro did not understand the importance of this first contact with Paul Durand-Ruel. Indeed, it

would have been difficult for him to anticipate that this serious, methodical gentleman who looked like a notary and who—what's more—was a monarchist would champion the avant-garde of his era and would be the architect of the Impressionists' worldwide success. Like Daubigny, Monet, and Pissarro, Durand-Ruel had taken refuge in England, having managed to escape Paris on the last London-bound train in September 1870, arriving just in time to take reception of a good fifty crates filled with paintings sent from Paris. Some thirty-five of the crates contained the stock from his Paris gallery; the others were filled with works entrusted to him by various collectors. He had previously settled his wife and five children on the family estate in the Périgord, and they were quick to join him in London. Only his youngest daughter stayed in France with her grandparents.

Paul Durand-Ruel had already established his standing in the Parisian art scene in 1870. His father, Jean-Marie Durand, had had very modest beginnings in that milieu, managing a stationery shop that belonged to a young woman called Marie-Ferdinande Ruel. He acquitted himself so well of his duties that he went from employee to husband. The newlyweds combined their names and liked to be called Durand Ruel (it was another fifty years before the name was legalized by the hyphen). Their business grew rapidly; all sorts of supplies for painters—easels, canvases, brushes, and paints—drew a clientele of artists who were also delighted to use the firm's framing service. A few painters deposited their works with them for safekeeping, and this formed the beginnings of a small

art dealership. The store progressively became a meeting place for young painters.

Jean-Marie Durand-Ruel's own taste developed and became more refined. Some of his customers were considerable connoisseurs, and they introduced him to English painting and to French landscape artists. He was bitten by a passion for art and, along with it, for dealing in art; so much so that he now found himself less of a stationer and more of an art dealer and decided to separate the two activities. The stationery remained on the rue Saint-Jacques, in the shadow of the Sorbonne, and he opened an art gallery in the rue de la Paix on the Right Bank. A bold move. Durand-Ruel's profit margins were slender, but with his substantial stock of oil paintings as well as lithographs and watercolors, he had a regular source of income from renting artworks. This was a common practice at the time. People could rent art for parties or to allow a young woman to copy a work at her leisure or perhaps for an art teacher to illustrate a point.

Durand-Ruel's only son, Paul, was a fervent Roman Catholic with little predisposition for business. He was tempted to become either a soldier or a missionary and did not seem destined to succeed his father. But he had to forgo his possible careers bearing arms or dispensing alms because of a health problem (in his memoirs he does not specify the nature of the complaint that led his doctor to advise him against enlisting). He decided to follow in his father's footsteps. Paul began his career as an expert, and his combination of affability and firmness worked wonders. Then his father made him a business partner. They

both admired the Romantics and the Barbizon landscape painters, artists of the "belle école" of 1830—Corot, Théodore Rousseau, Diaz, Dupré, and Daubigny. They also liked the realists, particularly Jean-François Millet. When the founder died in 1865, the gallery did not change its orientation. Was Pissarro aware of the Durand-Ruel gallery? There is nothing in his correspondence to indicate that he was, but it seems unlikely he never visited it if only because he too admired the Barbizon school. But there had certainly been no personal contact between Pissarro and Durand-Ruel.

Once Durand-Ruel arrived in London, he lost no time in setting up an exhibition. By October 29, 1870, an "Exhibition of High-Class French Paintings" was ready to open in temporary premises. Meanwhile he was making arrangements to open his own gallery, and he rented a suitable space—which went by the then unfortunate name of German Gallery—in the elegant neighborhood of Mayfair. A few days earlier he had come into contact with Daubigny, who was struggling to earn a living in exile. It was a providential meeting for the artist because the dealer immediately commisioned three paintings from him. A providential meeting as well for Monet and Pissarro. Monet reports that, "during the course of an evening at the Café Royal, Daubigny asked [me] what [I was doing]. 'A few little landscapes in the park,' I replied. And Daubigny went on to say, 'But that's wonderful, you won't sell that. I'll introduce you to a dealer.' And he went to look for Durand who had set up

a store in London to sell paintings during the war. We have stayed in touch ever since."[13] In his memoirs, Durand-Ruel describes how Daubigny showed him Monet's paintings, saying, "Here's a young man who will be better than all of us.... Confronted with these unusual canvases, I was a little disoriented and hesitant. Daubigny said: Buy. I promise to take back any that you don't manage to sell and give you my work in exchange because you prefer it."[14]

Things were a little different with Pissarro. Was it Daubigny or Monet who urged him to drop off a painting at the gallery? The dealer did in fact have some knowledge of his work since he had mentioned him in the *Revue Internationale de l'Art et de la Curiosité* that he had founded in 1869, but the two men had had no contact. He thanked Pissarro for the painting in a gracious note: "You brought me a delightful painting and I regret that I was not at my gallery to pay my compliments in person. Do tell me what price you want for it."[15] In a subsequent letter of January 1871, he said: "Would you be so kind as to send me more paintings as soon as you can. I need to sell a good many of them for you here." Ultimately, Durand-Ruel bought two paintings from Pissarro for two hundred francs each. Tremendous progress for someone who relinquished his paintings to Père Martin for forty francs, but it was not enough. And Pissarro's financial situation remained precarious.

The armistice, along with stringent conditions, came into effect on January 28, 1871, marking the end of the

fighting, but the political situation in France was far from calm. Nevertheless, the exiles' hopes were raised, and Durand-Ruel, believing the worst was over, returned to France in mid-March—although he left his wife and children in London. The very day after he returned, however, an assortment of revolutionary groups came together to form an insurrectional government in Paris under the name of the Commune while the official government led by Thiers was in Versailles. Weakened by internal dissenters, the Commune was unable to resist an attack from Versailles troops, who retook Paris on May 21 and instituted savage crackdowns. Durand-Ruel found everything about the revolutionary movement abhorrent, and there is no doubting that he would have been relieved to see order restored, but his passion for painting was still stronger than his political convictions.

To his credit, he courageously championed the artists who had sided with the Commune and who were subjected to astonishing verbal violence. The poet Lecomte de Lisle clamored for a number of executions, not only of "that disgusting dauber Courbet but also the repulsive gang of painters, Corot, Manet and Renoir."[16] The most threatened was Courbet, who had to take refuge in Switzerland, having been accused of toppling the column in the place Vendôme and condemned to re-erecting it at his own expense. Durand-Ruel subsidized him generously, sending him regular payments via his landlady as advances for paintings. When Courbet's studio was threatened, Durand-Ruel arranged for his paintings *The Painter's Studio* and *A Burial at Ornans* to be moved to his own home

on rue Lafitte. Renoir applauded his attitude with this witticism: "We needed a reactionary to defend our painting that the *salonnards* deem revolutionary. At least he doesn't run the risk of being shot as a Communard."[17] The fact that Durand-Ruel was able to separate his political views and his artistic tastes so completely was promising for Pissarro, whose Jewish origins and left-wing opinions—which would become more trenchant—could have alienated the dealer. But in the early months of 1871 Pissarro was battling with such difficult personal circumstances that any sort of political commitment was impossible for him.

He already knew from Julie's sister who had stayed in Paris during the siege that Louveciennes had been bombed. And Edouard Béliard, an old friend from his Académie Suisse days, wrote him with grim humor: "I have no news of your house in Louveciennes. For your blankets, clothes, shoes, and linen, believe me, you can mourn their passing, for your studies, which are generally admired, I'd like to think they'll adorn Prussian living rooms. Having the forest so nearby will undoubtedly have saved your furniture."[18]

The truth was bleaker still. According to a neighbor, Mr. Ollivon, the Pissarros' home could no longer be described as a house: "I would call it a stable, there were certainly two wagons of manure there. In the small room next to the living room there were horses, the kitchen and storage room were sheep pens and the sheep were slaughtered in your garden, you'd be right to think that many of the trees and flowers served as grazing." He adds that there was a lot of theft "after the soldiers left and, in the

absence of homeowners, there was no possible recourse. I can assure you that there are plenty of people who had very little before the war and are now well provided for in every way.... there is also a lot of damage, the garden is terrible, and sheep too, they killed all these animals in your gardens, I can tell you they left baskets and barrels of blood, which didn't smell too good, it all had to be buried."[19] Ironically, on March 10, eight days before the insurrection and the establishment of the Commune, Julie had been reassured by a letter from her sister Félicie (whose spelling was very distinctive): "you can come back to Paris quite sayflee its very calm there aren't enny riots nothing and best of all food is now back to wat it was befaw the war ixsept your house is uninhabitabal."[20]

Pissarro summarized the situation in a letter to his landlord, who was demanding rent. He would have to wait till there was a resolution to what he very diplomatically described as "the differences that exist between Paris and Versailles" before he returned to Louveciennes, which he intended to do as soon as possible. He acknowledged that he had lost three-quarters of his belongings and that there was very little chance the government's planned compensation would take into account the loss of his paintings:

> I had twelve to fifteen hundred paintings, studies, and sketches, work from twenty years of my life. I think that if any property is sacred, it's property that is the product of our intelligence and made with our own

hands, and yet I don't believe that in Versailles they intend to do anything for those who have suffered this sort of loss. I now have just a broken bed, no mattress or box springs, no crockery, no cookware etc. . . . and so many little things that make up a household, my albums, my books, the tools of a painter's craft, when all is said and done, I can see three or four large pieces of furniture have been saved with various degrees of damage, it's pitiful.[21]

It was worse than pitiful, it was devastating. His canvases had been thrown on the ground like floor mats, spattered with muck, torn, and trampled by horses, others had been stolen (some would reappear when he became famous) and still others pilfered by women in the village.[22] Pissarro told Jean Grave, an anarchist friend of his, that when he returned, he noticed that several women in the village came to the washhouse wearing splendid canvas aprons patched together from pieces in a variety of sizes and colors. He solved the mystery when he lifted the corner of an apron only to discover his own signature.[23] Only the canvases entrusted to Pissarro by Monet survived the occupation. Pissarro had stored them in a case that the soldiers failed to notice or to open.

Camille eventually returned in June 1871. He shared in Piette's indignation when he heard the details of how the Commune had been crushed. Piette was not a rabid socialist; he had been elected town counselor as a liberal conservative but had been horrified by the court-martials, the summary executions, and the treatment of twenty-eight

thousand prisoners crowded into moored pontoon boats and massacred in cold blood. He wrote to Pissarro: "To my mind, Versailles's ferocity has exceeded all previous killings...all those sinister rivers of blood were just rivulets of forget-me-nots compared to the torrent that has flowed as a result of Versailles's reaction." He ended the letter, wishing his friend, "Paradise at the end of [his] days, by which I mean a good ditch in which to sleep peacefully and sheltered from men, as La Fontaine used to say, but until then, paint plenty of paintings, sell them well and keep joking as you always do."[24] Pissarro followed this advice, although I am not sure he was much in the mood for joking. Duret had warned him in the letter cited earlier: "Paris is still full of horror and terror. No one has ever seen the like of it."[25]

Pissarro briefly contemplated moving closer to Piette by settling in the provinces, but eventually decided to stay at Louveciennes, convinced, quite reasonably, that he absolutely must sort out his affairs. And, despite the pleasure that Pissarro's company would have afforded him, Piette supported the decision: "I think your blood will flow faster in Paris than it would it here, where, in spite of everything, you're always overrun by a sleepy lethargy and despair."[26] The Pissarros moved temporarily into the house next door to their own. Lucien was sent to elementary school, and life gradually picked up again. Julie immediately set to work making their home habitable with her characteristic courage and furious determination while Camille, who wasted no time on bleating and regrets, was delighted to be back in the landscape that inspired him. Only work could restore his serenity and zeal.

He displayed a degree of passivity in the face of the inevitable and, during periods of introspection, he attributed this to his upbringing. There was no point in seething and raging. In a letter to Octave Mirbeau, he said that everything—sadness, bitterness, and sorrow—was erased by the sheer joy of work.[27] At his easel, he had renewed physical and mental energy. His *Route de Versailles, Rocquencourt*, one of the first works he painted on his return, exudes a serenity that does not appear to have been touched by recent events. Pissarro's optimism was in fact appropriate: France was rising. The colossal war reparations owed to the Germans—some five billion gold francs over three years—had been swiftly paid.[28] The reign of incompetence and corruption was giving way to a young republic that left ample room for hope. "Our reign is coming," Zola proclaimed. In the meantime, what did come to the Pissarro household was a third child, little Georges, on November 22, 1871.

By then Camille had received a fraction of the compensation for which he had applied to cushion his losses, which he had evaluated at 50,000 francs; he was awarded only 835 francs. But Durand-Ruel's support put him back on an even keel. The dealer's activity continued despite the terrible tragedy that struck him in November 1871. Emerging from the Opéra, his wife, who was pregnant with their sixth child, felt sick. She was dead of a lung infection within a few days. She was not yet thirty. And he never recovered; he had lost not only the wife he loved but also a wise and shrewd adviser. She had reined in the impetuosity of the man Mirbeau described as "the impenitent

risk taker."[29] After his wife's death, Durand-Ruel adopted
a policy of frantic buying without worrying unduly about
salability. The new school of painters didn't complain and
were delighted that his interest in contemporary art was
undiminished. He had recognized Monet's and Pissarro's
talents in London. Now back in Paris, he discovered Manet
and bought twenty-three paintings from him for thirty-
five thousand francs. He also took an interest in Degas,
whom he had just met, and in Renoir. Sisley, whose family
lost everything during the war, was only too happy to sell
him twenty-five paintings at two hundred francs apiece.
Durand-Ruel didn't focus on an exclusively French cus-
tomer base but also established branches in London and
Brussels. In 1872 he exhibited thirteen Manets, nine Pis-
sarros, six Sisleys, four Monets, and three Degas in Lon-
don, and was not discouraged by the lack of enthusiasm
shown by the English.

At last, Pissarro could envision a future in which he
would be able to paint without being consumed with wor-
ries. For the first time in his life, he glimpsed the possibil-
ity of supporting his family. After a visit to Durand-Ruel's
gallery in January 1872, he could give the good news to
Julie: "I went into Durand-Ruel's gallery, and he talked
about my paintings, he really encouraged me and told me
he wanted to buy paintings from me, small or large. He
told me that if I didn't live so far away, he would have come
to see and choose for himself. I'm thrilled with the direc-
tion my work has taken. I shall show him the best I have."[30]
This allows us to gauge the catastrophic consequences
for Pissarro of the loss of his 1865–1870 paintings. The

destruction of part of his output—a loss that was all the more tragic because his work at that time had been outstanding—restricted the choice that he could offer his dealer. But Pissarro was not a man to allow himself to be overcome by bitterness and regret. And, moreover, others rejoiced for him. His friends congratulated him and could see a peaceful future ahead for him. "You've come through the worst of the storms," Guillemet wrote to him after a visit to Durand-Ruel's gallery, "you're successful...and I'm genuinely happy for you."[31] Piette, as usual, was more demonstrative and less grammatically correct: "You haven't told me about yourself, my dear Pissarro, in the flush of victory which, trusting in your lucky star through the struggles and difficult battles, now that you're all set to become a big Name, and *you fully deserve it*.... You won't be short of money. That's what I hope."[32]

Between March and December 1872, Pissarro in fact received fifty-nine hundred francs from Durand-Ruel in eleven payments, while still selling to his own customers because the dealer had not yet insisted on exclusive rights to represent him. Pissarro personally sold two paintings to Dr. Gachet: one *Lever du soleil* (sunrise) and one *Route de Versailles, Louveciennes, Winter Sun and Snow*. In May 1873 Duret bought a large canvas—*L'Inondation* (the flood)—for five hundred francs. Another important customer was an unusual character, Jean-Baptiste Faure—one of the most famous opera singers of the time, who built up an astonishing Impressionist collection over the years, mostly buying from Durand-Ruel. At one point he owned sixty-seven Manets, including *Le Déjeuner sur l'herbe* (bought from the

artist in 1878) and *The Fifer*, as well as sixty-three paintings by Monet, including *The Argenteuil Bridge*, fifty-eight Sisleys, sixteen Degas, and thirty-seven Pissarros. Lastly, a banker called Gustave Arosa bought a *Printemps* (springtime) and commissioned four overdoor panels.

In late 1872 the whole group was back in Paris or the surrounding area. Confidence was restored. The disgust they felt for the Salon organizers' maneuvering and politics was still so strong that plans for a first Impressionist exhibition started to take shape.

7

An Open-Air School
Work and Friendship

In the spring of 1872 Pissarro decided to leave Louveci-
ennes and return to Pontoise, where he would live until
1882. The next two years would prove exciting for him as
he gathered a number of his painter friends around him
and worked very closely with Cézanne. But this period was
not only about painting; he also went to great lengths to
expand his client base and ensure that the first Impres-
sionist exhibition took place in 1874. However, this return
to a landscape that he loved—and which was so condu-
cive to his work—would be a painful time for him as a fa-
ther, as he watched the inexorable decline of his daughter,
Jeanne, who was known to the family as Minette.

One of the great advantages of this move was the
proximity of Dr. Gachet, who had just settled in Auvers,
a village near Pontoise, and who was a constant source of
support to Pissarro. The previous year, while Pissarro was
still in Louveciennes, he had already reestablished con-
tact with Gachet when his youngest, Georges, had been

seriously ill. There were fears that the baby's brain could be in danger, and the doctor had come from Paris to see him. The child recovered. "He seems more cheerful and laughs all the time, which is a good sign, according to the old women in Louveciennes," reported a grateful Pissarro.[1] Since the Pissarros' return to Pontoise, Dr. Gachet had been treating the whole family, including old Madame Pissarro, who sometimes came to rest in her son's home and took every opportunity to reprimand her daughter-in-law, always quick to criticize her or swipe her with her walking stick. (Since Camille and Julie's marriage, she had agreed to see Julie but always treated her as a servant.) Dr. Gachet's support was not limited to the family's health. He also bought two paintings; his enthusiasm for Pissarro's talent was so infectious that not long after the Pissarros moved to Pontoise, he persuaded the grocer, Mr. Rondest, to accept Pissarro's offer to pay his debts with a painting. The grocer's heirs came off very well as a result. On the doctor's advice, Rondest kept *Le Tribunal de Pontoise, place Saint-Louis*, which was not sold until he died in 1929. We can bet that its value then far exceeded the full amount of Pissarro's debt. It is worth noting that Pissarro always paid the doctor's bills very conscientiously.

As we have seen, Pissarro had always enjoyed working in the company of friends. On his return to Louveciennes from England, he went back to those habits, with Sisley and Renoir. In Pontoise he went one better, drawing in so many fellow artists that there was talk of a Pontoise school. From late summer, he worked alongside Armand Guillaumin, Béliard, and Cézanne. Other young painters—Victor

Vignon and Frédéric Cordey, whom Renoir introduced—came to join them. Piette dropped by frequently, and the Pissarros resumed their tradition of spending vacations in Montfoucault. There was always a warm welcome for transatlantic friends: the Puerto Rican Francisco Oller and another childhood friend, the Cuban José Aguiard, who was a physician and liked to paint in his spare time. Surviving photographs show them always wearing boots typical of landscape artists and an assortment of hats.

Julie, who was probably too busy feeding all these people, is nowhere to be seen whereas little Lucien appears frequently, perhaps perched on the backrest of a bench or at his father's side. He listened with a precocious child's attentive ear and remembered everything. His testimony allows us to reconstruct some conversations and the familial atmosphere of this period, as when, for example, twenty years later he told his youngest brother, Paul, that during a heated discussion, their father had cried out, "But, So-and-so, we're not painting a face, we're establishing harmonies."[2] Of all his father's friends, Cézanne certainly fascinated Lucien the most. And it was, in fact, companionship and closeness with Cézanne that afforded Camille the greatest joy and allowed him to think more deeply.

Cézanne's mistress, Hortense Fiquet, had just given birth to their son, Paul, and prompted by Pissarro, Cézanne left a cramped and awkward apartment on the rue de Jussieu (a place, according to Cézanne's friend Achille Emperaire, filled with "a racket to wake the dead") and moved closer to him.[3] For a few months, the new father commuted back and forth between Paris and the Pontoise area. He

often stayed at the Hôtel du Grand-Cerf in Saint-Ouen-l'Aumône, which was owned by the painter Béliard, before moving to Auvers in January 1873 and renting "a hut [fifty meters from Dr. Gachet's house] which just about meant he could paint outside. He had a lot of trouble finding the one hundred francs a year owed to [his landlady] Marguerite Drop."[4] This proximity, which continued over future visits, had an effect on both artists, whose work evolved in ways that demonstrate the reciprocity of their influence.

They had known each other since the time of the Académie Suisse where Pissarro, eight years Cézanne's senior, had been struck by him. "I saw things clearly in 1861," he told Lucien in 1895, "when Oller and I went to see that peculiar Provençal fellow at the Académie Suisse, where Cézanne drew nudes that were laughed at by all the dunces of the studio particularly the famous Jacquet who had long since descended into 'pretty' and whose work sold for a fortune!!"[5] Together they had braved insults and jeering from visitors to the Salon des Refusés in 1863, without losing heart. Cézanne was not easy. Inflexible, stubborn, keen to shock. "He is made of one piece." Zola wrote to their mutual friend Louis Baille. "He slashed more canvases than he completed and threw brushes at the ceiling in fits of impatience."[6] Embroiled in an impossible situation because he dreaded telling his father about his son's birth, he constantly battled to stave off destitution. The "subtle and prudent" Pissarro grasped that it was important to gain his trust first, and he advised Dr. Gachet, "when talking to Cézanne to be sure [to avoid] anything that might irritate him."[7]

In 1872 Cézanne already had a significant body of work behind him, one that was recognized and well-regarded by his peers, even if buyers were rare and the critics recalcitrant. Which is why, when Zola admitted during the course of a conversation that he had lost faith in Cézanne, Renoir leapt so fiercely to his defense that Zola admitted defeat and even went so far as to end the discussion by saying that painting was not his field (a strange admission for a writer who prided himself on being an art critic).[8] Pissarro did Cézanne an immense favor in 1894 when he recommended him to the very young dealer Ambroise Vollard, who was struggling to put together an interesting stock of art:

> [Vollard] amassed more and more paintings until the providential day when he met the painter Pissarro, who told him, "Go see Cézanne, he has never sold a single painting and he'd be grateful and flattered if someone took an interest in his work. He has a lot of paintings, he's an artist with a future, believe me." Vollard immediately took action, hired a handcart, went to see Cézanne, and swept up the whole lot. He had trouble loading it all up but eventually managed to. He was starting to drive the cart away when Cézanne appeared, his hair awry, calling out, "But you forgot these two." It was a large painting, *La Montagne Sainte-Victoire* and a smaller one of people playing cards. The first is in the Metropolitan Museum, the other belongs to the famous American collector, Barnes.[9]

Cézanne did not come to Pissarro as a pupil, and yet he wanted to learn from him: to see things differently, take

up plein air painting, and observe nature. He accepted Pissarro's authority, but this did not translate into a master-pupil relationship, even though Cézanne later said, "As for old Pissarro, he was a father to me. He was someone you could consult and something like the good Lord."[10]

Pissarro calmed the hotheaded Cézanne, who was now emerging from his *couillard* (ballsy) period, which had been marked by brutal violence. The older man's calm, tolerance, and gentleness managed to tame the man who Renoir compared to a porcupine. "Our Cézanne," Pissarro wrote to his friend Guillemet, Lucien's godfather, "gives us hope...At home I have a remarkably vigorous, powerful painting. If, as I hope he does, he stays a while in Auvers where he intends to live, he'll surprise a good many artists who were too quick to condemn him."[11]

The atmosphere in the Pissarro family suited Cézanne. Julie was generous, efficient, and astute. On several occasions she came to help Hortense, who was often overwhelmed by looking after a baby. Doubtless she was reassured by the absence of immediate financial worries and had more self-assurance now that she was married. Life was falling into place and improving. A few months after coming to Pontoise, the Pissarros moved to 26 rue de l'Hermitage, a house that was in the same part of the village, but in a better location and not so damp. Julie was now in her element: she busied herself in her kitchen garden with alternating rows of vegetables and attractive flowers for Camille, and she increased her stock of hens and rabbits, even offering a rabbit that was about to have a litter to Madame Zola, who had a garden and a rabbit

hutch on rue Saint Georges in Paris. There were always children around, which contributed a degree of inventiveness to the running of the household. Neither Camille nor Julie cared about usual conventions, and they laughed at Cézanne's eccentricities that were so frowned on by his old friend Zola.

One evening some collectors came for dinner with Pissarro, who was hoping to sell them some paintings. They had only just started eating when Cézanne appeared wearing his usual tattered clothes. Naturally, he was invited to join them for dinner. Madame Pissarro worked hard at behaving as the perfect mistress of the house, which piqued Cézanne's mischievous sense of humor. He started scratching furiously, saying "It's just a flea," as if to reassure his hostess. She didn't hold it against him. Even the local police weren't spared by this southerner, as Lucien reports:

He had great big dark brown eyes that rolled [at the least excitement]. He usually walked about armed with his pike as a walking stick, which rather frightened the peasants....In Pontoise, on market day, conscripts came through town singing—Cézanne was over in a corner leaning on his pike, blinking at the strange effect produced by this mixture of peasants and city folk—he must have looked very odd because a police officer broke away from a group of local dignitaries and came over to ask him for his papers, hence this little dialogue:

POLICEMAN: Do you have your papers?
CÉZANNE: No.
POLICEMAN: Where do you live?

CÉZANNE: In Auvers.

POLICEMAN: But I don't know you.

CÉZANNE: To my *e-nor-mous* regret.

And, not knowing what to do, the police officer re-turned sheepishly to his group.[12]

Cézanne liked joking around with Lucien and felt so at home in his friend's house that he sometimes invited himself to the Pissarros on the spur of the moment, as this letter shows:

> Monsieur Pissarro, I am using Lucien's quill at a time when the train should have been taking me safely back to my lares and penates. Which is to say in a roundabout way that I have missed the train.—No need to add that until tomorrow Wednesday [Thursday, in fact] I shall be your guest. —
>
> So then, madame Pissarro invites you to bring some Nestlé powder home from Paris for little Georges.—And Lucien's shirts from his aunt Félicie. I wish you good evening.
>
> Paul Cézanne

Lucien added a palpably urgent message: "My dear papa, Mamman wants me to tell you that the door is brokun you must come quickly because robber coud get in."[13]

As soon as he was settled in Auvers, Cézanne took to com-ing to work with Pissarro, and whenever the weather was

fine the two artists set out to paint in the countryside, with their portable easels and tubes of paint stowed in their backpacks. Pissarro woke very early and observed a disciplined work schedule that impressed Cézanne. Young Lucien often came with them. It is thanks to one of his letters that we have a description of the two painters and their subjects. Cézanne would sometimes sit on the grass waiting for the light to be right and watching Pissarro. "A passing peasant came up to papa and said 'not takin' the strain, then, yer laborer.' Cézanne lived in Auvers at the time and he walked the three kilometers every day to come and work with papa—there was endless theorizing—I remember one day they'd had special palette knives sent from Paris to do some studies using them—there are several works by both painters from that time the subjects and the execution being inevitably similar because they were trying to achieve the same things with the same tools and the same subjects." A good many works do indeed reveal a rather curious method: they were juggling with two different overlaying techniques—the brush and the knife. This can be seen by studying the surface of the canvas, for example in Pissarro's *La Bonne à Pontoise*, where brushstrokes and the firmer marks left by the edge of a knife can be seen. Neither of the artists continued with this method for long.[14] Lucien also mentions, in this connection, the question of influence: "It's impossible to say which of them influenced the other—All I can say is that Cézanne borrowed a painting of papa's in 1870 to copy it, probably to get to grips with certain theories—Cézanne's copy still exists I think it's in Doct. Gachet's collection—it's worth saying this, because

some day someone will come up with the idea that it was papa who copied Cézanne."[15]

In an 1895 letter to his son Lucien, Pissarro talked at length about the reciprocal influence that he and Cézanne had on each other's work:

> Cézanne has been shaped by outside influences as we
> all have and...all in all that detracts nothing from
> his qualities; [the critics] don't know that before
> anything else Cézanne was subjected to Courbet and
> even to Legros, like all of us; he was influenced by me
> in Pontoise, and I was by him. You'll remember Zola's
> and Béliard's comments about this; they thought
> that artists invented painting from scratch and were
> original if they weren't like anyone else. The strange
> thing is that in this exhibition of Cézanne's at Vollard's
> gallery you can see the family likeness between
> some of the Auvers, Pontoise landscapes and my
> own. We were together the whole time for goodness'
> sake, but one thing is certain, we each kept the only
> thing that matters, "our feeling." It would be easy to
> demonstrate.[16]

This certainly can be seen by looking at Pissarro's *Louveciennes* and the copy that Cézanne made of it. The two works—a woman and child walking along a road beside a wood overlooking a village—were hung side by side in the 2005 *Cézanne and Pissarro* exhibition at New York's Museum of Modern Art.[17] They are strikingly similar and also different. Cézanne's work has more light and brings out

more depth. It "seems denser and tighter: the contrasts between tones are more pronounced...the colors more intense," Joachim Pissarro points out. He goes on to say: "The way the paint is applied is different: where Pissarro used three or four brushstrokes, Cézanne uses just one, and it is longer, wider, and bolder," there is essentially a complementarity in their vision.[18] One other detail: the tender gesture in Pissarro's version, with the child holding the woman's hand, has disappeared in the Cézanne.

Lastly, along with Cézanne and Guillaumin, Pissarro made the most of an invitation from Dr. Gachet, who had just bought a printing press, to come and work in his etching studio. The doctor's house was in keeping with his unusual character: he lived in a former boardinghouse next to a disaffected cemetery where bones sometimes reappeared on the small property. "Your victims having their revenge!" one of his regulars teased.[19] Gachet shared his home with his two children (he had lost his wife early), a horde of cats, a goat that had lost all its fur, and a featherless old peahen. When he wasn't busy with his numerous patients (he treated all the destitute in Auvers for free), he took refuge in the studio that he had set up in the attic, accessed by going up a long ladder and through a trapdoor.[20] Pissarro shared Gachet's passion for engraving and, together with Guillaumin and Cézanne, constantly pushed the boundaries of new techniques. A drawing by Cézanne shows him at work, watched by an attentive Dr. Gachet with his pipe in his mouth.

Pissarro's portraits of Cézanne, one oil and one an engraving, date from this period. They are two very different

views of the same man. According to Lucien, the oil is a close likeness. The fact that Pissarro kept the painting until his death shows how much he valued their friendship even though they drifted apart over the years. Cézanne is shown in three-quarters profile, with a cap tugged down almost to his eyes, an unkempt black beard, and his hands cut off by the frame; he exudes an almost peasant-like sturdiness emphasized by a certain coarseness, and by the absence of any style in his clothes or charm in his expression. Without knowing the sitter's name, no one would guess he was a painter. He has none of an artist's elegance or attributes. However, those attributes, or rather clues to them, are there, pinned to the wall behind the subject. Here Pissarro used the method adopted by Manet in his portrait of Zola. In this instance, instead of reproductions of work by Manet, Velasquez, and Utagawa, Pissarro chose more political themes: an André Gill caricature of Thiers brandishing a baby in a wad of banknotes, symbolizing the liberation of the country and, its corollary, the birth of the Third Republic; and one of Courbet, smoking his pipe, with a glass of beer in his hand. The beer and the pipe symbolize the proletariat of the day and, therefore, evoke the progressive opinions that Cézanne shared with Pissarro.

Courbet lived in exile at the time (he had taken refuge in Switzerland after he was condemned for his role in toppling the column in the place Vendôme during the Commune) and had been rejected by the official art world. He sent two paintings to the 1872 Salon, but they were refused. Ernest Meissonier, the president of the jury and, according to Degas, "a giant among dwarfs," had declared:

"Gentlemen, there's no point in looking at that: questions of art have no place here, there is only the question of dignity. Courbet must be dead to us all."[21] In such a climate, any reference to Courbet was meaningful.

But Pissarro certainly didn't overlook painting itself, the strongest link between the two men: on the wall in the background, a fragment of one of his paintings is visible. It is *Route de Gisors, maison du Père Gallien*, which Cézanne must have particularly liked because he went on to pin it in the background of his *Nature morte à la soupière*. Pissarro's engraving of Cézanne, which is from the same year, shows a different man, he is more elegant and well-groomed, less peasant and more gentleman farmer—proof that Pissarro was well aware of the complexities of a man who hid his sensitivity and good upbringing beneath a gruff exterior.

That same year (1873) was when Pissarro painted his first self-portrait, the first of a series of four. He depicts himself as calm and self-assured, against a background of wallpaper that appears in other paintings and to which several landscapes have been glued. He is forty-three years old and looks older because of his large graying beard. He is in his prime and needs all his strength, first of all to work but also to sell, seeking out and gaining the support of *amateurs* (the term Pissarro used to refer to his private buyers). Durand-Ruel's support meant that his day-to-day needs were met, but like all his comrades Pissarro was always looking for new outlets. With this end in mind, he had taken a pied-à-terre on rue Berthe in the Montmartre neighborhood of Paris. Here he hoped to show his work

to a variety of possible buyers, who were brought to him by two brothers, friends of Manet and Degas, the Belgian bankers Albert and Henri Hecht, whose taste in art was very assured. He also sold through his framer Pierre Cluzel, through Julien-François Tanguy, and Père Martin, the old dealer from his early days.

Old Tanguy is another of those improbable characters who gravitated around the Impressionists. Originally a plasterer, he married a pork butcher from Saint-Brieuc and started working with her. They saved enough money to move to Paris in 1855. He then changed professions, working first for the Chemins de Fer de l'Ouest and then as a grinder of pigments. From there he started selling paints and opened a small store on rue Clauzel, where Pissarro became a regular customer very early on. Tanguy expanded his business by becoming an itinerant salesman. As he worked his way around Argenteuil and Barbizon, he developed friendships with his customers, the future Impressionists. In 1870 he started storing their paintings for them, whereupon the political storm ruined him. As a member of the Commune, he was arrested at the time of the repression. He was tried and deported to Brest, where he spent two years in the horrors of floating prisons on pontoon boats. Once back in Paris, he resumed his trade in an unprepossessing shop. He spent his days there in a blue apron, a knitted vest and, whatever the weather, heavy clogs, "while old mother Tanguy silently shook her incredulous head with its thinning hair, thinking bitterly that they had no food to put on the table and they owed three rent payments, apparently looking down on all these

'featherbrained smooth-talkers' from the full height of her own pragmatic philosophy."[22]

Moved by the misfortunes of his supplier who was struggling to find customers for his tubes of paint, Pissarro brought paintings to Tanguy for him to sell. More significantly, he also introduced him to Cézanne, who had been turned down by Durand-Ruel when he returned from London in 1871, and therefore did not have a dealer at the time. Tanguy's customers rarely paid, but Pissarro was patient.

Were it not for his concerns about his daughter's health, Pissarro could now have enjoyed a productive period with nothing preying on his mind. But his work was frequently interrupted: "For four or five days we've been worried to death. Cézanne must have told you. Jeanne is sick."[23] Dr. Gachet received these calls for help every few days. Pissarro steadied himself by asking the child to pose for him. He had always liked painting her, and of all his children, she is the one featured in the most portraits. When she was very little, she already appeared alongside Julie in the large canvas *L'Hermitage à Pontoise*. She is two years old and is clinging to her mother's apron. In 1870, in *The Conversation, Louveciennes*, she is the little girl looking straight ahead next to her mother, who has her back turned. There are five fine portraits of her from 1872. The first may be the most touching; it is small and was painted on her seventh birthday. She is looking directly at her father, her pretty face standing out clearly against bister-colored wallpaper dotted with posies of flowers. Another, larger portrait is of her in the garden, absorbed in studying

something, perhaps a doll, that she is holding. In the third she stands facing her father in the dining room of their home, but her gaze is more distant. She does not fill the frame, and this accentuates her small stature. A crystal decanter, a Chinese porcelain object, and a silver coffeepot stand on a table behind her, forming a still life and demonstrating that the Pissarros were relatively well-off at the time. Pissarro gave this portrait to the Piettes in recognition of their warmth and hospitality. When Minette died, Piette made the exquisitely sensitive gesture of returning the painting, quite understandably feeling that Pissarro would want this image of his child where he could see it. The fourth portrait concentrates on the little girl herself; she is very elegantly dressed and wears a flat-crowned hat decorated with blue ribbons, with her long blond hair tumbling from beneath it. The final portrait, painted the year she died, reflects the progress of her illness, a fatal respiratory infection. The child has had her hair cut and is drained of energy. She still looks at her father, but her eyes have lost their spark. The last sketch, which shows her lying in bed, is so poignant that some believe he drew her on her deathbed.

Despite this constant anxiety, Pissarro was making plans for the future with Monet. Durand-Ruel bought paintings from these young protégés but still had difficulty selling them, though he had managed to place one of Pissarro's canvasses with an amateur collector in Boston, Henry C. Angell, an ophthalmologist who painted in his free time.

To his credit, Pissarro was not discouraged—quite the op-
posite, in fact. However, he did notice that paintings that
had at first elicited an amused smile now provoked more
virulent reactions. The debate would intensify violently
when the artists resurrected their plans—which had
aborted in 1867 for lack of funds—to have a joint exhibi-
tion. They had more self-confidence now and had a little
more money.

The empire had collapsed, French society had been
rocked by the Commune and its repression, but the Salon
withstood all these upheavals, immutable and hostile to
any artistic innovation. Daubigny, who had been a member
of its jury and knew how it operated, admitted in conversa-
tion that the system was absurd. Pissarro and Monet then
took the initiative of freeing themselves from the yoke of
the Salon's jury and organizing the first Impressionist ex-
hibition. They wanted to reach the public directly. After
many discussions, misgivings, and obstacles, the two
partners succeeded in setting up the Société Anonyme
Coopérative des Artistes, Peintres, Sculpteurs, Graveurs
(the limited company cooperative of artists, painters,
sculptors and engravers). Each member had to commit to
contributing five francs a month for a year; they all had
equal rights and the company would receive 10 percent of
every sale. This charter drawn up by Pissarro was inspired
by the bakers' union in Pontoise. The always fraught ques-
tion of whose work would hang where was also settled by
Pissarro. Each artist's place in the exhibition space would
be determined by drawing lots. Thirty artists participated
in that first event, not all of them revolutionaries. Degas

had sensibly insisted on including artists who were more conventional than his Impressionist friends. He wanted this diversity to distinguish their enterprise from sad memories of the Salon des Refusés and felt that including engravers, watercolor painters, ceramicists, sculptors, and enamelers would make the exhibition more interesting. The blend of different genres would surely attract a greater number of visitors. Manet and Corot refused to take part—Manet because Cézanne was exhibiting, and Corot because this new school clashed with his own leanings. But Boudin joined in with the whole group: Pissarro, Degas, Renoir, Monet, Sisley, Morisot, and Guillaumin, among others. Thanks to Durand-Ruel's financial support, circumstances looked favorable, but then a banking crisis threatened Paris in 1873, and this somewhat undermined the participants' splendid self-confidence.

Proof came in the form of a letter from Duret to Pissarro pointing out that he was known and admired by a certain number of dealers and collectors, but to reach a wider public he needed either to offer his paintings for auction at the Hôtel Drouot or to exhibit at the Salon. Duret ended the letter by advising Pissarro to abandon his risky venture with the Impressionists and take the wiser option. Having the imprimatur of the Salon certainly reassured potential buyers. A medal awarded at the Salon acted as a sort of certificate of quality and facilitated sales, and this gave exhibitors a more assured and easier path. Pissarro realized that Manet had chosen this route by refusing to exhibit with them and continuing his rise thanks to the Salon, but Pissarro was unfailingly loyal to his comrades, and despite his

growing financial needs (a fourth child was on the way), he held out. He referred back to this difficult decision in a letter to his son Lucien in May 1883: "Duret, who is to be trusted, unlike some others, very cautiously telling me that I was treading the wrong path etc....I did well to keep going."[24] And so the first Impressionist exhibition was held, bringing together thirty artists.

Nadar, the famous photographer, had offered his exhibition space at 35 boulevard des Capucines for the event. Its walls were hung with a red-brown fabric. The exhibition was open from ten in the morning till six in the evening and then (and this was an interesting innovation) from eight until ten at night. It opened on April 15, 1874. Pissarro attended despite his grief—little Jeanne had died on April 6—and faced the critics. In the end he exhibited five recent paintings, the most experimental of which, *Gelée blanche à Ennery*, with its blurry colors, tangled furrows, and shadows cast by hidden trees, gives a winter morning an icebound sense of unreality and shows the intensity of his research into the effects of light.

Predictably, opinions were mixed. Philippe Burty, an influential critic and editor of Delacroix's correspondence, compared Pissarro's landscapes to Millet's best and admired *Gelée blanche*, as did his opposite number on *Le Gaulois*, who deemed it "excellent," but others proved sarcastic. Louis Leroy writing in *Charivari* launched a sneering attack:

Very gently and feigning complete innocence, I took Joseph Vincent [a landscape artist] to look at Mr. Pissarro's

Gelée blanche. Confronted with the formidable land-
scape, the dear fellow thought the lenses of his specta-
cles were fogged. He wiped them carefully and put them
back on his nose. "By Jove!" he cried, "What on earth is
this?" "Look, you see...a white frost on deep furrows."
"Those are furrows? That's frost?...But it's just a palette
knife that's been scraped uniformly over a dirty canvas.
It has no rhyme or reason, no top or bottom, no front or
back." "Perhaps, but it does give the impression." "Well,
it's a peculiar impression, oh!"[25]

And Leroy didn't pull his punches on the subject of a
Monet either: "What's this painting of? *Impression, Sun-
rise*: impression, I might have guessed. I was also thinking:
since I am impressed there must be some sort of impres-
sion in all that."

His intentions were malicious, but the name Impres-
sionists stuck and matched the aims of this new school of
landscape artists who specifically did not want to portray
their subjects in realist terms. (The title of Monet's paint-
ing had in fact been suggested by Edmond Renoir, Auguste's
youngest brother, and gave rise to the term Impressionism.)
Exploring a subject for the different tones and not the sub-
ject itself was what they hoped to translate onto canvas.
They weren't interested in representing objective reality.
Only the feeling, and therefore the tone, mattered. Never-
theless, Degas still rejected the name *Impressionist*, and Zola
continued to prefer the term *Naturalist*.

This snide banter was not general, however, and
the public was showing an interest in the artists' bold

undertaking. The exhibition was seen by thirty-five hundred visitors, each of whom paid one franc for entry and a further fifty centimes if they wanted a catalogue. The results, while not remarkable, were certainly not humiliating. There were some ten paintings sold. Sisley achieved the highest price with 1,000 francs, Monet and Renoir sold paintings for 200 francs each, and Pissarro for 130.

But the venture lost money, and they had to liquidate the company that had fostered so many hopes. This was done on December 14, 1874: each exhibitor had to pay 184.50 francs to clear the company's debts. Pissarro took comfort in the fact that one of his landscapes had been auctioned for 580 francs at Hôtel Drouot on April 20, 1875, and he withdrew philosophically to the country. In a letter to Duret he said: "The critics are ruining us and they accuse us of not studying, I am returning to my studies, it is more productive than reading [them], one learns nothing from them."[26]

However, the hardest blow came from Durand-Ruel, who had to suspend his payments precisely when Pissarro's third son, Félix, known as Titi, was born in July 1874 when Julie was still grieving her second daughter. Durand-Ruel explained that the vicious press campaign against Monet, Sisley, Pissarro, Renoir, and Degas, whom he showed in his gallery, was so relentless that it was denting the confidence of his best customers. He was finding it impossible to sell works by even the most popular artists of the previous generation because his support for the new school had unnerved his clientele.

Duret tried to raise Camille's spirits, but his encouragements were almost ironic, given Pissarro's desperate

circumstances: "Business isn't good at all at the moment. Perhaps it will pick up again after January.... Come to see me when you return...and we'll talk. As for the general public and the tide of supporters, dilettantes, and critics, they always love the same mediocre, everyday things, the showy trash. You have to come to terms with human stupidity and make do with approval and sales from a limited small clan and their purchases. I know how difficult that is when it comes to balancing the books, but I can't think of a solution."[27] Once again, Piette came to the rescue and invited the whole Pissarro family to Monfoucault for a few months, which meant they would have enough to eat. But it was unthinkable for Pissarro to stay away from Paris and possible buyers for such a long time. They had to return to Pontoise. Overwhelmed by how hard the times were, Pissarro confessed his despair to a friend, Eugène Murer: "And besides, why does anyone need art, can you eat it? No. Oh well!"[28]

8

Upheavals, Poverty, and Unexpected Changes

Losing Durand-Ruel's financial support was tough for the painters, though the dealer's recognition of their talent afforded them a degree of confidence, which had been justified by a few sales to serious *amateurs*, particularly Ernest Hoschédé, a textiles merchant who owned a department store and was sufficiently open-minded and independent to support the new school. And when, in January 1874, he came to sell a small portion of his contemporary art collection, the results had been encouraging for the artists. The fact that their paintings were part of a renowned collection and were offered for sale alongside known, respected names such as Courbet, Corot, and Diaz worked in their favor. Buyers felt sufficiently reassured to take a bet on something new, and dealers were tempted by potential profits. And so it was that a dealer, Hagerman, bought five of the six Pissarros being offered. "The effects of Drouot's sale can be felt as far away as Pontoise," Pissarro wrote to Duret. "There's considerable surprise that a

painting of mine could command as much as 950 francs. We've even been told it was an astonishing price for a pure landscape."[1] Duret congratulated him by return of post: "The Hoschédé sale has made you advance more than any particular exhibition imaginable. It has brought you a new and diverse public."[2]

But success was short-lived. When Renoir, Monet, Sisley, and Morisot set up an auction a year later (Pissarro did not participate in this venture), they were confronted with surprisingly violent animosity. Was it because the four artists were presenting their work without the protective cover of respected predecessors? In any event, the sale had to be suspended at one point because of the appalling uproar. Renoir remembers: "two camps formed and came to blows. Police officers were called in. People ran in off the street. The Hôtel Drouot was invaded. It was a brawl. The drubbing started then. The doors had to be closed until calm was restored."[3] This incident had one great advantage: from this point on, the Impressionists had defenders, and many of them were vehement, such as Victor Chocquet, a lowly civil servant in the government customs department, whose support would become invaluable. This was not enough to make their prices rise, however. The results of this sale were very disappointing for all except Morisot. One of her paintings, an *Intérieur*, fetched a respectable price, but the commentary in *La Chronique de l'Hôtel Drouot* clearly illustrates the reactionaries' views with its insultingly condescending tone: "This young woman has a supremely distinctive way with color; in this regard she is gifted. When one has such a gift, madam, one must

swiftly shrug off the company of those among whom you have strayed; be quick to learn everything that you lack; with your intelligence, this will be easier for you than for most and, we would venture, you must want this more ardently than anyone else. Let it be so then and, rather than allowing us to give you advice, we shall be weaving your laurel wreaths." After this, sales became increasingly difficult for all the Impressionists.

Berthe Morisot did not live from her art and could afford to wait, unlike Pissarro, Monet, and Renoir, who were in truly dire straits. They demonstrated admirable solidarity during this period. One of the few benefits of this fiasco was that Victor Choquet came into their lives. He had been struck by Renoir's paintings at the ill-fated sale. He contacted the artist and asked him to paint a portrait of his wife and then one of himself. Renoir was delighted to accept and introduced Choquet to Monet. He then took him to see Cézanne's paintings, which, thanks to Pissarro's intervention, were in storage with Tanguy. It was when Renoir took him to Tanguy's premises that Choquet saw Pissarro's and Cézanne's paintings and fell under the latter's spell.

Meanwhile, Pissarro spoke well of Monet to Duret, whose support was of great importance to them all because the critic was wealthy enough to build up his own collection. Troubled by Duret's lack of appetite for Monet, Pissarro set about making him change his mind: "Aren't you afraid that you're mistaken about Monet's talent, he is, in my view, very serious, very pure he is true to a different point of view than the feelings that motivate you; but

his is a very studied art, based on observation, and with a quite new feeling, it achieves poetry in the harmony of its true-to-life colors. Monet is someone who adores real nature."[4] He had no hesitation in admonishing Huysmans, who had sent him his book *Modern Art*: "How is it that you don't say one word about Cézanne, whom not one of us has failed to acknowledge as one of the most singular temperaments of our time, and one who has had a very great influence on modern art? I was extremely surprised by your articles on Monet. How can such astonishing vision, such phenomenal execution and such rare and extensive decorative feeling not have struck you back in 1870.... I saw [some paintings] again recently and stood there struck with admiration for such beautiful and thoroughly consistent work. It's a serious mistake."[5] Pissarro was often more vigorous in defending his friends than he was in defending his own work. There was a genuine mutual support network at play; it worked extremely well, and this facilitated the organization of a second Impressionist exhibition in the spring of 1876, in Durand-Ruel's premises, which he had put at their disposal.

The hard core of founding painters—Pissarro, Monet, Renoir, Degas, Sisley, and Morisot—were joined by an important newcomer, Gustave Caillebotte, sponsored by Monet. Luck played a part in their meeting. In 1874 Monet lived in Argenteuil on the banks of the Seine; drawn by the effects of light on the water, he wanted to have a boat as a floating studio. His neighbor, Gustave Caillebotte, had already built one and offered to help him. A friendship developed, reinforced by the fact that young Caillebotte—eight

years Monet's junior—had studied at the Ecole des Beaux-Arts and his paintings demonstrated real talent. Monet introduced him to his friends, and he fitted easily into the group. Caillebotte came from a family of cloth merchants. Unlike his new friends, he had a substantial fortune, much of it amassed by his father, who sold cloth to Napoleon III's armies. He inherited in 1874 when his father died, and was free—without a second thought—to indulge in his passions not only for painting but also for sailing and gardening. As a bachelor with no financial or family concerns, he helped Monet, Renoir, and Pissarro—as Bazille had done before him—by buying paintings from them at times of real distress.

In contrast to the first exhibition, paintings by the different artists were grouped together to give a better sense of their work as a whole. Duret, who came to the gallery before the opening, gave Pissarro this warning by letter: "Monet dominates the exhibition with the size and the number of his paintings, followed closely by Renoir, they take up entire walls with 18 and 15 canvases, respectively. Degas is represented by 24 paintings and Berthe Morisot by 17, when you're offering only six. That's too few. Have more brought over and don't hesitate to borrow mine if you need them."[6] Duret sent the letter to Pontoise, and Julie immediately forwarded it to Camille, scribbling on the back of the envelope: "He's right. No time to lose." Pissarro spurred himself into action and ended up hanging twelve paintings, two of which belonged to Durand-Ruel and one to Chocquet. Among Caillebotte's eight paintings on show were the two versions of *The Floor Scrapers*, two of the first representations of urban workers. The works had

no political message but showed rigorous realism. A vulgar subject, agreed the journalists who, once again, unleashed a barrage of criticism. The most venomous article was by Albert Wolff, the correspondent for *Le Figaro*:

> Rue Le Peletier has terrible luck. After the fire at the Opéra a new disaster has befallen the neighborhood. An exhibition claiming to be of paintings has just opened at Durand-Ruel's gallery. Lured by the flags decorating the façade, horrified eyes are subjected to a cruel spectacle. Five or six lunatics, including one woman, a group of hapless creatures bitten by the madness of ambition have come together here to exhibit their work. Some people laugh out loud at the sight of them, for my part, it left me heavy of heart.... A terrifying spectacle of human vanity straying into the realms of insanity. Someone please explain to Mr. Pissarro that trees are not purple, the sky is not the color of fresh butter, that the things he paints are not to be found in any country and no sound mind could adopt such delusion. You might as well waste your time telling one of Dr. Blanche's patients who believes he is the Pope that he lives in Batignolles, not the Vatican.... And this is an accumulation of shoddy offerings being shown to the public with no thought for the fatal consequences they may entail. Yesterday a young man was arrested on rue Le Peletier because, after seeing the exhibition, he took to biting passersby.[7]

Eugène Manet, Berthe Morisot's husband, had to be talked out of challenging Wolff to a duel. Other critics were more measured, and there were many visitors. But apart from

Monet, who sold his *Madame Monet wearing a kimono* for the prodigious sum of two thousand francs, there were not enough sales to cover expenses.

Pissarro now found himself with no financial resources at all. To bring in enough to pay the rent, he made and decorated ceramic tiles, using subjects familiar to him—apple harvests, cabbage picking, a few shepherds, and for variety, some rocky landscapes and a series of miniaturized views of Venice, which were probably copied from Corot because he had never been to Italy. Piette offered him a refuge once again, but Pissarro could not stray away from Paris, where he was chasing buyers. He couldn't even afford to rent a room to spend the night there. When he was in the city, he stayed with his mother on rue du Paradis-Poissonnière. The group's solidarity was still exemplary even though they were all soliciting the same five or six *amateurs*. The only buyers they could rely on—the ones they always hit up for sales, to use Renoir's expression—were Hoschédé, the illustrious baritone Faure, Chocquet, Dr. Gachet, and another physician, Georges de Bellio. The latter, the heir to a wealthy Romanian family, who had moved to Paris in his youth, was a great art lover and started collecting in 1876 with such enthusiasm that, according to one of Lucien's letters to Paul Gachet, de Bellio owned so many paintings that he had to rent a shop to store them.[8] Renoir told Ambroise Vollard that "whenever one of us desperately needed two hundred francs we would rush to the Café Riche at lunchtime; you could be sure to find M. de Bellio, who would buy the painting he was being offered without even looking at it. At that rate, his apartment was soon full. So much so

that he eventually hired some premises where he stacked his paintings."[9]

It was at this point that Pissarro met two people who would have very different effects on his life. One of them, Paul Gauguin, would lead him on a remarkable artistic adventure; the other, Eugène Murer, would leave less of a mark on history but would be no less important to Pissarro in the short term. It was his friend Guillaumin who introduced him to this unusual character. The son of a milliner who could not afford to raise him, Eugène Murer set off to try his luck in Paris after a brief stint at a high school in Moulins. He found working as an errand boy in an architects' office so unrewarding that he became an apprentice at a patisserie on the boulevard Poissonnière. His employer, Eugène Gru, taught him his trade but didn't stop there. Gru was an educated man who kept company with journalists and followed political and literary developments. He was delighted with how open-minded his young apprentice was and encouraged him to read and educate himself. With Gru's consent, Murer continued to put cakes in the oven while living a parallel life as a quasi student. He moved into a room on rue Souf-flot, in the heart of the Latin Quarter, and reestablished contact with Guillaumin, an old school friend. The two of them often roamed through the Louvre together, but Murer never neglected his work. In 1869 Murer married and set up as a pâtissier-restaurateur in his own right at 95 boulevard Voltaire in Paris, working with his half sister Marie, who was an excellent cook.

Murer was a very generous, enthusiastic character with an inquiring mind, and every Wednesday he held an open

house to which he invited the whole group of Guillaumin's friends, and this is how he met Pissarro, Cézanne, Renoir, Monet, and Sisley. Thanks to them, the room was soon embellished with decorations that would not have been out of place in a museum. Garlands of flowers painted by Renoir gave a cheerful note to the walls that Pissarro had covered with views of Pontoise. These gatherings were frequently attended by Dr. Gachet and a dentist called Georges Viau who would amass one of the great collections of Impressionist works—the sale of his paintings in 1907 would feature nineteen Pissarros as well as fifteen Renoirs and twelve Sisleys, among others. The Impressionists left their work at Murer's so that he could show them to his customers. Murer himself bought from all his friends, benefiting from the extremely low prices they were asking in those straitened times, and even then he was quick to haggle with them. Pissarro depicted him at work at his baking oven in a large pastel dated 1877, a year that was so bleak for Pissarro that Murer, who wanted to help him, came up with the idea of holding a raffle with one of his paintings as the prize. Murer calculated that if he could raise one hundred francs by selling a hundred tickets for one franc each, he would achieve a reasonable price for one of his friend's paintings. He had no trouble at all off-loading the tickets because all the little girls in the neighborhood wanted to try their luck, but when Murer presented the prize to the winner she admitted that she would have preferred a Saint-Honoré cake. Murer was happy to make the trade.

Over ten years he accumulated an astonishing collection: twenty-five Pissarros, ten Monets, sixteen Renoirs,

twenty-eight Sisleys, eight Cézannes, and twenty-two
Guillaumins. Renoir and Pissarro were the two painters
he was closest to. In 1877 Renoir made a fine portrait of
his son and one of his sister Marie, choosing a pretty oval
frame for the latter. The following year, Pissarro painted
a companion piece of Murer, but the sittings had to be in-
terrupted because the sitter had a health problem. He lost
so much weight that Pissarro asked him to grow a little
beard to mask how much thinner his face was. "It will add
extra charm, because I can see an opportunity to add rich
colors."[10] There was a small skirmish over the price: Renoir
had asked for only 100 francs, while Pissarro wanted 150,
despite the client's objections. "I would like to point out
that, before giving you a price, I consulted our friend
Renoir and we both settled on this price, which strikes me
as very fair, I know full well that, as an eminent portrait-
ist, Renoir could ask more than I can, but less [than this]
seemed impossible."[11] (By way of comparison, Renoir was
paid 300 francs the following year by Madame Charpen-
tier for a large painting of herself with her daughters. The
Metropolitan Museum of Art in New York bought it from
Durand-Ruel in 1907 for 84,000 francs.)[12]

In a later letter, Pissarro refused to get embroiled in an
argument that would entangle Renoir. "Renoir has no part
in this, this is quite aside from any artistic issue, this has
to do with a starving stomach, an empty purse, and a poor
wretch."[13] The candor with which he describes his situa-
tion clearly shows the terrible difficulties he confronted.
It is worth pointing out that Murer often lent money to
Pissarro at the time, while still being very acerbic when it

came to agreeing on a price. Pissarro did not let his indebt-
edness shackle him: although he had every reason not to
upset Murer he unhesitatingly intervened in a family dis-
agreement. It was about Murer's son, whom Pissarro felt
had been treated too harshly by his father for abandoning
an apprenticeship with a wood sculptor, when the young
man felt he was learning nothing. He was used only to run
errands:

> I beg you to forgive my intrusion into such a sensitive
> business, I'm merely following my conscience: do as
> you must, whatever the consequences!
>
> It relates to your son!... I know he's in a ghastly
> position, in such misery! I'm taking the liberty of
> intervening in his favor and would beg you to do
> everything for him that a loving father can for his
> child.
>
> Whatever his faults, it's time to stop the damage,
> he's so young: in any event, you can stop him falling
> any lower. What will become of the boy, with no *family*,
> *no dream*, with routine work his only distraction,
> nothing good, believe me. Consider this, Murer, you'll
> see that your son can be forgiven, he is a pawn of
> inevitable circumstances.
>
> You won't hold this against me! Will you?[14]

This letter highlights the sense of responsibility that Pis-
sarro deemed indispensable to any parent, as well as his
generosity toward children and teenagers. Pissarro's con-
victions were so strongly held that they went beyond his

own family circle. In the next chapter we shall see the freedom he granted his children—freedom that was not at odds with his insistence on hard work.

In the early 1880s, however, most of his attention was focused on the need to earn a living. His letters give us a gauge of the effort that could go into securing a deal. In those lean years, selling a painting meant writing to Duret or Murer and asking to be introduced to some possible buyer, then organizing a visit and traveling from Pontoise to Paris, often for nothing, with all the anxiety of leaving his wife alone in the country with young children to care for and, moreover, in the summer of 1878, in the late stage of pregnancy. He briefly pinned his hopes on a Mr. Leroux, who was recommended to him by Murer, but he was "so difficult to budge" that Pissarro dared not believe in him, despite having written, "if I could make a sale to him, it would be a great relief because difficulties, or rather destitution have hit my household and threatens the family at every moment."[15] And he made it clear that, should Murer think it necessary, he would go to Paris immediately. He raised the subject again a few days later. If only Leroux would make up his mind, he could "give the butcher two hundred francs, and the rest or part of it to the baker."[16]

He admitted he had made a disappointing sale to a young American woman. This was probably Louisine Elder, who—along with her sugar magnate husband, Henry Havemeyer—amassed one of the most beautiful American collections. Louisine Elder was brought to Pissarro by Mary Cassatt and bought "only a little painting for fifty francs which was swallowed up in the abyss like a drop of

water in a house fire."[17] The item was probably a fan that the collector bequeathed to the Metropolitan Museum of Art. During these difficult years, Monet and Degas also created small works in the shape of fans that were easier to sell but earned them little. Degas asked two hundred francs for them but commented bitterly that Edouard Detaille, a fashionable painter for whom he had little respect, had secured five thousand francs for a similar item in a public sale.

Another tough blow was Ernest Hoschédé's forced sale after his bankruptcy in 1878. The balance sheet was disastrous for all the Impressionists, particularly Pissarro. Of nine paintings, some were sold off for seven or ten francs, and only one reached one hundred francs, and even then its price was justified by the frame—Durand-Ruel commented that at this critical time the frames were often worth more than the paintings.[18] These results frightened off one buyer whom Pissarro had identified. "The Hoschédé sale has killed me," he concluded.[19] In a rare moment of despair, he admitted that he thought of giving up painting: "I keep making studies but with no end in sight, no enjoyment, no drive, because of this idea that I must abandon art and try to do something else, if it's possible for me to learn something new! Sad!"[20]

Pissarro was driven to despair by the public that rejected his art as it did Monet's, Sisley's, Renoir's, and Cézanne's, "this gloomy art, this stupid, demanding painting that requires attentiveness and reflection—it's all too serious. With new advancements, it should take no effort to see and feel, and most of all one should have fun."[21] He

could see no way out of his situation, and his courageous Julie couldn't take it anymore. He felt all the more guilty about her because he realized that she was in very real terms carrying the heaviest load, giving birth to a fourth son in November. Unexpected help then came from Caillebotte, who bought three paintings from him, which allowed him to pay his rent and the most vociferous of his creditors. Far from foundering, he then pulled himself together and justified his decisions. "What I've had to suffer is inconceivable, of course, but I have lived and...even though I am convinced that I have no future...I think that, if I had to start all over again, I wouldn't hesitate to tread the same path."[22] The passivity he had noticed in himself vanished and was replaced by fighting spirit.

It may have been because he was acutely aware of his responsibilities or because he was passionate about his art, but in any event, Pissarro did not surrender to depression or the temptation to abandon the Impressionist exhibitions of 1879, 1880, and 1881. The only remedy for depression, he said repeatedly, was to work and not give up on exhibiting his paintings. This persistence was possible only for someone with his force of character and resilience. In contrast, Monet was so discouraged he couldn't imagine exhibiting in 1879. "I'm absolutely sickened and demoralized by this life I've been living for such a long time....Unfortunate we are and unfortunate we shall remain....And so I completely relinquish the fight and any hope of succeeding, and I no longer have the strength to work in such conditions. I hear that my friends are putting on another exhibition this year. I shall have to forego taking part,

having produced nothing worth exhibiting," he wrote to Dr. de Bellio.[23] Caillebotte tried to raise his spirits and offered to do whatever it would take to get Monet's paintings to the gallery.

Meanwhile Pissarro refused to be dragged down into defeatism and was supported by Degas, who was very much in favor of an exhibition: "I would really have liked to see Monet about this. I fear a total rout. . . . If the best are shying away, what will happen to our artistic group?"[24] In the end Monet capitulated, but "I allowed myself to be swayed only reluctantly and so as not to be seen as a deserter," he admitted to Murer in a letter.[25] Renoir, Cézanne, and Sisley stepped down and decided to try their luck at the Salon (participating in the Impressionist exhibitions was incompatible with exhibiting at the Salon). Renoir sent his portrait of Madame Charpentier, wife of the publisher Georges, depicted with her two daughters. She knew a member of the jury, who did the necessary to ensure that the painting hung in a favorable position. Renoir finally achieved great success. "I think he's now launched," Pissarro wrote to Murer, "and a good thing too, poverty is so hard!"[26] Neither Sisley's nor Cézanne's work was even accepted.

Pissarro and Degas could congratulate themselves for holding out and not giving in to pressure to exhibit at the Salon. The exhibition, which finally opened on April 10, 1879, on avenue de l'Opéra, was better received than its predecessors despite an innovation that might well have shocked the visiting public. The Impressionists attached supreme importance to the way in which their work was

presented. A bold decision consisted in forsaking "the pe-rennial gold frame with its florets and rosettes" and pre-senting their oils, pastels, and watercolors in white frames or frames painted in a color that complemented the domi-nant tones in the composition.[27]

At the end of the eighteenth century, frame making had been transformed by the invention of "economical pastes," which could be molded to imitate sculpted wood ornamentations.[28] This led to mechanized production of frames by the meter, which were easy to gild. Gallery owners and curators liked this traditional and luxurious-looking presentation, which, according to Monet, im-pressed the crowds. A richly decorated frame symbolized the market value of the painting. Needless to say, this tac-tic "reeked of bourgeois ideals" and exasperated Pissarro. Along with Degas, Morisot, and a number of other artists, he devised original designs for his works. As early as 1873, Whistler had started using colored frames, and he claimed to have fathered the idea: "I am the inventor of all this kind of decoration in colour in the frames [and will] not have a lot of clever little Frenchmen trespassing on my ground."[29]

Fortunately for the Impressionists, there was no pat-ent to stop them making whatever frames they pleased. Their first attempts steered them toward adopting colored frames with a flat profile. Flat frames had the advantage of not throwing any shadows on the canvas. White, usu-ally an off-white, was the most frequently used color, to the extent that white frames were seen by the public and critics alike as a manifesto of this new painting style. But

the Impressionists did not limit themselves to white. They also used frames of different colors.

According to Huysmans, Pissarro's series of frames was "surprising": "There's a bright spray of Veronese green and sea green, of maize and peach flesh, of amadou and lees red, and you have to see the delicacy with which the colorist has matched all these shades, the better to show off his skies and bring out his foregrounds. It is the keenest of refinements."[30] Pissarro continued in this vein, and in collusion with Degas, he even went so far as having the walls of the exhibition space repainted in colors that worked better with the paintings on display. For the following exhibition Degas chose yellow fabric for his room, and Pissarro asked for a lilac background for his with a canary yellow border. But he deeply regretted that he and his colleagues—the "poor little painters, rejected pariahs"—didn't have the funds to decorate the premises to match their dreams.[31] Sadly, these astounding frames have been lost, but the work of two newcomers who were invited to contribute to the exhibition would stand the test of time. The first, Mary Cassatt, was introduced by Degas and the second, Paul Gauguin, by Pissarro.

Adding new members to the group often posed problems. Even though the painters were united in the face of adversity, their judgments of one another's work could still cause genuine rifts between them. Unlike Gauguin, Mary Cassatt was readily accepted. She was American, born in Pennsylvania to a wealthy family. As a child, she had spent several years in France, where her parents had hoped to find a treatment for her brother who had

bone cancer. She not only learned French and German but also became familiar with museums and galleries in Paris at a very young age. Back in the United States she had lessons at the Pennsylvania Academy of the Fine Arts, and then at twenty-one she returned to Paris with a friend, Emily Sartain. The two young women studied with various painters, including Jean-Léon Gérôme; they were granted copyist cards for the Louvre and discovered Manet and Courbet. Three years after her arrival, one of Cassatt's paintings was accepted by the Salon. When war broke out in 1870, the two Americans headed back to the United States but returned to Europe as soon as peace was assured. They traveled to Italy, where they learned engraving in Parma with Carlo Raimondi, one of the masters of the art, and then to Spain and the Netherlands. Emily Sartain went back to the United Sates and became the director of the Philadelphia School of Design for Women, and Mary Cassatt settled in France, where her talent flourished. She exhibited at the Salon for three consecutive years, 1872, 1873, and 1874, but was infuriated by the jury's capriciousness. (In 1875 one of her paintings was refused and then accepted after she darkened the background.) Nevertheless, the great advantage of the Salon was that, despite the sheer number of exhibits, an astute eye could pick out new talents. Thus, Degas noticed her work and made her acquaintance thanks to a mutual friend, Jean-Gabriel Tourny, a painter who earned a living making copies of famous works for Adolphe Thiers, who had resigned as president of the Republic in 1873. Degas suggested that the young Cassatt

should give up on the Salon and exhibit with his friends, whom he referred to as the Independents rather than the Impressionists. She didn't hesitate: "I was delighted to accept, at last I could work completely independently, without worrying about a jury's verdict."[32]

It is worth noting, in this connection, the total absence of misogyny among the Impressionists in their professional relationships. Admittedly, Degas was not at ease with women, and Morisot found it amusing. "Mr. Degas came to sit beside me, purporting to be wooing me," she told her sister, "but this wooing was confined to a long commentary on the Solomon proverb Woman is the Desolation of the Righteous."[33] Perhaps he genuinely believed this because he was never known to have affairs, but where art was concerned he treated female colleagues as equals. He supported Suzanne Valadon, buying her paintings and endlessly singing her praises. He proclaimed the talents of the gifted painter, engraver, and ceramicist Marie Braquemond who was often eclipsed by her husband, the engraver Félix Braquemond. Morisot had been accepted by her colleagues as a matter of course, and they ensured that her work was well placed at exhibitions. Pissarro always called her "Our comrade Berthe Morisot." The same was true of Cassatt, but she was also extremely useful to her friends because she opened the American market to them. She adroitly led a double life, as an artist and as a society woman, careful to cultivate her contacts in American business circles. Thanks to her, transatlantic *amateurs* were quick to take the risk of buying from contemporary painters.

Paul Gauguin first came into the Impressionists' orbit not as a painter but as a businessman, and he provoked hostile reactions, particularly from Monet. He was born in Paris in 1848 and had not had a traditional youth. His father was a republican journalist and his mother the daughter of the militant Flora Tristan, whose grandparents were members of an extremely wealthy and influential Peruvian family. He spent his early years in a palace in Lima, where his mother had taken refuge after her husband, Gauguin's father, died. Gauguin returned to France to study but was clearly longing for adventure and was drawn to faraway places. He enlisted in the merchant marine, and his crossings took him not only to South America, Brazil, Chile, and Peru but also above the Arctic Circle via Scotland and Norway. Toward the east, he traveled as far as Constantinople and the Black Sea. He did his military service in the navy and participated in the capture of four German vessels during the 1870 Franco-Prussian War. In the meantime, his mother had died, and he came under the protection of a guardian, a banker and longtime family friend, Gustave Arosa. Nothing about Gauguin seemed to predispose him to a career in finance, but he was unpredictable and became a stockbroker. His passion for art was equally unpredictable.

His friendship with Gustave Arosa and Arosa's brother Achille introduced him to both the world of finance and the world of modern painting. Gustave Arosa's very remarkable collection comprised more than sixteen works by Delacroix, many Corots, Courbets, Boudins, and Jongkinds, and (more important for our purposes) at least four

Pissarros. The Arosas, who were originally from Spain, were Sephardic Jews, like Pissarro. They had commercial interests in Latin America—their fortune was built on trading in guano. They immediately struck up a friendship with Camille when they met him in 1872, and Gauguin first saw Pissarro's work at their house before he got to know him around 1874.

The two men became close, and Gauguin, who liked to draw, showed Pissarro his sketches. Pissarro, a teacher at heart, gave him some advice and encouragement, never thinking that Gauguin, a married man with a family, would give up his career as a stockbroker. In fact, Gauguin was already painting more seriously than he admitted to real professionals. He even had a painting accepted by the Salon in 1876. He not only worked for himself but also very quickly started accumulating a collection. Very shrewd and keenly aware of the value of a work of art, he hardly ever bought directly from artists: he turned to minor dealers and different intermediaries, always trying to secure the best price. He bought some Cézannes and Daumiers very early on. It is not always clear exactly when he bought many of the pieces, but he ended up owning Manets, Renoirs, a Degas pastel that he partially reproduced in a still life of his own, and some Pissarros.[34] He also started dealing with Durand-Ruel, selling paintings to him and buying others, particularly Manets. In the circles in which he moved, he was frequently asked for advice about buying paintings, so he often acted as a go-between for potential buyers and artists, and knew how to handle the sensitivities of the latter. For example, before sending

Pissarro a young buyer, he apologized to him for speci-
fying that it would be a good idea to offer the man two
"charming" pictures because, he explained, the bourgeoi-
sie are difficult to please. He added that the young man
didn't know a thing about art but at least he didn't claim
to know what he was talking about.

Whenever Pissarro spent an evening in Paris he would
see Gauguin, and he then invited him and his family—
Gauguin had three children with his Danish wife, Mette—
to spend the summer in Pontoise. There the two men could
paint *en plein air* side by side, which gave Gauguin the op-
portunity to study Pissarro's technique at close quarters.
Gauguin proved a good pupil. He drew a deeply sensitive
double portrait of himself and Pissarro. Later, during the
winter, he completed views of Pontoise in the snow seen
through a curtain of trees, works that have echoes of Pis-
sarro's canvases.

Degas, although very exacting, shared Pissarro's en-
thusiasm, and at the last minute (a week before the vernis-
sage), Gauguin was invited to contribute to the 1879
exhibition, not with a painting but with a marble bust of
his son, "a pleasing little sculpture, the only one there,"
commented the critic Edmond Duranty.[35] Thereafter he
would contribute to all of the group's events as an artist
and a collector. The first exhibition in which he partici-
pated was a success; journalists were gradually becoming
accustomed to this new way of seeing things. More than
ten thousand visitors came over the course of the month,
and for once the artists did not lose money. Quite the op-
posite, they each had a profit of 439 francs. Cassatt bought

herself a Degas and a Monet with this money. Pissarro paid off his grocer.

In 1881 Gauguin was once again invited to exhibit alongside the Impressionists, and he came back to spend the summer with Pissarro in Pontoise, where he met Guillaumin and Cézanne. A sketch made by Pissarro's son Georges of a picnic in the summer of 1881 gives some idea of the high spirits of this group of friends. Guillaumin and Pissarro are sitting on rocks, devouring slices of bread. Gauguin is walking toward them with his hands in his pockets, and Cézanne is at his easel, painting. The other artists' easels are dotted about, and Madame Cézanne is frying eggs in a large pan over a brazier kept going by young Georges, who is blowing on the flames. The young artist—he was only ten years old—wrote the names of the subjects along the bottom of the sheet of paper, but this was an unnecessary precaution: all the characters are recognizable—Pissarro, of course, because of his bushy white beard, but all of the others, who are seen in profile, are astonishing likenesses in this sketch that borders on caricature. Pissarro must surely have taken great pleasure in seeing how sharp an eye his child had.

What the sketch does not show is the tension between Gauguin and Cézanne. Cézanne, with his permanently raw sensitivity, hidden beneath an often aggressive exterior, chafed at Gauguin's more unctuous and easygoing manner. They were in fact both going through personal crises. Cézanne would not return to Pontoise after 1882, and having moved back to the south of France, he grew increasingly reclusive; his contacts with Pissarro became

less and less frequent, although their mutual admiration never wavered. At the same time, Gauguin was struggling to reconcile his family life with his vocation as a painter. In 1884 he moved to Rouen before accepting that he and his wife and children should return to his wife's family in Copenhagen. He had been criticized for failing to support his family ever since he abandoned his position as a stockbroker, and he eventually left Denmark to paint full-time in Paris, before moving to Brittany, and a few years later, to Polynesia. His relationship with Pissarro changed and then soured. Pissarro was discomfited by Gauguin's obsession with selling his work. "Gauguin really does worry me," he wrote to Lucien, "he's a terrible dealer too, at least in how much it preoccupies him. I don't dare tell him how wrong this is and how it doesn't help him much, he has very great needs, his family is accustomed to luxury, true, but it will do him a great disservice; not that I think we shouldn't try to sell but I think it's a waste of time to think about that alone; you lose sight of your art, and exaggerate your own worth."[36]

The rift between the two men grew rather swiftly. Pissarro may have found Gauguin a little too crafty for his liking, but in a study of Pissarro's writing, Gauguin reveals unexpected reservations about the older man's character. He deemed him lazy, parsimonious, and sometimes selfish and unaffectionate as a father.[37] This last point is so strange and so unfounded that one might even wonder whether it reflects Gauguin's feelings about himself when he was contemplating abdicating his responsibilities as head of his family. Pissarro did not make a habit

of pronouncing judgments about his friends' private lives, but he must have been shocked by Gauguin's decision to flee rather than struggle to overcome his financial difficulties. Ultimately, however, their friendship would end over artistic differences.

Pissarro might have appreciated his former disciple's pottery, describing it as "so strange, exotic in flavor, barbaric, wild, and full of life," but he was incensed by his adherence to the Symbolist movement.[38] Unlike the Naturalists and Impressionists, who restricted themselves to what was there to see, the Symbolists would resort to spirituality, imagination, and dreams to give wider meaning to what they saw. The gentle Pissarro was suddenly in a rage: "Gauguin's no psychic, he's a wily devil who has caught wind of a retrograde turn by the bourgeoisie.... The symbolists are all doing it! So we must fight them like the plague."[39] This was because he could see that "the rumpus of religious symbolists, religious socialism, ideas-based art, occultism, and Buddhism" expressed a need to reintroduce the masses to superstitious beliefs.[40] Gauguin's Martinique phase did nothing to persuade him otherwise. In fact, it did the opposite. "I saw Gauguin, who theorized about art and assured me that the young would find salvation in this: immersing themselves in our wild and distant origins! I told him that this sort of art didn't belong to him, that he was a civilized man and as such he was duty-bound to show us harmonious things.... Gauguin certainly has no shortage of talent, but what a struggle he's having pulling himself together, he's always poaching on other people's territory, he's currently pillaging the

savages in Oceania."[41] The developments in Gauguin's career unsettled the Impressionist that Pissarro was. In his view, Impressionism was forever "sane art based on feelings, and it's honest."[42] It goes without saying that over the ensuing years they saw less and less of each other as indicated by a letter of Pissarro's to Mette Gauguin: "Gauguin has ended up in a different milieu and it's only through other people that I hear occasional news of him."[43]

But let's return to the 1880s, a time of camaraderie and agreement. The financial crisis finally blew over, Durand-Ruel started buying again, and Pissarro could view the future with optimism once more. In a letter to his niece Esther, he tells her that Durand-Ruel had offered to take everything he made: "That means peace of mind for a while and the ability to paint some large works."[44]

He set to work with renewed energy. The moment worries about money receded, his enthusiasm returned intact. For a long time he hadn't been able to paint human subjects for lack of models, except—occasionally—for his niece Nini. There were certainly no professional models in Pontoise, but by offering a few coins he managed to persuade various inhabitants to pose for him. For years now he had been frustrated that, for want of money, he hadn't been able to take Duret's advice and paint larger canvases featuring people. As soon as he had the freedom to do this, he completed a series picturing peasants either at work or at rest, a series that, as Huysmans pointed out, revealed a new facet of his talent. Pissarro was careful

not to impose tiring or artificial poses on his models, who were not used to staying motionless. These paintings exude an astonishing sense of harmony precisely because of the natural stances. The painting *La Cueillette des pommes* (apple picking) represents three young women: one is gathering the fruit that her friend is shaking from the tree, but the third isn't working. She is sitting down, biting into an apple. Huysman wrote about this series: "Pissarro has completely freed himself from memories of Millet; he paints his country folk simply, with no false grandeur, just as he sees them. His delicious girls in red stockings, his old peasant woman in a round bonnet, his shepherdesses and washerwomen, his peasant women breaking for lunch or collecting grass really are small masterpieces."[45] Apropos of this ensemble, the critics "threw Millet in his face," and Pissarro retorted that, for a Hebrew, he was less biblical than Millet.[46] It's true that his peasants don't stand quietly in prayer at the sound of the Angelus bells, and if they kneel it's to pull up weeds.

While exploring his new approach in more depth, he continued to collaborate with Degas and Cassatt on engravings. Along with Cézanne, he had already made use of Dr. Gachet's printing press. But now, urged on by Degas, he ventured into more ambitious experiments and proved, in Degas's words, "*ravishingly* enthusiastic."[47]

Degas was harboring plans for a monthly periodical, *Le Jour et la Nuit*, devoted to engraving. He confided this idea to Mary Cassatt, to the skilled etcher Félix Braquemond, and to Pissarro. They were quick to accept, and an intimate collaboration between Pissarro, Degas, and Cassatt

began to take shape. The latter was even-tempered, but it is difficult to say the same of the irascible Degas, whose habits and character were so different from Pissarro's. As a tender and kindly family man, and a conciliatory country dweller with liberal views, Pissarro led a life diametrically opposed to that of Degas, an arrogant Parisian and a loner who paradoxically dined out every evening.

There was never a warm friendship between the two men that could be compared to Pissarro's intimacy with Monet or Cézanne, but Degas was not looking for intimacy. On the contrary, he admitted: "I was or came across as hard with everyone, due to a sort of indoctrination with the brutality caused by my own doubts and ill humor."[48] But Pissarro was too astute not to gauge the complexity of the man whom he rated "the greatest artist of our time."[49] Although he admitted that Degas could be "terrible," he added in a letter to Octave Mirbeau: "He's frank and loyal, we've been good friends for years now."[50] He thought him "very kind and sensitive to other people's difficulties."[51]

Above all, they were bound by great loyalty to their principles. They were the only artists to participate in all eight Impressionist exhibitions, because they were the only two who did not succumb to the commercial temptation of the Salon. Neither of them was striving for popular success—Degas went so far as to tell Octave Mirbeau: "You work for two or three living friends, for other people you never knew or who are dead. Is it any journalist's business whether I make paintings or boots or carpet slippers? It's private."[52] Their research into engraving therefore did not steer them toward finding an outlet for their work or

simply exploring possibilities for illustrations. Rather, it was an opening for experimentation. To translate what Pissarro called engraved impressions, they dared everything, filling in backgrounds and adding color. Not caring for traditional techniques, they innovated, "cooking things up," like tinkerers endowed with genius, and exchanged what genuinely amounted to recipes. Degas explained to Pissarro:

> This is how. Take a very smooth plate (that's essential, you'll understand). Clean off absolutely all grease with Spanish white [chalk powder]. Before this you will have dissolved some resin in very concentrated alcohol. Pour this liquid over [the plate] as when photographers pour collodion over their glass plates (be careful, just as they are, to drain the plate well by tilting it), this liquid then evaporates and leaves the plate covered in a fairly thick layer of tiny granules of resin. When you wipe it, you'll have a darker or lighter line depending on whether you mopped more or less. You need to do this to get even colors; you can achieve a less regular effect with a blending stump or finger or any other pressure on the paper covering the soft varnish.[53]

Degas had his own printing press, as did Cassatt, and he invited Pissarro to use it whenever he was in Paris. Even when the three artists were not working side by side, they kept in close contact and shared the results of their trials. Degas would sometimes print Pissarro's engravings, and when he did, he would annotate them in pencil: "printed

by Degas/for Pissarro." Mostly, Pissarro printed his own work, often on strange pieces of used paper. The print runs didn't exceed twenty copies, often fewer.[54]

They didn't call on the services of a professional printer because their inking technique was so individual—they even sometimes superimposed layers—and it was crucial that they could correct something at the last minute with a dab of a cloth. One time when Degas was particularly pleased with the results that Pissarro had achieved, he wrote: "Congratulations on your ardor; I raced over to Mademoiselle Cassatt with your package. She sends the same compliments as I do." In the same letter he asks, "What did you blacken your varnish with to get that sooty shade in the last image? It's very pretty."[55]

In 1879 and 1880 Pissarro produced sixteen etchings and drypoint prints, which would be exhibited at the fifth Impressionist exhibition. He revisited subjects that were customary for him: peasants at work and at rest, haystacks by the light of the setting sun, bustling village markets, and landscapes. One of the most successful engravings, *Paysage sous bois, à l'Hermitage (Pontoise)*, is the mirror image of a painting by the same name. The painting shows houses in Pontoise nestled in the valley under a faraway sky. The foreground is filled with a curtain of trees with sinuous branches. In the bottom right-hand corner, a person is heading toward the woods.

Sadly, Degas's journal *Le Jour et la Nuit* never saw the light of day. Financial support that had been promised by Caillebotte and Ernest May, a banker friend of Degas's, proved insufficient. A disappointed Pissarro told Duret

that the venture came to an abrupt end and that they had neither the time nor the money to continue with their efforts, but the experience had opened up a new path for his talent, had given him the joy of working so closely with Degas, whom he wholeheartedly admired, and had consolidated his friendship with Cassatt, who consistently praised his work.[56] "Pissarro is such a good teacher that he could teach the stones to paint properly," she said in an interview.[57] Over the next decade, he would teach drawing not to stones but to his own children.

9

The Family Man

Exile, house moves, professional successes and disappointments, and constant financial worries had not slowed the expansion of the Pissarro family. After Georges was born just after they returned to France in 1871, Julie gave birth to Félix in 1874; and four years later to Ludovic-Rodolphe, named in memory of their friend Piette who died in 1878; then a girl, Jeanne, known as Cocotte; and the youngest, Paul-Emile, in 1884. There was a twenty-one-year gap between the eldest, Lucien, and the youngest. Camille and Julie therefore had to confront the problems posed by parenting a young man, a teenager, little children, and a baby all at the same time. This was a vast program that, far from discouraging Camille, galvanized him and made him concentrate on his children. In this sense he was very much the exception in the group. Renoir was keen to paint his sons, but the sittings often ended in tears. He had neither the time nor the patience, and perhaps no desire, to introduce them to painting. Monet had such a complicated family life that his only desire was a solitude propitious for work. Only Morisot had the same

passion and ambition for her child as Pissarro. She never tired of painting her little Julie and—when the child grew up—of taking her daughter to work alongside her in order to pass on her craft. But she had only one child and lived in comfortable circumstances instead of permanently worrying about tomorrow, so she was not concerned for her daughter Julie's future. Whereas Pissarro's life was dominated by poverty. And if the vise loosened occasionally after 1881, it wasn't until the 1890s that he had sufficient regular income to give him much-needed peace of mind.

One effect of the constant lack of money was to highlight the fundamental disagreement between Camille and Julie about their children's upbringing, a question brought to the fore by concerns for Lucien's future. Their eldest child was sixteen in 1879, at a time when the Pissarros were teetering on the brink of destitution. Julie—who had to leave school before she even learned to write properly and who had worked hard ever since the age of fifteen—felt that Lucien should find a job and help his parents. And so he took work with a wholesaling company in Sentier, the clothes manufacturing neighborhood, where his job was to make parcels for delivery. Three years later, he was employed by another business, where he appears to have been learning something about fabric. Convinced that this work would lead nowhere, his father then decided to send him to London to learn English. Julie couldn't envisage any other occupation than that of an employee whereas Camille, who had suffered crushing boredom during his time in his father's business, had much more far-reaching ideas and ambitions and wanted to offer his son the

possibility of a stimulating occupation. It was too early for him to think that Lucien could become an artist like himself, but there were other options. In particular, he knew that industrial art offered wide prospects. But this meant knowing how to draw.

Julie came close to believing that drawing amounted to "doing nothing," whereas Camille knew that, on the contrary, mastering that art required sustained effort. Lucien set off for London in 1883. He had no job or income and lived with his Isaacson cousins. His father, who sent him money regularly, didn't seem unduly troubled by this precarious situation and allocated to him the not inconsiderable sum of 150 francs a month. But he thought it vital that Lucien visit museums, educate himself, and learn English and drawing, and he gladly accepted the sacrifices justified by this aim. Distance didn't stop him keeping well informed about the young man's occupations. He was delighted that Esther Isaacson had taken him to the National Gallery, but irked because Lucien did not mention the Turners that he had taken him to see in 1870: "Did you see the Turners? You say nothing about them, did they make no impression, the famous *Rain, Steam and Speed*, and *Peace—Burial at Sea*...Have you lost your memory because you seem to remember nothing? For fear that you'll forget even more I'll send you some medicine very soon."[1] This reveals Pissarro's obsession with homeopathic medicine and the enthusiasm with which he tended to everyone close to him. Lucien's search for work made little progress. He eventually found a post with a musical publishing company, but it wasn't remunerated and,

worse than that, actually involved further expenditure: he had to pay for his transportation and his lunch. Camille and Julie agreed that if working entailed extra costs, he would do better to resign and concentrate on learning the language.

In the ensuing letters there is little talk of other jobs. It is clear that the young man was drawn to the arts but was easily discouraged. "It's so hard to remember pass-ersby, their movements and clothes, and to draw them from memory once back home," he wrote to Camille. English did not come easily to him, and he admitted pitifully: "I'm like Georges, I made 21 mistakes in my dictation."[2] He seemed to be drifting. This was hard for his father to accept, and Camille sent a succession of entreaties: "What I'd like is to see you settled on, firmly settled on whatever it might be. I'm not like your uncle saying: there's just this or just that, what I want is to see you with strong resolve that's entirely your own!"[3] The mention of Lucien's uncle—by which Camille meant his own brother, Alfred—refers to an offer of work that Alfred had made to his nephew but on condition that the young man commit to the post for three years, "with no secret plans to go back to [his] illustrating or painting."[4] Pissarro was somewhat reassured to hear that Lucien was buckling down and learning English but continued to nudge him toward drawing, even if only for his own pleasure. "If you could just convince yourself that it's the most intelligent and most agreeable occupation! ... If you could be passionate about that art, Sundays and holidays really would be days of happiness, eagerly awaited."[5] Pissarro

was clearly thinking of his years as an apprentice in Saint Thomas, when only the joys of drawing helped him cope with the ordeal of working for the family business. He alternated between goading and praising: "Gauguin came to spend last Sunday with us. . . . He couldn't have been more amazed by your still life, as well as the landscapes you'd started."[6] But he always came back to the need to work tenaciously, to rise early, and get to work quickly. The same admonishments return again and again like a leitmotif: "Till next time and, most important of all, get to work, with enthusiasm. You know that to succeed you must work hard, make the most of being free in London to think about nothing else, who knows how long it can last, lots of drawing, lots and lots."[7]

At the same time, Pissarro did not lose sight of the pragmatic aspect. He was no dreamer. He endlessly pointed out to Lucien the opportunities offered by drawing. It could lead to illustration, for example, or to the art of furniture design or ceramics. He reports that Gauguin was considering making some Impressionist tapestry designs and that he himself was trying his hand at this with the thought that it might one day benefit Lucien. "It's obviously a branch of industrial art that could easily be exploited, only you need to draw, to draw a lot."[8] Camille clearly never wearied of telling Lucien that he must think about earning a living. He told him about a letter he had received from Julie when he was away in Rouen, in which their difference of opinion was raised. "She tells me you've promised her that you're working hard, she doesn't really seem to believe that, she's asked me to advise you to stop

wasting your time. I'm not as skeptical as she is, I think you realize that you need to set yourself up for the future, and do it while you're free, and there isn't a minute to lose, later you'll be very glad to have accumulated a wealth of knowledge that you'll then be able to put to good use, in whatever branch of art or industry you choose."[9]

Julie was not so easily convinced and was irritated by Camille's confidence that drawing would lead to a trade with a future. In one of her rare letters to Lucien, she says, "you absolutely must earn a living, things are still very tight for us, business is going very badly. Whatever you do, don't play around making art, that's stupid, get into business and leave art to people who have bread on the table."[10] Ever conscious of the sacrifices that their poverty inflicted on Julie, Camille did not tackle her head-on but neither did he back down on the core principle and he never would. "Your mother is very worried about my letter, she says that I'm pushing you toward art rather than to think about earning a living; I don't know if I'm wrong, in any event...I was only recommending that you do a lot of drawing so that you will get to be very good...when you're good, you can do what you want. Perhaps that's a mistake."[11]

The disagreement between Lucien's parents would go on for years and would become more vehement when Julie realized that Camille was preparing to follow the same policy with the other children: "I am steadying myself against the storm and try not to be distraught. Your mother berates me with claims of selfishness, indifference and nonchalance. Inside, I make superhuman efforts to

stay calm, so that I don't lose the fruits of so much work and thought."[12] And he adds: "Your mother accuses me of raising you to do nothing. I let it blow over, as usual. Because ultimately, what sort of work can you make these boys do.... Put them into factories where they'll be exploited, where they'll learn nothing or learn badly. That's idiotic. But these misguided ideas are stopping me from getting them to work consistently."[13]

Nevertheless, Pissarro was adamant that Lucien show great respect for his mother, and he reprimanded him for not replying to her letters. "Always make it a rule to write to her in person, separately."[14] When Lucien wrote to his father in English, to be sure that his references to his brother would stay between the two of them, Camille advised against this: "Write openly if and when it is in Georges's best interests. Your mother won't have any grounds for comment but otherwise, she'll think we're conspiring, and we don't want that."[15] He was taking into account Julie's prickliness, well aware that her lack of schooling and her inability to express herself in measured terms made her prone to violent verbal outbursts. In a letter addressed to her, which is less ironic than it may seem, Pissarro appears to echo her own words, imagining her delight at being relieved of "this idiotic, stupid, indifferent creature who has absolutely no love for his wife whom he loathes or for his children whom he can't abide."[16] This is a gauge of the juggling act he had to perform to achieve his ends and the restraint he had to exercise to avoid crushing Julie. He even accepted her criticisms good-naturedly. "I'm doing a pastel portrait of your mother, apparently it doesn't look

like her, it's too old, too red, not refined enough, in short, it's not right."[17]

Their different views on their children's upbringing clearly affected the equanimity of their relationship. In a letter wishing her a happy New Year, he wrote: "I hope we will bicker less and that we will both understand that, at the end of the day, the best thing to do is to make concessions to each other, so we can live in peace: it's also in the children's interests."[18] By contrast, they were in perfect agreement on questions of morality and responsibility. Their third son, Félix, often had casual adventures and didn't seem to be overly troubled by the consequences. And then one young woman with whom he had had a brief fling wrote asking him for help with his child, and she attached a photograph of the child, who bore a striking resemblance to Félix. Julie informed Camille, and he immediately insisted that his son comply with the request: "When we make a big mistake, we must make amends as best we can. I think you should not abandon this child, it is absolutely necessary that you do something for her. I don't think there's any need to see the mother, especially when there's a chance that the relations were a passing fancy rather than based on affection, on both sides, but the child is blameless."[19] Julie, who must have witnessed plenty of similar dramas among acquaintances, wrote along the same lines in a clearer, more precise letter than Camille's, vividly demonstrating her honesty and sense of justice: "Think about what you did, don't be unkind. . . . Don't laugh about a poor girl who gave herself

to you.... How does anyone expect a girl who earns twenty sous a day to raise children? She'll be forced to prostitute herself, and you see that's terrible and the man who caused it deserves to be hanged."[20] In the same vein, she was admirably virulent in accusing Murer of mistreating a servant girl: "I don't understand how people like you and me and plenty of others who have been servants ourselves aren't more indulgent toward others."[21] Julie was not the sort to disown her roots.

Despite this common ground, the fundamental differences between Camille and Julie about their children's upbringing, along with the fact that it was impossible for Camille to involve her in his artistic endeavors, meant that Lucien soon became his father's preferred confidant. In fact, the young man often served as an intermediary between his parents, who genuinely seemed incapable of talking things over together. When Julie was exasperated by how calm Camille was, Lucien pointed out that it was strange to be irritated by his serenity. What would become of them all, he asked, if Camille allowed himself to give in to despair? He wouldn't be able to work. Peace of mind was indispensable to him.[22] But exchanges between the mother and son were few and far between whereas Camille wrote his son several times a week. And in this remarkably frank correspondence he disguised neither his professional difficulties nor the domestic ones derived from this disagreement with Julie and sometimes exacerbated by his younger sons' fecklessness.

It was only with Lucien that he discussed everything that mattered to him: art, literature, and politics. He sent

him Baudelaire's *Les Fleurs du mal* and a volume by Verlaine, adding this comment: "I don't think this book would be appreciated by someone who comes to it with traditional English preconceptions and certainly not bourgeois ones. It's not that I'm unequivocally defending the substance of these two books, any more than I would Zola's which I find a little too photographic, but I can see their superiority as works of art and from the point of view of certain modern ideas of criticisme [*sic*].... In my view, the most corrupt type of art is sentimental art, syrupy art that makes pallid women swoon."[23] He even confides in Lucien with his reservations about Gauguin, who seems exclusively preoccupied with the market value of his work. "It's better to sell things cheaply for a while, and besides it's easier if the material is good and original, and then make gradual progress as it happened to all of us."[24] This connection as equals would strengthen over the years, although the father never relinquished the freedom to criticize his son's work very firmly if the need arose. In 1884, the year that Lucien turned twenty-one, Pissarro was rattled by a more serious problem, the question of his eldest son's military service.

The antimilitarist in Camille wanted Lucien to avoid it, but not at any price. He knew all too well "that you mustn't get on the wrong side of the law, especially in France, where [Lucien] needs to live," so he urged him to make inquiries at the Danish consulate. What Lucien needed to find out, he reminded him, was "whether a Dane's son born in Paris is French or Danish and whether he can opt to be Danish."[25] He then drew Lucien's attention to the

advantages of this possible solution: "I think you would be glad to continue with your studies over those five years. What a waste of time and time that, when it comes to drawing, is so difficult to catch up."[26] But neither Lucien nor Pissarro's other children could opt to be Danish. Not only were they all born in France to a French mother but, as Pissarro's father was also French, Camille could very well be considered French himself. Even so, he always had his sons registered as Danish on their birth certificates and never gave up consulting lawyers on this issue. Lucien ended up settling in England, as his brothers Georges and Félix would do later, and he married an English woman; he would not be a naturalized British citizen until 1916, but he doesn't appear ever to have met with any trouble during his visits to France.

Paradoxically, the geographical distance seemed to reinforce this close bond between father and son. The Pissarros had a very good habit of keeping their letters, and the to-and-fro of correspondence between Camille and Lucien paints a vivid picture of family life. The major event of 1883–1884 was the Pissarros' move: after ten years in Pontoise, having searched in vain for an affordable house to rent, Pissarro resigned himself to leaving the town. Finding a new home was not just a question of price. He needed somewhere interesting with appealing landscapes and a degree of bustle. This all took a great deal of time. One disappointing visit made him waste a whole day in Meaux: the place was characterless. "The market is awful,

a vast modern hangar built like a railway station, less curious than the covered market in Paris."[27] He was wary of the faux capital of Versailles. Six months later he was still searching and still in vain. He went to see a house in L'Isle-Adam, a village some ten kilometers from Pontoise, but "thought the countryside awful, a huge plain with little hills in the distance, long long roads, sad sad walls, and stupid stupid bourgeois houses. How could a painter stay there? I would have to keep traveling the whole time."[28] Compiègne suited him no better. Eventually, he extended his target area. Seduced by the ancient city of Gisors in Normandy, he chose the small village of Eragny-sur-Epte three kilometers away. "The house is magnificent and not expensive, a thousand francs with garden and meadows," he wrote to Lucien. "It's two hours from Paris, I have found the countryside more beautiful than Compiègne...the pastureland is green, the silhouettes in the distance finely shaped. A barn will be the studio, the chicken coop will be useful, and a rabbit hutch will be built. At two hours away by train, Paris is a little far; but Monet in Giverny is very near."[29]

The family must have turned some heads in this tiny village of fewer than five hundred inhabitants: Pissarro with his long white beard setting up his easel in the middle of a field, sometimes unintentionally accompanied by Da, the family's Danish mastiff; and the children, who didn't mix much with the village children but often followed their father. Only Julie didn't seem out of place. She blended easily into her neighbors' lives, used the communal washhouse, and helped by working

in the fields at times when every spare pair of hands was appreciated.

Pissarro would have suffered from the isolation had he not regularly traveled to Paris to show his paintings to dealers and *amateurs*, to organize his exhibitions, meet his friends, and stay up-to-date. Once back at home, he didn't feel the need to venture far into the countryside, never tiring of painting the immediate surroundings of the house. He made some forty views of Bazincourt, the neighboring village. He was all the happier to stay at home because he had set up what amounted to a drawing school for his children.

They don't appear to have been intimidated by the Cézannes, Monets, Degas, Manets, Cassatts, Sisleys, and others that Pissarro had hung on the walls. As soon as he had a studio large enough to accommodate his artists-in-the-making, he encouraged them to draw, make caricatures, and illustrate their letters and stories. The whole family—except, of course, for Julie, who was always busy running the household—contributed to *Le Guignol*, an occasional periodical crammed with caricatures. Pissarro attached great importance to caricature, a mark of his admiration for Daumier (he owned some drawings by him and referred to them as "marvels") and his mistrust of anything prettified.[30] He sometimes suffered the consequences of this encouragement, such as when Georges made a drawing of him backing away from a furious Julie. Copies of *Le Guignol* were bound in satin by Georges, and some have survived. Pissarro liked decorating his house with his children's creations. Georges had a predilection

for farmyard animals and covered the walls of corridors with turkeys, roosters, and hens. A black-and-white rat guarded Félix's door.

This great pedagogue—Cézanne and Gauguin recognized how indebted they were to him—managed to steer his five sons toward the arts, but did he have any method other than giving his children the freedom to express themselves? Yes, and freedom did not mean sloppiness. Pissarro knew that precision does not kill the imagination but, conversely, stimulates it, and he was therefore keen for his young pupils to learn to look and to replicate. He took them all out for walks and identified plants and insects along the way. Back at the house, the elder children reproduced their finds and, if need be, transformed them, but their starting point was always extremely close observation. Thanks to his letters to Lucien, we can follow the progress of these budding artists. The cost of postage meant that the proud and happy father couldn't send the children's entire output to his eldest, but he described in detail "wonderful landscapes, fearsome horsemen, terrifying exterminations in which warriors fight on regardless, having lost their heads... it's a whole indescribable, Hoffmanesque world."[31]

It's never too soon to handle a pencil. In a letter sent in 1889, Pissarro comments on the abilities of his youngest, Paul, who at the age of four, "is starting to draw outlandish compositions; sometimes he spends whole days in the studio, singing, whistling, and painting extraordinarily bizarre things."[32] He's happy to talk at length about the scrawls that the child transformed into coaches, horses,

and coachmen.[33] But neither does he skimp on very precise advice about the use of color. He wrote to Georges in 1890:

> Dirty tones should be absolutely banished from our combinations; look at the Orientals, see how they separate the shades; I can understand that people like muted shades but on one condition and that's that the elements are not muddled up, you do know that!... In one way, some can like dazzling harmonies, it's a question of personal taste. It's absolutely untrue that orange on blue is garish, just say that it's dazzling, that's the spirit! It's like a blast of a trumpet in an orchestra, you might reply that that's only noise, ah! Good heavens, that's what they said about Wagner.[34]

It would however be inaccurate to see Pissarro simply as a father blinded by his children's obvious talents. He frequently bemoaned their laziness and their tendency to avoid any sustained work and to spend many an hour bicycling instead of drawing. Most of all, he complained about the constant noise around him. As soon as he could, he would escape for a few days to work in Rouen, on the advice of Monet, whose brother lived there.

Rouen, a city with a wealth of Gothic architecture and very picturesque riverbanks, had attracted a number of painters whom Pissarro admired. Turner and Corot had worked there back in the 1830s. Turner had included the cathedral's portal in his book of engravings of French rivers. Corot and, a few years later, Johan Barthold Jongkind

had concentrated on the docks and boats. When there, Pissarro painted either out of doors or from his "superb" room in a hotel that belonged to Murer. Meanwhile, his patience and hard work with his children were rewarded. Lucien started focusing seriously on engraving, and his work was accepted by *La Revue Illustrée*, one of the first illustrated periodicals. Presented bimonthly, it was meticulously printed on glossy paper with ornamented page design that heralded Art Nouveau.

At the same time, Lucien started taking an interest in the production of books as collectors' items, illustrated with his own woodcut engravings. Ever concerned with protecting his son, Pissarro told him to put some thought into his signature. The problem was twofold. On the one hand, Pissarro was afraid that his name could be "dangerous because of the disfavor I was in for so long," and on the other, he was afraid that his own fame might overshadow his sons.[35] He suggested that Lucien adopt his mother's name, Vellay.[36] Ultimately Lucien always signed using his family name and first name. In 1888 Camille recommended that he put a hyphen between the two, which would help people (journalists in particular) to avoid confusion between the father and son.[37] All his brothers adopted pseudonyms: Georges would be known as Manzana, Félix as Jean-Roch, Rodolphe as Ludovic-Rodo, and Paul as Paulémile. Years later, Lucien's daughter would choose to use just her first name, Orovida.

While the children were growing up, different family problems arose. Pissarro's elderly mother, who had become "cantakerous" just as she was regressing to a childlike

state, died at the age of ninety-four, and the subject of in-
heritance would poison his relationship with his brother
once and for all. A first mention of this appears in a letter
from Camille to his niece Esther as early as 1882. (Esther
was by then twenty-five and corresponded regularly with
her uncle.) "For ten years now my brother and the whole
family have treated us like strangers. Why?...Is it because
we're from a milieu that society condemns?"[38] Camille
and Alfred clearly lived in different worlds. Alfred was a
merchant, and his wife ran a children's clothing business.
When she took the step of criticizing the Pissarro boys'
interest in applied arts while pleading the case for com-
merce, Pissarro retorted: "Who knows what commerce will
be like in ten years' time. Do we know whether these fine
commercial gentlemen might not one day be very happy to
know how to hold a tool?"[39] They would fall out definitively
in 1887, and it appears that Camille was disadvantaged
when the estate was settled.[40] They were never reconciled,
and Camille heard of his brother's death from a printed
notice.[41]

In the meantime, the subject of his second son,
Georges, and his future came to the fore. Pissarro was
firmly against the French system of competitive exams,
"one of the great calamities of our time, especially with
respect to art," and he considered sending Georges to Lon-
don.[42] His niece Esther was happy to give him accommoda-
tion, and in June 1889, Georges enrolled at the Guild and
School of Handicraft founded the previous year (1888)
by two men: the architect Charles Robert Ashbee, a pupil
of the very influential critic John Ruskin, and William

Morris, the poet and architect who was famous for his designs for glass, fabric, wallpaper, enamel, and furniture. One of the school's fundamental rules was not to follow a master's teaching but to learn by trial and error. Georges adapted readily to this system:

> This school...is often the school we dreamed of, we're so free and people are so obliging that it's really very agreeable. On Sunday Mr. Holman Hunt [a founder of the Pre-Raphaelite movement started in 1848, which advocated limpid painting in the style of Italian masters from before Raphael's modern style] invited all of the school's students to go see the countryside and I was part of the group...and we visited this famous painter's studio....As you can see, we have every advantage at this school.[43]

He was housed, fed, and spoiled by his female cousins, and on top of this, his father sent him "a few sous" for his omnibus fares, his boots, and his boxes of paint. Georges was far more independent and determined than his older brother. According to a friend of Lucien's, he still proved shy with English young ladies, but otherwise was sure of himself and was not always even-tempered. Things needed to be pointed out to him a little at a time, his father wrote to Lucien: "We don't get anywhere with shouting and anger, as I often tell your mother...patience and determination, they're the great resource!"[44] As a result, Camille's letters to Georges very soon became more technical and professional than those to his eldest, who needed more

encouragement and emotional support. Georges experimented with different possibilities in industrial art, and Pissarro was so pleased with his results that he chose to use some copper frames Georges had made for his engravings that were to be exhibited at Durand-Ruel's gallery for the 1889 Painters and Engravers exhibition, to which Lucien also made contributions.

Despite constant worries due, as we shall see, to insufficient sales, Pissarro was uplifted by the thought that there might soon be an event with all his sons alongside him: "To achieve this result we need a certain number of items on different subjects and done in different ways, frames, wall-lights, candelabras, decorative firedogs, furniture etc...etc...We're dreaming of an exhibition in the near future in which we could bring together paintings, furniture, wall-lights, in the end all sorts of things, you need to start preparing now. It will be the Pissarro family exhibition."[45]

In 1890 the third son, Félix (known as Titi) turned sixteen. He had started an apprenticeship with a cabinetmaker in Gisors, but his father felt that he had learned nothing there, and he would have liked to find a position for him with the famous glassmaker Emile Gallé. However, he hesitated to send the boy off to Nancy and risk having him lose "the family's traditions." Pissarro wanted to keep the family's cohesion and wrote to Georges: "Lucien and I are looking into how we can make things together combining all our different aptitudes. Lucien, you, Titi, and Rodolphe will each have a part to play in this work. What would you say to a piece of furniture made by all of you

with painting by Lucien, sculpture by you, and whatever the others can do some day? That piece of furniture would be made by the Pissarro brothers...like the Le Nain brothers, who made such beautiful paintings in their time."[46]

This gives a measure of the father's optimism and pride as he rightfully reckoned that he was on the brink of winning the wager he had placed on his children's abilities. He not only chose to steer them toward art but also did it with so much tact and savoir faire that not one of his sons dug in his heels against paternal authority. But Julie still did not back down; when Georges returned to France, she forced Camille to find a position for him and for Félix in Paris. Exasperated by the fact that her sons were still dependent on their father, she wrote to him: "Try to get a job for Titi. Doesn't he have a fine future as a starving artist?"[47] In vain. The boys went back to London. But raising their brood was like driving a four-in-hand of unpredictable horses. In 1892 the romantic entanglements of the elder two would make a stir and push artistic concerns to the background.

Lucien had been in love with a young Englishwoman, Esther Bensusan, for two years. He was the least evasive of the four sons and had confided his feelings to his father. Miss Bensusan—the daughter of an Orthodox Jew of Spanish origin whose fortune depended on buying and selling ostrich feathers—was a long-standing friend of Esther Isaacson. The families saw a good deal of each other. Lucien had often seen Esther Bensusan and her parents at the Isaacsons' house and so, when the Bensusans decided to go to Paris for a vacation, it was only

natural that Lucien should offer to accompany them. A visit to Eragny was arranged, but Mrs. Bensusan excused herself from this trip, citing her nonexistent French, so Esther went to the Pissarros alone. She spent five days with them and the visit was a great success; Camille thought the young lady "very nice and likable" and gave her a sketch as a gift. Everything went so well that she was about to kiss Camille goodbye as she left but held back at the last minute![48]

From that moment on she became Esther 2 or Ster B to distinguish her from Esther Isaacson. In December of that year, Camille sent her a pen drawing. The young couple saw each other frequently in London, where Lucien taught drawing classes. Esther 2 wanted to enroll in the course, but when her father heard of this plan, he choked with indignation and forbade his daughter from seeing "people who have had no religious training and who boast of principles that would not be tolerated in any Jewish or Christian family."[49] Of course, the young pair continued to meet, sometimes at the British Museum and then in more discreet places. Esther's aunt, Orovida, was in the know about their idyll and encouraged it. She also secured some commissions for Lucien, particularly for decorating fans, and he started to make a name for himself. But Mr. Bensusan would not yield.

In the end, Camille took matters in hand and wrote to Lucien: "I know that you love Esther B.... All right! There's no other solution but to ask her father for her hand. I'm prepared to do what's needed to secure it.... Your mother fully accepts your decision, we like Esther B very much. My

word what more is needed? For my part, I'll do whatever I can to help you, I don't have much but you will try to do your own small part and it could work."[50] This stance was especially generous because the house that the Pissarros rented was now up for sale, and Julie—in Camille's absence and on her own—had made the most of the opportunity by asking Monet for a substantial loan to help them buy the house. Monet consented with great generosity, but because Camille simply couldn't oppose his wife on this, he found himself heavily in debt precisely when he was hoping to be somewhat relieved of his perennial financial problems. Incidentally, it is striking that, so long as the question of the children's artistic education was not at stake, Camille gave his wife ample freedom and was prepared to suffer the consequences. He did not hide his situation from Monet and wrote to him: "I confess that I had absolutely no idea that my wife intended to go to Giverny and I suppose she explained things to you; you know my circumstances: I'm only just starting out and I am not yet sure of my success; my wife is besotted with the house we live in and I dare not refuse her this satisfaction that she has certainly well deserved."[51] From London Camille did his best to handle the questions raised by the notary and came to an arrangement with Monet, but Julie had miscalculated and they were still lacking a substantial sum, which Pissarro reluctantly borrowed from Durand-Ruel.

Meanwhile, negotiation with Mr. Bensusan was making little headway. Camille had no illusions about their chances of winning him over. The Pissarros never denied their Jewish origins but were resolutely opposed to any

religion be it Jewish, Protestant, or Catholic. Lucien did not want to commit to raising his future children in accordance with Jewish customs and refused to be circumcised so that question remained unresolved. After seeing Mr. Bensusan, Camille wrote to Julie: "The father is more stubborn than ever, the daughter doesn't want to rush him because of her grandmother and the more concessions she makes, the fiercer her father becomes.... I would say we mustn't listen to the father, in six months' time we'll be no further along."[52]

A less grounded man would have been shaken by this multitude of problems assailing him simultaneously. With no obvious effort, Pissarro withstood all the pressure. He had dragged his friend Maximilien Luce along with him on this trip to London in the hope of consoling him after his wife's infidelity, and Luce was amazed by Pissarro's equanimity: "What a man and how wonderful it is to see such serenity and admirable calm, and what heart!"[53] One reason for Pissarro's calm was that he managed to work during his stay.

He settled in Kew, which was at the time a village in the southwestern outskirts of London, a place famous for its botanical gardens. Here, he told Mirbeau in a letter, he was "making the most of an exceptional summer, by throwing myself body and soul into my plein air studies, in these glorious gardens in Kew, oh! My dear friend, what trees! What lawns, what pretty, imperceptible undulations of the terrain! It's a dream."[54] He brought home eleven paintings from a five-week stay and would return to London for Lucien's wedding.

Refusing to be bullied by Mr. Bensusan's threat to dis-
inherit his daughter, the young couple were married in a
civil ceremony on August 10, 1892. The only witnesses
were Camille and two friends of Lucien's, the great collec-
tors and bibliophiles Charles Ricketts and Charles Shan-
non. The newlyweds set off for a honeymoon in France,
where they intended to live. But Lucien found it difficult
to secure work in Paris. He had more promising con-
tacts in London, and—to make matters worse—it very
quickly became clear that Julie did not get along with her
daughter-in-law, finding her too spoiled and extravagant
and incapable of running a household. The pinnacle of
her incompetence was that she didn't know how to darn
a dishcloth. Julie, who had suffered so terribly from her
own mother-in-law's animosity, replicated this pattern
with her characteristic energy.

After these tumultuous weeks, Camille was back "at
Eragny at last, delighted to find [himself] among the fam-
ily and surrounded by [his] work," but another upheaval
lay in store for him.[55] On December 20, a letter from his
niece Esther Isaacson informed him that she and Georges
had just married. He replied with his usual kindliness and
cordiality: "I have only one thing to say to you: be happy!"
but added cautiously: "I don't know what Julie will say."[56]
In fact, he was quite sure what Julie would say. She would
fly into a rage and would not want to hear the marriage
mentioned. It was a peculiar situation: The whole fam-
ily loved and valued Esther 1, particularly since she had
welcomed Lucien so generously when he first came to
London, and the fact that they were so closely related

was no shock to a Jewish family who were accustomed to such matches, but Julie could not bear the thought that Georges had married a woman fourteen years his senior. Besides, the whole family was wounded by the (admittedly understandable) secrecy with which the affair had been conducted. Even Esther's sister Alice had not been in the know. She was so hurt that she broke off all contact with the young couple.

Camille wrote to Lucien, who was also shocked by his brother's unexpected wedding, in the hope of avoiding a rift between the two young men. He explained that his own response was "more philosophical, bearing in mind that we can no more stop love's passions that we can the ocean or a torrent, the only remedy is to channel such forces rather than fight them, I let nature take its course, believing the harm is great enough evil without adding one that's greater still. Not that this prevents substantial concerns for the future."[57]

All these family disagreements would seem pointless nine months later: Esther 1 died in childbirth, leaving a son, Tommy. The whole family rallied around Georges. Camille sent Félix to London to support him, and Lucien, who was about to become a father himself, fretted about the best feeding bottles for the newborn baby and asked Camille for advice. He welcomed his brother into his own home, and the baby was cared for by his aunt, Alice Isaacson. As usual, though, money was tight, and Camille immediately asked how much he should send. He was also concerned for his other daughter-in-law, who was in the latter stages of pregnancy and was traumatized by the

unfortunate Esther 1's death. "Don't get yourself in a state in advance," he wrote to Lucien, "what happened to poor Esther was really exceptional. Take precautions, particularly make sure that after giving birth your wife is never alone for a moment. That's the dangerous time but your wife is in good health, and it would be unfortunate for such sad catastrophes to come one after another."[58]

A month later he was happy to hear that Orovida, his first granddaughter, had been born, but he could not travel. His eyes were causing him pain. Since 1887 he had suffered from an obstructed tear duct, which regularly caused abscesses and appalling inflammations. As usual, he wanted to treat the problem homeopathically and refused to be discouraged by the lack of results. In practical terms, he needed to avoid wind and dust—not easy for a landscape artist who braved the elements out of necessity. He had too much work to complete to be interrupted. He was also beginning to feel his age. Thus, when his third son announced that he wanted to be married, Camille reacted sharply: "Here's what I think: it would be madness for anyone to marry at twenty-one when they have nothing and are in no position to provide their family with bread.... You know full well how many responsibilities I have, and this would be an added expense that, despite my willingness, I would not be able to assume.... No, my dear Titi, believe me, wait until you have some funds before committing yourself."[59] Félix-Titi submitted.

In the meantime the Pissarro boys' circumstances were improving. Lucien founded the Eragny Press and, with the help of his wife, who had learned bookbinding

and engraving, he published a series of beautiful books that he had illustrated with woodcut engravings. He still needed Camille's support but appeared to have found his path. Thanks to their father, Georges and Félix sold two paintings to Père Martin. A still more important development was that Pissarro established contact with Samuel Bing, an art dealer of German descent. Bing had come to France in 1854 to join his father, who had a porcelain factory, and he accumulated considerable wealth from the porcelain trade. He became one of the major specialists of Japanese art (he had traveled to China, Japan, and India just after the Franco-Prussian War) and had recently been persuaded of the importance of Art Nouveau. Besides, he was interested in the concept of giving an artistic dimension to everyday things; and so, in 1888, he decided to transform his private mansion on rue de Provence into a large modern exhibition and sales space, lit by electricity. Over two floors, he displayed furniture, jewelry, glassware, ceramics, fabrics, and books, all by famous artists such as René Lalique, Emile Gallé, Edouard Vuillard, and Maurice Denis. He also exhibited a stained-glass panel designed by Henri de Toulouse-Lautrec and made by Louis Comfort Tiffany, whom he represented in France. Pissarro sent three of his own paintings, and even more significantly for him, Lucien also exhibited his first book, *La Reine des poissons*, while Georges and Félix worked together making wooden boxes decorated with animal designs. Pissarro went to a great deal of trouble to ensure that they were well displayed and eventually secured "a little spot in a rotunda next to a small room decorated by Van de Velde.

[The] five boxes are arranged by themselves opposite a window, very well lit, the display cabinet is locked."[60] The proximity of the very influential Belgian architect Henry Clemens van den Velde was valuable. Pissarro was pleased to report that Van den Velde, who was exhibiting some superb furniture, had seemed open to collaborating with the Pissarro brothers. The boxes were admired. Camille concluded that Bing's business was not a bad springboard. Camille had put an immense amount of energy into galvanizing his sons and giving them an opportunity to exhibit their work. And, admirably, he had never sacrificed his own work, his studies, or experimentations to these endeavors.

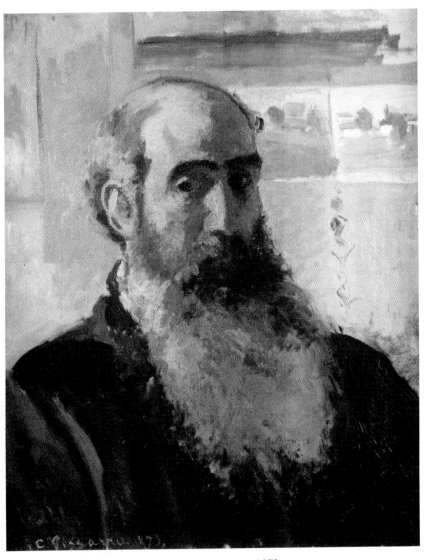

Camille Pissarro, *Portrait of the Artist*, oil on canvas, 1873.

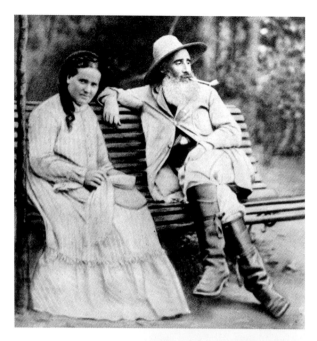

Camille and Julie,
circa 1875.

(Pissarro Family Archives)

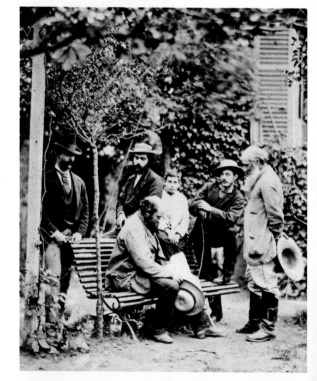

Camille standing in
front of Paul Cézanne
[seated]; Lucien,
Camille's oldest child,
leans on the bench.

(Pissarro Family Archives)

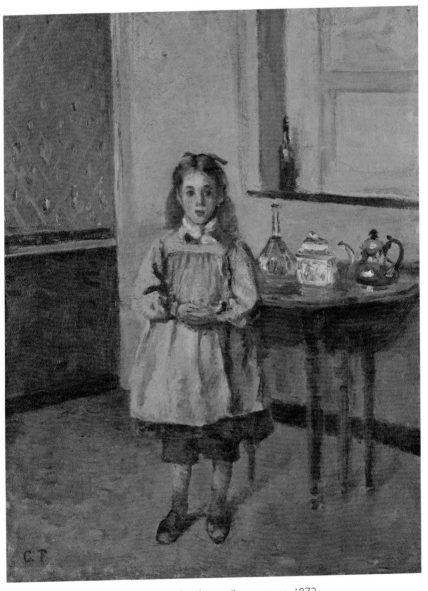

Portrait of Minette, Camille's eldest daughter, oil on canvas, 1872.

(The Ella Gallup Sumner and Mary Catlin Sumner Collection Fund, Wadsworth Atheneum Museum of Art; photo by Allen Phillips / Wadsworth Atheneum)

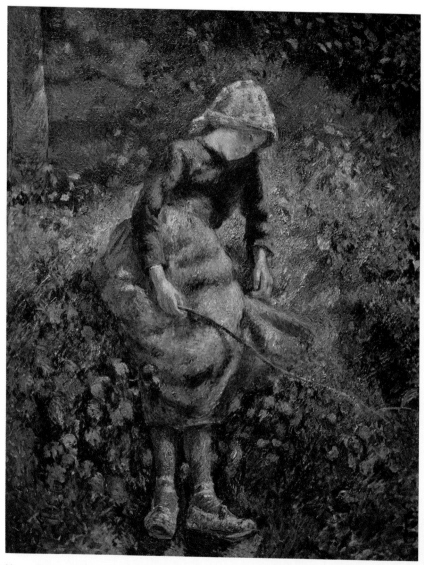

Young Peasant Girl, oil on canvas, 1881. (Musée d'Orsay; Peter Barritt / Alamy Stock Photo)

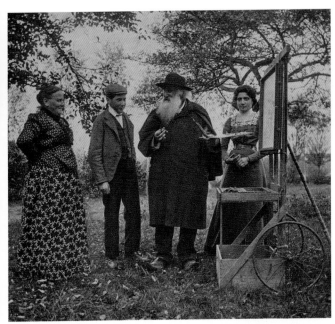

Pissarro with Julie and their youngest children, Paul-Emile and Jeanne, painting on his rolling easel in the garden in Eragny, circa 1890s.
(Heritage Image Partnership Ltd / Alamy Stock Photo)

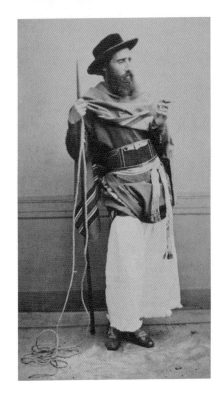

Pissarro dressed in a Venezuelan *Llanero* costume, circa 1852–55. (Heritage Image Partnership Ltd / Alamy Stock Photo)

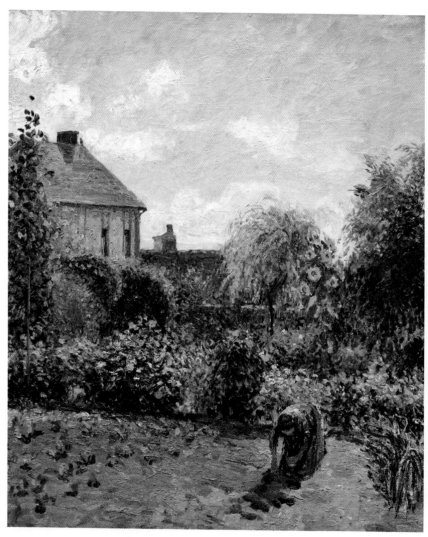

From Pissarro's pointillist period, *The Artist's Garden at Eragny*, oil on canvas, 1898.

(Ailsa Mellon Bruce Collection, National Gallery of Art; incamerastock / Alamy Stock Photo)

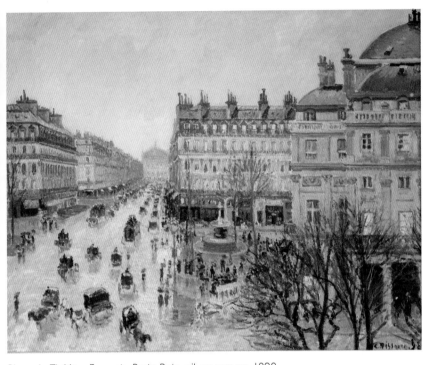

Place du Théâtre Français, Paris: Rain, oil on canvas, 1898.
(The William Hood Dunwoody Fund, Minneapolis Institute of Art; Ian Dagnall Computing / Alamy Stock Photo)

The artist in his studio.
(Pissarro Family Archives)

Pissarro pushing his portable easel in Eragny. (Pissarro Family Archives)

10

A Painter and His Dealers

In 1892 Pissarro turned sixty-two. It could have been said of a less complex man that at this point he had *arrived*, just as his old comrades had. At the time Renoir appeared to have mastered the pitfalls of fatherhood and marriage and was devoting himself to his art with abandon. Monet, who was nearing sixty, put his personal life in order by marrying Alice Hoschédé, widow of the collector. Having settled permanently in Giverny, he began work on his series, starting with the *Cathedrals*, whose great success would ensure his financial well-being. Although Pissarro was not achieving the same prices as his friends, his circumstances were now more reassuring. He could at last envision the future with optimism and felt able to spoil his patient and indefatigable Julie somewhat. Yielding to her longing to "plot a little jaunt without kids," he took her to the theater to watch a play by Maeterlink and was delighted to see her so elegantly turned out.[1] "She's terrific," he wrote to Lucien, "you wouldn't recognize her in her black velvet coat, with her chic hat and her lorgnette…it's a resurrection."[2]

He exhibited very regularly in Paris and the provinces as well as in England, Germany, the Netherlands, Belgium, and the United States. (Back in 1874, it had been a Pissarro, *Inondation à Pontoise*, that was chosen by Henry C. Angell, the first American collector to buy an Impressionist painting.) In December 1891 Camille reported to Lucien that "Carrière came to shake my hand and told me point-blank: 'I've come to tell you that you have a lot of success in New York and before long you will receive offers.' . . . I told him that I suspected as much. . . . [Alexandre] Bernheim told me yesterday, 'At the first sale where you have paintings, you'll find five or six dealers pushing up the prices, and if you want, I'll give you an exhibition, your time has come.'"[3] All at once there were three dealers—Boussod and Valadon, Bernheim, and Durand-Ruel—offering him a major exhibition.[4] He decided on Durand-Ruel and, proving that he wasn't blinded by his love and his ambitions for his children, he explained to Lucien that he couldn't involve them in this show. "I'm about to reach my goal. . . . Everyone with an interest in my work acknowledges it. It goes without saying that if I have an exhibition I must do it on my own and make it first-rate. . . . You will understand that a small exhibition by several of us wouldn't match the expectations of the interested parties. . . . After that, perhaps we shall see; I must carve out my place; I have to break in while the opportunity is there . . . you can wait a little while."[5]

Does this mean that Pissarro had *arrived*? The notion is meaningless when applied to man of his temperament. Pissarro was devoted to searching, a stranger to any kind

of formula, ever ready to evolve. He never wanted to stop his explorations, he never hesitated to reinvent himself to the point of changing his style. In this, he proved the boldest of the Impressionists.

Satisfaction was alien to him. Alien too was the notion that the society in which he lived was satisfying. Even though he never fully committed to political struggles, Pissarro would always work toward progress and movement. Stasis was abhorrent to him. Success didn't encourage him to turn a blind eye to the injustices he saw. He was devastated by the 1891 shootings in Fourmies, which brought a blood-soaked end to a workers' demonstration for an eight-hour day. Although opposed to violence, he offered help to the families of anarchists who had been arrested after a number of assaults instigated by Ravachol (François Claudius Koenigstein), the most violent of the anarchists. Such events, compounded by the Dreyfus affair three years later, undermined his sense of his own safety.

Finally, a man who has *arrived* usually has a whole support system around him, be it a shrewd wife, a secretary, or efficient collaborators. If he had had someone to manage all the related activities required by his painting, his workdays would have been easier. But now more than sixty years old, he had to arrange the transport for his work, trips to the framer, and drawing up lists of works sent out to galleries. He was spared only the chore of paying bills. Durand-Ruel dealt with paying the dentist, the tailor, the framer, hotel rooms, and the children's allowances (at least during the prosperous years), which illustrates

how close and important the ties were between painter and dealer. But it was a complicated relationship; the two parties' interests sometimes diverged. The way these interests evolved is, therefore, important to understanding Pissarro's life in all its complexity.

I described in an earlier chapter how the two men met in London and how Durand-Ruel's support and early purchases granted Pissarro a degree of financial comfort. Like Monet and Renoir, he never forgot that Durand-Ruel, to use their perennial expression, saved them from starving to death. But a thirty-two-year collaboration—it would not end until Pissarro's death—is bound to have its tensions. We know the details from their correspondence (110 letters from Durand-Ruel have survived and 368 from Pissarro) and from Pissarro's many letters to his children and to Monet on the subject.

The relationship was inevitably unequal in that Pissarro was more dependent on Durand-Ruel than the latter was on him. Pissarro would sometimes complain that he couldn't escape Durand-Ruel's "clutches," but admitted that he did not have enough dealers and could rely only on Durand-Ruel.[6] He even went so far as to ask Lucien, who was short of money as usual, "If Durand abandoned me, how would you cope?"[7] The arrangement between the two men was that they settled their accounts at the end of each year. Pissarro offered his paintings; Durand-Ruel bought what he wanted and then paid the bills from this sum, but he was free to follow his own judgment and ability in buying or rejecting work, and moreover, he set the price. In this sense, he was leading the game. Pissarro

usually thought the dealer's valuations were too low, but they were dictated by the market. And when in 1898 Pissarro lamented the fact that Durand had been giving him the same price for ten years, we must remember that it took Durand-Ruel some twenty years to bring the general public around to the Impressionists.

Until 1900 the official art world remained obstinately unreceptive to contemporary art. On April 14, 1900, at the opening of the Centennale (an exhibition of nineteenth-century art to celebrate the opening of the Grand Palais) the elderly Jean-Léon Gérôme, a representative of the Institut de France and a symbol of academic art of the Second Empire, wouldn't allow the French president, Emile Loubet, into the Impressionists' hall, crying: "Don't stop here, Mr. President. This hall is the dishonor of French art!"[8] So for a long time Durand-Ruel stored more than he sold. To take just one example, he bought *La Jeune fille à la baguette* (one of Pissarro's most endearing paintings, now in the Musée d'Orsay) in 1881 and sold it only in 1910 to Isaac de Camondo, who later bequeathed his substantial collection to the Louvre (the museum's Impressionist works are now in the Musée d'Orsay). It was Isaac's cousin Moïse who built the Nissim de Camondo Museum to house his own collection devoted to eighteenth-century French works.

The dealer fought on behalf of his painters with truly admirable energy and determination. He wasn't satisfied with exhibiting their work in his gallery but also lent

paintings to various provincial museums and galleries. Above all he didn't allow himself to be disheartened by the extraordinary animosity provoked by this new style of painting. Virulent articles ridiculed Monet, Sisley, Renoir, Degas, and Pissarro, and Durand-Ruel was accused of having lost his mind:

> And I, being guilty of displaying and daring to defend such works, was labeled a madman and acting in bad faith. Little by little, the confidence I'd managed to inspire disappeared and I became suspect to my own clients. The numerous masterpieces by our great painters that were in my possession did not redeem me in the eyes of the public and certainly not of those whose taste I'd apparently offended and whose interests I'd failed to serve. I was so discredited that anything seemed to lose its value in my hands. And in order to meet my many obligations, I had to sell the most remarkable works by Corot, Delacroix, and Millet at a loss and often for half my cost price.[9]

Despite such an unfavorable climate, Durand-Ruel managed to sell a few Pissarros in 1874, but this was not enough to provide for the artist's needs. This was Pissarro's first financial crisis, during which he turned mostly to Duret for much needed help. On the brink of bankruptcy, Durand-Ruel had to stop all payments for several years, until a banker, Jules Feder of the Union Générale, refloated him in 1880. As soon as he could, the dealer started buying again enthusiastically: "I hadn't forgotten the poor artists

whom I'd been forced to abandon to their unfortunate fate since 1874."[10] Pissarro could breathe again: "I'm not rolling in gold as the romantics say, I'm enjoying moderate but regular sales, I ask only one thing and that's for it to continue, my only fear is returning to the past."[11]

Sadly, Féder went bankrupt two years later, and Durand-Ruel once more had to stop buying. He still continued to promote his artists, particularly by organizing individual exhibitions, a novelty of which the painters were wary. But what troubled them the most was a lack of clear communication. The vagueness, if not downright opacity, that Durand-Ruel maintained about his projects and their outcomes was a constant source of irritation to his artists. Monet turned to Pissarro for news:

> And so I'm coming to you to ask for some news of the situation, Durand's and our own, because try as I might to ask Durand, his letters are rarely long and his replies aren't direct. You go to Paris more frequently and see a lot of people so you must know how things are. It would be very kind of you to give me some information and tell me how things really stand for, far away and in solitude, one sometimes tortures oneself unnecessarily.
>
> What was the final result of our exhibitions? Did you sell anything, you or Durand? I won't disguise the fact that I'm a little worried not for the future, if I could be sure that Durand could stay the course, but for the present, and for Durand himself, because I can see that it isn't easy for him to give out money at the moment: do tell me what you think.[12]

Pissarro's reply reveals his despondency. "As for giving you news of the state of our business with Durand, I don't think anyone could give a reliable report. I can only set out the situation.... I know that sales are not going well at all, neither in London nor in Paris. My exhibition brought in no money. There were one or two offers but Durand was asking too much and *held out for his prices* (very strange!)"[13]

Pissarro went on to describe Durand-Ruel's fruitless efforts in Boston and Rotterdam, efforts that he did not abandon because he felt it was so vital to exhibit the painters from this new school. The letter concluded: "All of this proves to me that things aren't going smoothly.... Can Durand go on like this for long? It's hard to tell; I'll say once again that I know absolutely nothing other than what I've observed since the crash [of Union Générale]. I can hear other dealers, minor traders and *amateurs* who speculate saying, 'He'll last a week.' ... But it's been going on for several months, I hope it will be just a bad phase."[14]

Monet and Pissarro both agreed to put their faith in Durand-Ruel although it was difficult for them to accept his reticence about revealing the state of affairs. Mary Cassatt shared what little she knew with her friends. "You never know where you stand with that devil Durand," Pissarro wrote to Lucien. "When I was in Paris recently I heard that Durand had to take back a number of paintings sold at a considerable price from an *amateur* who had gone bankrupt. Is that true? A mystery! ... and according to Miss Cassatt, it seems Renoir, all of whose work he takes, is still very annoyed, not least because he has to paint to please!"[15] And Pissarro announces the disagreement that

will pit him against the dealer when he describes as *strange* the latter's determination not to budge on price. Durand-Ruel was playing the long game, thereby proving his belief in Pissarro's future when the artist himself simply wanted to pay his grocery bill.

It was impossible for Pissarro to bide his time and refuse possibilities that presented themselves. He informed Durand-Ruel that he had sold a painting to a customer, a major paint manufacturer who had been introduced to him by his friend Guillaumin. A disappointed Durand-Ruel explained that he was doing everything in his power to secure some money for him and ended his letter by asking him "to do everything you can not to sell."[16] Lowering the price was in his view a damaging strategy.

As soon as circumstances improved, Durand-Ruel did indeed start buying again but the art market collapsed in 1884. Pissarro and Monet exchanged anxious letters once again. "I'm devilishly worried...and don't have the heart to work," lamented Monet, "being so preoccupied with poor Durand's situation and with the fate that inevitably awaits us."[17] Pissarro did little to reassure him: Durand-Ruel had told him that he had secured an out-of-court liquidation but this did not help their affairs. Pissarro admitted that he himself was "at the very end of my tether. I shall be forced to sell, for better or worse....It's easy enough to talk of selling but to whom?...It's driving me to distraction."[18] And a few days later he added: "Do you have any news for me? I've received a letter from someone who said that Durand is absolutely lost, along with Petit, that they can't get back on their feet....What

are we to do? We should meet in Paris if we can and make a plan.... I imagine you'll have to sell because Durand can't do much for us now."[19] Pissarro, like Monet, did not set upon Durand-Ruel and, despite a situation that seemed hopeless, showed him understanding and a rare delicacy. "I dare not ask you for money knowing how distressed you are.... Let us hope, however, that you will overcome the difficulties. You have so much to do that I cannot ask you to write me the state of things either."[20] Gauguin was far more aggressive and impatient than his friends. He wrote to Pissarro: "It would have been better if Durand and Petit had gone under straightaway rather than dragging it out, we'll see later. There is less and less that is understandable with Durand now."[21]

Pissarro would not be persuaded, even though Durand-Ruel's mysterious maneuvering and his lack of clarity, candor even, often exasperated him. And anyway, how could he break things off with Durand-Ruel? But because he was backed into a corner (not only did he not have a penny, but his eighth child had just been born), he entrusted a few paintings to Hippolyte Heymann, a publisher, bookseller, and art broker, who sold three works for a modest 175 francs. Cut to the quick, Durand-Ruel immediately sent Pissarro three hundred francs "while we wait for something better," and wrote:

> Don't give anything more to that beast Heymann, who displays your paintings unframed in filthy shops to make a laughingstock of them. It would be difficult to do yourself more harm than with this sort of behavior.... Don't

lose heart. We must fight a little longer and we shall succeed in overcoming our adversaries.... Work industriously and give me some pretty landscapes like the one that you sold to Heymann for so little. It's very beautiful and I truly regret it. Look for attractive subjects, that is a major factor in success. Put human figures aside for a while or make them incidental. I think there are much better chances of selling landscapes.[22]

Pissarro was well aware that a dealer like Heymann did not have Durand-Ruel's integrity. Heymann had indeed sold a Pissarro landscape very cheaply, claiming "that no one would know" and refusing to name the buyer. Camille therefore agreed to reclaim the other paintings and assured Durand-Ruel that he knew full well it was best to keep prices up "but you need to be able to."[23] And he told Monet in a letter that, according to their fellow artist the Bordeaux-based John-Lewis Brown, who was very close to Manet, Legros, and Degas, there were high hopes, but it would be another year before business was brisk again. In 1884 a cholera epidemic, sparked in Marseille and moving to Paris, frightened off every potential customer. Monet also stayed faithful to Durand-Ruel for the time being and acknowledged that "his tenacity would most likely save [them] because he'd managed to weather all his problems."[24] The fact remained that it irked the painters to be kept in the dark. However strong their faith in Durand-Ruel, they loathed his stubborn refusal to keep them informed. Monet wrote to Pissarro saying he had suggested to Renoir that they hold a monthly dinner, "just so we can

get together and talk because it's foolish to stay isolated, I myself am becoming idiotic and growing increasingly worried."[25]

In truth all the friends were in the same situation. Pissarro wrote to Lucien: "I know that Monet, Sisley, and Renoir are receiving no more than I am. Monet in particular must be very upset because Petit is doing very poorly, even worse than Durand." Not happy with merely bemoaning his fate, he tried to explain the cause of the crisis: "On all sides I hear townspeople, teachers, artists, and shopkeepers saying that France is lost, she's in decline, Germany is gaining ground, artistic France has been beaten by mathematics, the future belongs to mechanics, to engineers, major German and American financiers.... By God, yes, France is sick, but with what.... That's the question. She's sick with transformation."[26] A diagnosis that was as subtle as it was accurate.

It was at this exact moment that Durand-Ruel turned his attention to the United States. How can we not admire the imagination and enterprising spirit of this French bourgeois who was so anchored in a traditionalist world? Before his artists did, he grasped the growing importance of the American market and the validity of Mary Cassatt's efforts. But rather than setting up shop in the established arts centers of Philadelphia or Boston, he chose to do so in New York. The public there was more open to contemporary art, because the teaching of academic art was less developed in the city. Furthermore, the creation of the Metropolitan Museum of Art in 1872 gave a considerable boost to the art market and attracted many visitors.

Durand-Ruel did not speak English, but Pissarro did, so in 1885 the dealer introduced him to a Mr. Robertson, an American partner of the owner of exhibition spaces in New York, to discuss plans. They negotiated hard, and Durand-Ruel had strong support from James F. Sutton, the director of the American Art Association and son-in-law of the founder of Macy's. In the end Durand-Ruel obtained the right not to pay duty for the works he wanted to exhibit on condition that he returned any that remained unsold to France. Of course, he still had to pay the 30 percent tax on those that did find buyers. Moreover, Sutton undertook to cover the cost of transport and insurance. The painters proved far from convinced. Puvis de Chavannes refused point-blank. Monet agreed with some reluctance: "Much as I'd like to believe in your hopes," he wrote to Durand-Ruel, "what I would really like is for my paintings to be known and to sell here."[27] He added that he regretted that some of his work should be sent to the land of Yankees. Mary Cassatt gave her support to Durand-Ruel, but this was tempered by her wish to secure paintings for her American friends at the best possible price. She thought his asking prices were sometimes exorbitant.[28] In the end, Durand-Ruel succeeded in mounting a major exhibition in New York in April 1886—it included forty Pissarros (oils, pastels, and gouaches)—and didn't allow the paltry commercial results to discourage him: "Durand has told me," Pissarro wrote to Lucien, "that business is excellent and we mustn't give up on this."[29] As ever, Durand-Ruel had an eye on the future.

Durand-Ruel sold some fifty paintings and was encouraged by the thoughtful reaction of American visitors,

delighted that they were "probably no more astute than the French but they don't feel duty-bound to snigger when they don't understand."[30] "Don't take the Americans for savages," he advised Fantin-Latour as he encouraged him to exhibit over the Atlantic, "they are less ignorant and less hidebound than our French collectors. Paintings that took twenty years to gain acceptance in Paris met with great success there."[31]

The following year another exhibition had to be postponed because of the furious opposition of New York dealers who were exasperated that Durand-Ruel had secured an exemption from duties. The exhibition did not open until the end of May, which was too late to draw wealthy art lovers who had already escaped the city's summer heat. This imbroglio convinced Durand-Ruel that he needed to have his own space where he could store and display his stock and have much-needed freedom of action. He opened his gallery first on Twenty-Third Street, in what was at the time a bustling commercial neighborhood, and then at 295 Fifth Avenue in a building that belonged to the Havemeyers.

In the first instance, his Impressionists derived very little profit because Durand-Ruel was only just establishing himself in the United States, and he was offering painters from the 1830 School and what old masters he had been able to buy. But American tastes evolved rapidly. Collectors such as J. P. Morgan and Isabella Gardner Stewart accumulated eclectic collections that were almost royal in their sheer quantity and diversity; in contrast, enthusiasts of the French Impressionists bought their paintings one at

a time, more interested in owning a particular piece than in a name. Women played a key role. It took only a few years for Louisine Havemeyer and Bertha Palmer (the wife of Potter Palmer, who built a vast real estate fortune in Chicago) to amass remarkable collections, and they were only the two most eminent collectors, both of them acting on advice from Mary Cassatt. They hung their acquisitions on the walls of their living rooms, unfazed by their guests' reactions. One gentleman, baffled by a large Monet, asked Mrs. Havemeyer whether she wouldn't have preferred a pearl necklace: Why choose something made by an oyster rather than a person? she retorted.[32] Their legacies now enrich the collections at the Metropolitan Museum of Art, the Museum of Fine Arts in Boston, the Art Institute of Chicago, and many other museums.

Meanwhile, in Paris, Durand-Ruel's Impressionists were growing impatient and complained of being neglected. Monet and Renoir looked for other dealers. Pissarro, for his part, had come up against an additional and very particular problem. He had changed his style, and Durand-Ruel did not like it much. The new style was pointillism. Pissarro threw himself wholeheartedly into this method, devised by Georges Seurat, and in doing so he broke off with old friends and accomplices. For the first time since their youth the Impressionists were divided. The original group of romantic Impressionists were opposed to the so-called scientific Impressionists or Neo-Impressionists. The disagreement did not last long, but it highlighted Pissarro's boldness, independence, and pugnacity as well as his ability to admit when he was wrong.

The theory of pointillism or divisionism was revealed to Pissarro by Paul Signac and Georges Seurat, two young painters of his son Lucien's generation. Pissarro met Signac through his friend Guillaumin. The son of a wealthy saddlery merchant who died very young, Signac was raised by his mother. She adored him and allowed him to leave school before his *baccalauréat* to devote himself to painting. He and Pissarro instantly took a liking to each other (and, interestingly, he married a distant cousin of Camille's, Berthe Petit). Signac jealously guarded his independence and never wanted to submit to the Salon's official jury, so he exhibited in the Salon des Artistes Indépendants, which was set up in 1884 and was held in an outbuilding in the courtyard of the Tuileries. This show, organized without a jury, gathered together more than four hundred artists, including the equally unknown painter Georges Seurat. Signac was immediately drawn to Seurat's *Bathers at Asnières*, a painting made up of small touches, dots of color that were juxtaposed rather than mixed up on the palette. He introduced Seurat to Pissarro in 1885.

Seurat was serious, cold, logical, restrained, and good at explaining his theory and methods clearly. Pissarro immediately took an interest in this new technique and lost no time experimenting with it. His relationship with Seurat was very different from the one he had—or had once had—with Cézanne, Gauguin, and all his old comrades. The young painter did not come to learn from the older man at work. On the contrary, it was Pissarro who assimilated the younger man's discovery. At Durand-Ruel's request, Pissarro explained to him the divisionist doctrine

with great precision and made a point of specifying that Seurat had been first to come up with the idea. (Seurat was extremely sensitive on this subject and wanted to be seen as the leader of a new school.) In his note to Durand-Ruel, Pissarro wrote that it consisted in "substituting optical blending for a blending of pigments... because optical blending produces much more intense luminosity than blended pigments." Put another way, it is the eye that does the blending rather than the brush. Adherents of this system liked to believe that the result was brighter and purer than that obtained using traditional techniques.[33]

Durand-Ruel didn't seem convinced, but he still bought a painting from Pissarro that was representative of the new style. Camille was a little surprised: "Durand likes my paintings but not their execution.... [He] prefers the old style, but he does think that there's more light in the latest works. In short, he doesn't really understand much about it."[34] Nevertheless, Durand-Ruel agreed to exhibit Signac and Seurat alongside the "pure" Impressionists in New York. And although the American *amateurs*' reaction made him optimistic about the future, he soon realized that Pissarro's new paintings would be difficult to sell because the change in style put off his existing admirers.[35] His reticence would elicit this disillusioned comment from the artist: "What is killing art in France is that people like only what is easy to sell."[36]

Not only did the public balk at accepting this new painting method, but the early Impressionists were

disconcerted too. Degas's initial reaction was caustic. When Pissarro wanted him to concede that Seurat's newly completed *A Sunday on la Grande Jatte* was interesting, he replied: "Oh, I'll notice well enough, Pissarro, only that it's so big!"[37] A discussion with Morisot's husband, Eugène Manet, that was witnessed by Renoir grew very heated. Pissarro reported to Lucien in a letter that, in order to cut it short:

> I explained to M. Manet, who can't have understood any of it, that Seurat was contributing a new element, that these gentlemen couldn't appreciate it despite their talent, that I personally was convinced of the progress that there is in this art and that, sooner or later, it will produce extraordinary results. Besides, I don't give a fig about approval from other artists, whoever they may be, and I don't accept the unfounded verdict of the Romantics, who have a vested interest in fighting against new tendencies, I accept the battle and that's all there is to it.[38]

Despite his surprisingly aggressive tone, no breach from the old group took place, and in May 1886, Pissarro attended a big dinner for Impressionists held in Belleville. It was a cheerful and interesting get-together to which Stéphane Mallarmé and Huysmans were also invited.

The growing rifts were, however, brought to light by the eighth and last Impressionist exhibition. Monet, Renoir, Sisley, and Caillebotte refused to exhibit alongside Seurat and Signac. Degas—who, like Pissarro, participated in every Impressionist show—was present, as were

Cassatt, Morisot, Gauguin, Guillemin, and Jean-Louis Fo-
rain. Pissarro had achieved his objective of insisting that
Seurat, Signac, and his own son Lucien be included, and
he secured a whole room to bring together all the Neo-
Impressionists, a room dominated by Seurat's immense
A Sunday on La Grande Jatte, which measured more than
two by three meters. Degas was not exaggerating when
he said it was big. The public reaction was stormy, but Pis-
sarro had seen plenty of similar reactions and appears to
have been somewhat stimulated by the conflict. What did
surprise him, though, was that the relationship between
the romantic and scientific Impressionists didn't improve.

The atmosphere deteriorated toward the end of the
year. Meetings at the Café de la Nouvelle-Athènes saw
some petty nastiness: Guillaumin and Gauguin refused to
shake hands with Signac. Gauguin left abruptly without
greeting Pissarro. None of this overly troubled Pissarro.
What disturbed him more was that he was already begin-
ning to have his own doubts about pointillism. It wasn't
because his paintings from this period were any less beau-
tiful and personal—the gentleness and subtle nuances of
his work had nothing in common with the austerity of
Seurat's—but the technique was so time-consuming that
his output was affected. The numbers bear this out: He
completed thirty-four oils in 1885, seventeen in 1886,
nine in 1887, and only eight in 1888.[39] (By way of compar-
ison, sixty-four oils date from 1902 and forty-two from
1903, the year he died.) In July 1887 he admitted to Lu-
cien: "I'm making very little headway with my painting *la
Cavée* even though I'm working at it every day. It really is

taking too long.... Perhaps I'll be forced to revert to my old style? It's very embarrassing."[40]

He didn't give up quite yet, but these doubts gnawed at him and altered his behavior. This man who was usually so calm and philosophical now occasionally lost his temper. A conversation about pointillism with Renoir and Murer turned sour. "At one point," he told Lucien, "Murer told me, 'you know perfectly well that these dots are impossible.' And Renoir added: 'You've abandoned the dots, you don't want to admit that you were wrong!' I replied to Murer very heatedly that he was probably calling me a hypocrite and he knew nothing about it, and I told Renoir: 'My dear friend, I'm not all that senile...and as for you, Renoir, you're taking shots in the dark. I know what I'm doing." A few days later, he refused the dedication that, as a gesture of friendship, Murer offered him in his book *Un Quart d'heure d'amour*. He explained his reasons politely but with slightly grating irony:

> Despite our former friendship, I would prefer to refuse this and here's why: Artistically, our ideas have diverged considerably and consequently we can't understand each other: I say that very openly.
>
> I hope you won't hold it against me; it doesn't diminish my gratitude to you for thinking of an old painter from days gone by. Just think, my dear, of the risks your book would run under such patronage, you poor man, you must have forgotten how I've been crushed under my fellow painters' contempt, and so you want to brave fate! You won't resent me, will you?[41]

But his doubts were becoming clearer and did not concern just the time needed to execute paintings in this style; he was brooding over a more serious question, which was how to obtain a pure divisionist tone that was not harsh. "What to do to have the purity and simplicity of dots as well as the full-bodied, supple, free, spontaneous, and fresh feel of our impressionist art? That's what's preoccupying me a great deal, because the dots are thin, meager, without consistency, diaphanous, more monotonous than simple, even the Seurats, above all the Seurats....I shall go to the Louvre to look at certain painters who interest me in this context."[42] But he did not need to visit the Louvre to acknowledge that Monet's paintings were more luminous than Seurat's. Sometime later he would even go so far as to write to the painter Van de Velde, one of the founders of the Belgian modernist movement, saying that the theory of divisionism produced a feeling like "the leveling out produced by death."[43]

After a great deal of thought and experimentation, he eventually found a method all his own, which, to use Signac's expression, abandoned the period in favor of the comma. In his paintings from this phase he used not round dots of color, but small touches of paint that he allowed to dry to avoid unwanted merging, thereby leaving the fusion to occur in the viewer's eye. Durand-Ruel was relieved, if not entirely convinced. He was first and foremost a dealer and knew how taken aback *amateurs* might be by any change of style. He was quite justifiably concerned that buyers might hesitate to accept these surprising canvases. Any novelty unsettled the public.

Renoir was also struggling with his own wish to change, as he confided to Pissarro sometime after their skirmish. "I chatted to Renoir for a long time," Pissarro wrote to Lucien, "and he admitted that everyone, Durand and long-standing *amateurs*, was yelling at him, displeased by his attempts to move on from his romantic period. He seems very sensitive about what we think of his exhibition. I told him that for us, the search for unity should be every intelligent artist's goal, and even with major flaws, that was more intelligent and more artistic than languishing in romanticism."[44] All the while Durand-Ruel continued to buy, but he paid the painters very little.

Despite their discussions and differences of opinion, the Impressionists remained a close-knit group. Monet took the initiative of inviting Pissarro to exhibit with his old friends at the premises of Georges Petit, Durand-Ruel's most aggressive competitor; Pissarro felt free to do this given that Durand-Ruel never kept him abreast of how business was going. Monet, Renoir, and Rodin were among a number of artists who had formed a committee to organize a Universal Exhibition and had committed to using Petit's gallery. Pissarro expressed reservations about this project, thinking it too commercial, but Monet and Renoir, overlooking this, voted to include him: "I particularly want to write you to prove to you that despite the divergences there have been over the last year, divergences that are not of our making, we haven't forgotten our duty and, even though Renoir and I are aware of how you see things and of your distaste for this exhibition, we felt we had to vote in favor of your admission without knowing how you would

take that, having incidentally not had the time or the op-
portunity to consult you."[45] Pissarro accepted by return of
post, thanking both Monet and Renoir. He was delighted to
be exhibiting with his friends once more and to have a plat-
form to display his latest work. His most striking piece was
Railroad to Dieppe, which Durand-Ruel had bought the year
before and which he lent for the occasion. The reception
was better than could have been hoped. The critics were im-
pressed by Pissarro's new style. Emile Verhaeren, a Belgian
poet who was much liked by many artists including Degas
and Mallarmé, wrote favorably in *La Vie Moderne*, a review
founded by Zola's publisher, Georges Charpentier. He said:
"Mr. Pissarro is asserting his mastery. *Railroad to Dieppe*
victoriously portrays a place cleaved by a railroad and gives
an accurate feeling of this strange phenomenon: a train cut-
ting brusquely through flowers and greenery. This submis-
sion stands out from the others for its miraculous illusion
of expansiveness."[46] Octave Mirbeau was equally taken
with this vast landscape created by an explosion of multi-
color dabs of paint. Pissarro himself was not displeased
with it and commented in a letter to Lucien: "I did a lot
of work on [that] canvas....Working with dots is strange,
with time and patience, little by little you achieve an aston-
ishing softness."[47] The following year the landscape sold to
a major New York collector, Erwin Davis.

However, Durand-Ruel's business was stagnating, and he
did not hide from Pissarro the fact that he was not sell-
ing anything and was in trouble. And although he had

paid Pissarro only 439 francs in 1887, he still didn't want
him to forsake him for another dealer. Be that as it may,
Camille absolutely had to find other sources of income,
and the 1887 exhibition would offer a new possibility.
Theo van Gogh, Vincent's brother who had become the
director of Boussod et Valadon, had browsed through
the exhibition. He contacted Pissarro a few months later,
sold a drawing for him, and made a point of encouraging
the artist and promising his active support. From August
1887, Van Gogh became increasingly important to Pis-
sarro at a time when Durand-Ruel was being especially
evasive. In September 1887, to the painter's great relief,
Van Gogh sold a large oil and a small gouache. "It has
to some extent dug me out of a hole," Pissarro wrote to
Lucien, "and your mother is a little more relaxed and it
will mean I can work on a few canvases." He need say
no more to his son, who knew how indispensable a calm
atmosphere was to him.

Annoyed by the competition from Van Gogh, Durand-
Ruel wanted to break up this new relationship, but Pis-
sarro stood firm, particularly as Van Gogh continued to
represent him successfully through these years when his
very individual form of pointillism was at its height. Van
Gogh bought several important works—*Apple Harvest*
(now in the Dallas Museum of Art), *L'Ile Lacroix, Rouen (The
Effect of Fog)* (now in the Philadelphia Museum of Art),
and *The Gleaners* (exhibited at the Basel Kunstmuseum),
among others—and sold them very quickly. Emboldened
by this success, Pissarro resisted Durand-Ruel's attacks.
He wrote to Lucien:

Durand took me aside, and asked me whether I'd taken any paintings to Van Gogh. "Yes," I replied. "You shouldn't have taken paintings to that devil of a man, why didn't you bring them to me?" "Because you already have plenty and you wouldn't be able to sell them straightaway." "Bring them to me and whatever you do, don't do business with Van Gogh, because so long as he has paintings of yours, it damages me and stops me from selling." "Come, come, M. Durand, you are not selling my paintings!" "But I am, I've sold some in America." Oh if I had some money, that's the problem.

You will understand that I can't take Durand's advice, prudence itself tells me so; if I take everything to Durand, when he drops me, which he has done before, I will have no way out; I would end up locked in the citadel, at Durand's mercy; good man that he is, he'll do what he always does, in spite of himself, it's a possibility. So I told him very frankly that Van Gogh had sold my new paintings and, liking them, he defended them intelligently, I can't take back what I've given to him, that does not stop me showing you what I have. Conclusion: Durand is displeased to see Monet doing business with Boussod and Valadon; he would have liked to hold on to Monet, he is taking the initiative with me.[48]

The two men went through a difficult patch but whereas for Durand-Ruel it had to do with saving his business, in Pissarro's case it was literally about feeding his family or having a few pennies to put a stamp on a letter to Lucien. Durand-Ruel didn't want to let go of Pissarro, and the

artist desperately needed to sell his work. It is worth noting that he still acted in good faith and was prepared to offer his output to Durand-Ruel first. So he put the dealer to the test by offering him some small gouaches, and when Durand-Ruel refused them he felt perfectly within his rights to turn to Van Gogh. As he said to Lucien, if Durand-Ruel did not take all their work, he couldn't complain about either Monet, who dropped him in favor of Goupil, or himself, who was turning to Van Gogh. "There's no denying," he wrote to Lucien, "that there's a battle between Durand and Van Gogh; he's furious with him since the Monet business. Van Gogh knows this, there's nothing we can do about it. Were we not forced to look elsewhere? What will Van Gogh do? He'll do everything he can to prove to Durand-Ruel that the gouaches do sell."[49]

But tragedy struck the Van Gogh brothers. Vincent, after several bouts of madness and spells in a lunatic asylum, wanted to spend some time with the Pissarros to recover. While not close, the two men had a good relationship, but Pissarro was concerned for his children because of the terrible outbursts that ravaged the poor man, and he didn't want to expose them to what could well have been violent scenes. Nevertheless, Pissarro made arrangements to find lodgings not far from his home in an auberge in Auvers and secured Dr. Gachet's word that he would care for Vincent. Despite Gachet's best efforts, however, he was unable to prevent the final crisis. Two months after his arrival, Vincent shot himself in the chest with a revolver. He died on July 29, 1890.

The tragedy then became still more poignant. Theo crumbled a few months after his brother's death. The end

of his life was as appalling as it was unexpected. Having descended into madness, he tried to kill his wife and son and had to be interned at Dr. Blanche's clinic in Paris before being transferred to a psychiatric clinic in Utrecht, where he died in January 1891.

Pissarro then repaired his links—which had been stretched rather than broken—with Durand-Ruel, who reiterated his support in warm terms and suggested it was time for a solo show. The year 1892 did indeed start well, and Pissarro reported to Lucien that the gallery in Paris had made him an offer:

> Yesterday I received a visit from Joseph Durand [Paul's third son], who came accompanied by his friend Mellério, a young art critic. They were delighted with what they saw. Young Durand told me that his father intended to come any day now to reach an agreement with me about an exhibition of my work as a whole on their premises, but that it had to happen before January 25, before Sâr Péladan's planned exhibition which will make a lot of noise in the press and will drown out anything that comes after it....As you can imagine, I've been caught somewhat off guard.[50]

In the end, Durand-Ruel had to travel to London and therefore did not visit him. A little disconcerted by these swift developments and concerned by the coolness in his relationship with the dealer over the last few years, Pissarro turned to Monet for advice: "Old Durand...is constantly on the move so I'm left in a limbo that's very conducive to future difficulties. You have been through this, what

arrangement did you come to for the exhibition space and other expenses?... Tell me about the hidden costs I won't have thought of... The whole thing my dear Monet is very mysterious, and yet I can tell that I'm being made to jump through hoops as good old Sancho Panza was by the muleteers."[51] Monet replied by return of post:

> You're absolutely right to have an exhibition. The time is right and you are sure to succeed.... Durand-Ruel never asked me anything for the space or for anything else. You do understand that when we exhibit at his gallery, we bring business. So there's no reason for him to behave any differently with you than with me. Don't worry about the rest. If your exhibition is successful, as I'm sure it will be, be careful: various people will want to monopolize you. Don't let yourself be pushed around. Sell to everyone alike.[52]

Pissarro was working tirelessly. Preparing a retrospective is a major undertaking, and he hadn't had a solo exhibition since the one arranged by Durand-Ruel in 1883. But five days before the opening, he was able to tell Joseph Durand-Ruel: "I'm ready, now it is only a question of packing and transporting."[53] He managed to bring together paintings from almost every period. The catalogue was illustrated with three engravings by Lucien, including a portrait of Pissarro in profile, and had a very handsome introduction by Georges Lecomte, an influential art critic who made much of the path trodden by an artist who was never afraid to alter his techniques the better to

represent "the subtleties of his very accurate vision, the natural harmonies and rhythms of which he is aware."[54] Mirbeau published an enthusiastic review in *Le Figaro*. Pissarro could breathe at last. He made a point of thanking Mirbeau and showed a rare flash of self-satisfaction in a letter at the end of the exhibition: "I'm very satisfied with my sales; in the end Durand-Ruel took what paintings were left unsold.... How deeply indebted I am to you, my dear friend, it was clearly you who brought the masses to raid the redoubt."[55]

This success put the question of exclusivity back on the agenda. Durand-Ruel demanded it and thought it indispensable to guarantee prices that reflected the value of Pissarro's work; but the artist refused to grant it. At most, he agreed to ask three times as much from his private buyers (in other words, charging them what they would pay the gallery) and to give Durand-Ruel preference, explaining that he would do this "because you were the first to support us and you fought for us; nevertheless I can't promise to sell to you alone, that would be as awkward for you as for me."[56] Not without a note of humor, Pissarro found himself wrangling with his dealer: "He can probably tell that I'm feeling strapped, we've taken to watching each other, trying to find a weak spot to jump in. We're like a couple of boxers; I'm thin and short of breath, he's very sturdy and bandy-legged, so I try to use cunning... I've never been any good at that, though."[57] The success of the 1892 exhibition encouraged Durand-Ruel to put on another one the following year, again with good results. The relationship between the two

men remained cordial but never achieved the intimacy of friendship.

More significantly, Durand-Ruel seemed unmoved by his artist's political choices. Pissarro had never hidden his adherence to anarchist theories. To him, anarchism meant first and foremost a substantial mistrust of the government, indignation at social injustice, and opposition to the church and the army. He wasn't an activist, but he subscribed to two anarchist publications, and this was enough for his mail to be opened from time to time and for him to be the subject of very real—albeit only discreet—surveillance. Durand-Ruel, a fervent Catholic who admired the army, held diametrically opposite views, but these differences didn't influence his attitude toward the artist. Pissarro happened to be in Belgium when the French president Sadi Carnot was assassinated by an Italian anarchist on June 24, 1894, and he thought it wise not to return immediately to France where repression intensified. Some of his friends and correspondents—the most notable being the critic Félix Fénéon—were arrested, and his journalist friend Jean Grave was sentenced to two years in prison. Pissarro's very political decision in no way altered his relationship with Durand-Ruel, to whom he wrote very frankly on July 30, 1894:

> The vagaries of fate have brought me to Knokke-sur-Mer, a little hole that's quite new to me and pleasant for a painter. I have started a series of things that you'll like, I hope: windmills, red roofs, dunes.... Unfortunately, the season is a bit advanced and the weather too unstable

for me to settle here; on the other hand, I'm concerned that as a foreigner and a friend of Mirbeau, Paul Adam, Fénéon, Luce, and Bernard Lazare, I could on the basis of these facts alone be troubled or deported, so I may well have to settle in Belgium or England. If I do stay in one of these countries for this reason, could I count on your support to help me live and work as you have done up until now? Do please tell me what you think.[58]

Durand-Ruel didn't keep him waiting; he replied three days later to reassure Pissarro that he was keen to continue their good relationship whether Pissarro lived in France or abroad. He did not doubt that the artist would find beautiful subjects in one or other of the countries and hoped that he would send him his paintings. He did warn him, though, that he would have to be very reasonable about his prices.

In the end, Pissarro returned to Eragny but was disheartened because his work didn't sell well. Once again, he felt he was going nowhere: "I'm starting to think, given the coolness of *amateurs*, that there's some gap, something essential that is missing in my art."[59] It hit him all the harder because Monet was selling extremely well and secured fifteen thousand francs for each series of his *Cathedrals*. Durand-Ruel continued to keep Pissarro's prices up by buying everything that was auctioned, but he couldn't find buyers for the more recent work. This inevitably led to a shortfall, which translated into a squeeze on Pissarro's resources and concern that his dealer might give up on him. Such fears were ill-founded, because Durand-Ruel

kept up his hard work and sent off paintings to numerous exhibitions abroad.

Pissarro finally relaxed when Durand-Ruel, encouraged by an upturn in business, decided to organize a solo exhibition for him in Paris in April and May of 1896. The exhibition was such a success that Camille was able to write to Lucien: "There's a big change in my favor at the Durands' after the great success of my exhibition. I gather from what I've been told that Degas gave me quite a leg up. On Sunday I met Blanche, who told me that he'd chatted to Degas about my *Rouens* and my trees, and he had praised them."[60] For our purposes, what is of even greater interest than the commentaries is the date, April 1896. Until then, there is no mention in Pissarro's correspondence of the Dreyfus affair. After November 1897 it became impossible to ignore it.

II

The Irruption of Politics
The Dreyfus Affair, 1894–1906

Even before the Dreyfus affair erupted, the group of friends had somewhat disbanded. Cracks had started to appear after the last Impressionist exhibition in 1886, and the tendency had not stopped accelerating. The ambitious youngsters of the 1870s had aged and suffered the loss of several of their comrades. Manet died in 1883 aged fifty-one; Seurat died in 1891, at thirty-one, of a throat infection; then Caillebotte died in 1894, followed a year later by Morisot, whose generosity and courtesy had contributed so much to the glue that held the group together—a whole sequence of blows to the characteristic sense of invulnerability of youth. In the meantime, there had been a geographical dispersal and, in some cases, a rejigging of their private lives.

When Pissarro moved to Eragny it became harder for him to travel to Paris than in his Pontoise days. And so he went

to the capital mostly for business or, when the cityscape appealed to him, to work. The only person he saw with any ease was his friend and neighbor Monet, who had lived in Giverny since 1883. But Monet was constantly on the move, wanting to paint under the sun in the south of France or Corsica if he wasn't spending time in Normandy or the Creuse Valley in central France. This was his way of escaping the complications of his private life. When Ernest Hoschédé was ruined in 1878, Monet had taken him in along with his wife, Alice, and their six children, at a time when his own wife, Camille, was very ill. She died the following year, leaving Monet with their two young sons. The situation became more complicated when Monet and Madame Hoschédé fell in love. Her husband eventually moved away, but it wasn't until his death in 1890 that the lovers were married. Of course, this had no bearing on Monet's friendship with Pissarro except that they saw less of each other through those tumultuous years.

Cézanne's visits stopped altogether, and he saw Pissarro only on his very occasional trips to Paris. The wise-cracking Cézanne, who scoffed at the police, teased Madame Pissarro, played with Lucien, and enjoyed rambling discussions with Camille about paintings and politics, had returned to the south once and for all and become a loner. After a reconciliation with his father, he finally married Hortense in 1896, but they soon separated. She preferred living in Paris, while he stayed in Aix-en-Provence with his sister and elderly mother. His trips to Paris became infrequent, but he did accept a lunch invitation from Monet in November 1894. The lunch, which

was also attended by Clémenceau, Rodin, and Mirbeau, was for Cézanne to meet the critic Gustave Geffroy, who had devoted a long and glowing article to him, the first to appear in the national press. Right up to the last minute, Monet was afraid Cézanne would fail to appear because he was now so "peculiar and afraid of meeting new people."[1] He did come, though, and went on to paint a portrait of the critic in 1895, but the portrait was never finished, as related by the dealer Ambroise Vollard:

> "I could tell," Cézanne told me one day, "what I had to put in to get the painting to where I wanted it to be. But during the sitting Geffroy kept talking about Clémenceau. So I packed my bags and slipped back to Aix."
>
> "So Clémenceau's not your man, then?" I asked.
>
> "Just listen, Mr. Vollard, he's the 'passionnatto' sort, but I'm just a weakling in life so I prefer to put my trust in Rome.'"[2]

Having abandoned the left-wing convictions he had shared with Pissarro, Cézanne had embraced the church once more and had transformed into an oversensitive conservative. And Vollard added this detail: Cézanne took his fierce longing for solitude to such extremes that, when a childhood friend whom he hadn't seen for more than forty years bumped into him in Aix and asked for his address, he was—as ever—obsessively afraid of being "pinned down" and replied: "I live far away...on a street..."[3]

Renoir, on the other hand, never left Paris, but the tenor of his life changed as well. During the 1880s he

often worked in Algeria and Italy. Once back in Paris, he relinquished his studio on the rue Saint-Georges to live in Montmartre with Aline Charigot, whom he married in 1890 and with whom he had three sons. Sisley also moved, swapping the Louveciennes region, which was so close to Paris, for Moret-sur-Loing, a pretty little town in the Seine et Marne region. Gauguin alternated between Brittany and Polynesia. Only Degas changed nothing about his way of life. A confirmed bachelor, he stayed in the New Athens neighborhood in Paris. But the man who had gladly spent time with Georges Clémenceau and had been labeled a Communard by Berthe Morisot's mother had now given way to an intransigent reactionary.[4]

This dispersal put an end to the close collaborations that had been so fruitful in the early days of Impressionism. The shared quarters and the outings they took together were now just a memory, and the artists all reacted differently to the cultural crisis that shook up the country at the end of the century. As a result of the rural exodus, cities were expanding and evolving. Electric streetlights replaced the gas lamps. The first tramways had been introduced in 1855, but when the first cars appeared in the 1890s traffic jams changed dramatically; the noise became more strident and the center of the city was clogged by crowds lured by the novelty of department stores. Renoir and Degas, who were the only city dwellers of the group, were horrified by this transformation. "Monsieur Renoir attacks all new pieces of machinery saying...that they're pointless, the automobile is an idiotic thing," Julie Manet reported in her diary.[5] Even

bicycles didn't find favor with him—it has to be said that he had broken an arm dismounting from his own. Degas proclaimed that nothing could be more stupid than the pursuit of speed at all cost, and Vollard reported that the very mention of modern comfort sent him into a rage.[6] Cézanne showed little more enthusiasm and regretted that the picturesque banks of the Estaque were now blighted by electric lighting. In contrast, Monet eagerly adopted the automobile and bought himself a Panhard to drive around the countryside; doubtless, had he had the means, Pissarro would have done the same. Pissarro certainly didn't turn a blind eye to the cruelties imposed by the industrial revolution, but he admired the energy of this new era, as indicated by his views of the ports of Rouen and Le Havre and of Parisian boulevards. Unlike Renoir and Degas, he was interested in a future of change. He didn't succumb to nostalgia.

Political choices inevitably became more defined as the century moved on. Pissarro and Monet continued to adhere to the principles of the secular Republic. Renoir's position is more difficult to characterize: he was left-wing when it came to defending the rights of workers in general—he took their side during the 1894 miners' strike—but he was also fiercely nationalist, anti-socialist, and anti-Dreyfusard, and his attitude toward Jews grew increasingly hostile. Pissarro never seems to have held this against him, any more than the stalwart Dreyfusard Misia Natanson did. Misia was the wife of Thadée Natanson, who ran the political and literary review *La Revue Blanche*, which sided strongly with Dreyfus's supporters. Misia—a

bright and cultivated woman of boundless curiosity—
makes an interesting witness: she had often posed for
Renoir (as well as for Vuillard, Bonnard, and Toulouse-
Lautrec), and the burning question of the captain's guilt
is highly likely to have been raised during their long con-
versations. She reported that, absorbed by his painting,
"[Renoir] had managed to escape the epidemic."[7] In the
past Renoir had unleashed many inopportune comments
and readily contradicted himself. In 1882, for example, he
wrote to Durand-Ruel that he refused to exhibit alongside
the Israelite Pissarro because he didn't want to be seen as a
revolutionary, then he swiftly backtracked and frequently
exhibited with him. In 1887 he even joined Monet in invit-
ing Pissarro to contribute to the show they were putting
together in Georges Petit's gallery. But he was too closely
attached to the army not to align himself with the anti-
Dreyfusards when the crisis exploded. Degas, on the other
hand, became an out-and-out nationalist, a partisan of the
narrowest form of Catholicism, and plunged into the most
virulent anti-Semitism. And yet, until 1896, his support
never failed Pissarro. Then his attitude changed, and he
broke off with his old comrades. And so the Dreyfus affair
accentuated the rift between the old friends and hardened
their positions. It would have been difficult to foresee how
political differences would break up the tight-knit group
of the 1880s.

Captain Dreyfus, a Jewish officer, was found guilty of
high treason by a court-martial on December 22, 1894;
he was publicly stripped of his rank on January 5, 1895,
and transferred to Devil's Island in April of the same year.

Dreyfus never stopped protesting his innocence, and egregious irregularities in the handling of his trial shed doubt on the fairness of the verdict. The affair gradually took on vast proportions. For twelve years French society was turned upside down by the dogged determination of the two opposing camps: on the one hand the Dreyfusards were appalled at the thought of a miscarriage of justice, and on the other the anti-Dreyfusards refused to concede this possibility. The conflict was soon fueled by violent nationalist and anti-Semitic polemics.

Pissarro did not react in the first instance. It took the publication of Bernard Lazare's brochure *Une Erreur judiciaire. La verité sur l'affaire Dreyfus* (A legal error: The truth about the Dreyfus affair) in November 1897 and of Zola's explosive pamphlet *J'accuse* on January 13, 1898, for him to become aware of the scandal. He revealed his thoughts in a letter to Lucien: "I'm sending you a few newspapers that will bring you up to date on the Dreyfus affair, which has so inflamed public opinion: you'll see that he could well be innocent. In any event, some elevated and honorable personalities are saying he is. Bernard Lazare's latest brochure that has just come out proves that the document that the general released to the press is false, as testified by twelve scholars of various nationalities. It really is terrible!!!"[8]

Pissarro, like all dejudaized Jews for whom the cult of republican values had replaced any religious practice, opted not to step forward and question the significance of Dreyfus's faith in the early days of the affair.[9] Nevertheless, he could not fail to notice the violent increase in

anti-Semitism in France, the cries of "Death to Jews" that had punctuated Dreyfus's public stripping of rank, and the brutality of the demonstrations. Until then, Pissarro had not suffered the effects of anti-Semitism, although, despite the respect and friendship his fellow artists had always shown him, when he was feeling especially despondent he sometimes wondered whether his origins played against him, but he dug no deeper: "A question of race, most likely. Until now, no Jew has made art here. I think this could be a reason for my bad luck."[10]

This was a debatable point insofar as professional circles of collectors and dealers were often Jewish. There was one incident when a stupid comment made by Renoir's youngest brother to a friend upset Pissarro and he complained about it to Monet:

> [That boy] really is intolerable, not that his gibberish has any effect on me, but for the discredit he projects onto his brother in particular and our group in general. . . . Apparently, I'm a schemer of the first order, devoid of talent, a money-chasing Jew, making underhand moves to oust both you, my friend, and Renoir. I really was very offended by him for a while, but it's so inane that I've stopped thinking about it. The only serious aspect is the divisions that are being stirred up, the disagreements that some are trying to incite. . . . People could well have unpleasant suspicions about the painter Renoir, which he definitely doesn't deserve. . . . I didn't want to talk to Renoir about it. I think it's best to take no notice of it. What do you think?[11]

Monet agreed with Pissarro that it was pointless to pick a fight, but he still felt "it would be good at some point to touch on it with Renoir, [whose brother] can only be doing him a disservice."[12] This entire exchange proves that anti-Semitism had no traction within the group during the 1880s. Granted, Renoir—who had a significant Jewish customer base including Charles Ephrussi, the Cahen d'Anvers, Eugène Fould, and the Nunès family—was sometimes irritated when the time came to discuss prices: "As for the Cahens' fifteen hundred francs, I will go so far as to say I think it's hard to take. You couldn't get more tight-fisted. I'm definitely giving up on Jews."[13] Those fifteen hundred francs in fact represented the highest price Renoir had ever achieved. But he never broke with his Jewish customers and never badgered Pissarro. Quite the opposite: he featured him among his friends in his painting *The Artist's Studio, rue Saint Georges* in 1876. We have seen how close Pissarro was to Degas who, before the Dreyfus affair, gave no sign of anti-Semitism. Degas's friendship with the Halévy family, a family of Jewish origin, offers further proof of this. In 1871, at their request, he painted a double portrait of the Grand Rabbi Astruc and General Emile Mellinet, who had served together as ambulance drivers during the siege of Paris. The rabbi's son was horrified by the portrait, which he called a pogrom, but—viewed objectively—it is hard to see it as a caricature of Jewishness. At any event, the painting stayed in Jewish collections, first in Charles Ephrussi's, and then it was acquired by the Reinach family, who defended Dreyfus ardently and effectively.

Ironically, Pissarro had few Jewish buyers except for the poet and art critic Gustave Kahn; Ernest May, a banker who posed for Degas for his painting *Portraits à la Bourse*; and Charles Hayem, who was, to use Monet's disdainful expression, a ribbon salesman. In fact, Hayem was a great collector, a patron of the arts, and an important donor to the Luxemburg museum. A pretty sketch of him by Degas has been preserved. It could be that Pissarro's reputation as an anarchist drove financiers away and that he himself made no attempt to court them. Pissarro loathed the capitalist system and was deeply mistrustful of banking, be it Jewish or Catholic. "The people," he wrote to Lucien, "are right not to like Jewish banks, but they have a weakness for Catholic banks which is idiotic."[14]

In 1889 he made twenty-eight pen-and-ink drawings on the theme of the hardships suffered by the poor and the grasping indifference of the wealthy, grouping them under the title *Turpitudes sociales*. In these drawings (intended for his nieces and not for the public) Pissarro became Daumier's successor. His political views aligned with those of Théophile Steinlen, Vallotton, and Luce as well as the Zola of *L'Assommoir*. And, in the name of his complete artistic freedom, he showed no hesitation in resorting to the worst stereotype of a Jewish banker when illustrating his capitalist: a portly man with a hooked nose clutching a bag of gold to his belly. For him, this condemnation symbolized his abhorrence of the current social system; it was certainly not a comment on Jews in general. Be that as it may, the image is still shocking.

The atmosphere in Paris was changing rapidly, however, and he could no longer ignore how vulnerable his

origins were making him and his coreligionists. In November 1898, Camille reassured Lucien that he was safe: "For now, there are just a few loudmouthed Catholics from the Latin Quarter whom the government favors. They shout 'Down with Jews,' but that's all." Paradoxically, in the same letter, he describes what could have been a bloody incident: "Yesterday, when I was on the boulevards on my way to Durand at five o'clock, I ended up in the middle of a pack of little schoolboys, followed by ruffians who were shouting 'Death to Jews, down with Zola!' I walked along in the middle of the heap all the way to rue Laffitte with no trouble, they didn't even take me for a Jew!!!"[15]

Perhaps those who didn't pick a fight could avoid being taken to task, but the mounting frenzy in the anti-Semitic press represented a dangerous threat and didn't spare the art world. A deputy from the Gers region wrote a venomous article that was reprinted by several newspapers:

There really are too many Jews in today's society....What gave me some consolation was believing that at least French art, our glory before all foreigners, had escaped their hooked fingernails. Yet, it appears I was mistaken....We must urgently, although it may be too late, raise a cry of alarm about the Jewish invasion in fine art, an incomprehensible invasion that cannot be justified on any front given that Jews are men of money, not of ideals, and that their dominant characteristic is a lack of taste and a love of all things garish, false, and tawdry....And these are the men charged with setting up state exhibitions, with expanding and enriching our museums, of which they are in charge.[16]

The individual targeted in this article was Roger Marx, inspector general of museums at the Ministry of Fine Arts, a great champion of Impressionism, and, to use Henri Rochefort's expression, "a synagoguist in high office" who was accused of wanting to force "Jewish dealers' art" onto the scene.[17] It was now becoming impossible not to take sides, and the painters' community was split just like the rest of the country: Pissarro, Monet, Cassatt, and Signac joined Eugène Carrière, the most politically active of the artists, followed by Vallotton, Vuillard, and Bonnard, all on one side; Degas, Renoir, Cézanne, and Forain on the other.

As soon as *J'accuse* was published on January 13, 1898, Pissarro and Monet both wrote to Zola to congratulate him and indicate their support. They joined a considerable number of signatories in putting their names to a protest "against the violation of legal norms in the 1894 trial" and demanding a review. In February, Pissarro—like many others, including Monet, Mallarmé, Marcel Proust, Vuillard, and Signac—wrote to Zola to express his admiration for him, and he contributed to "L'Hommage à Zola," an open subscription set up to have a medal struck in the author's honor. The writings of the Jewish polemicist Bernard Lazare strengthened Pissarro's resolve in this, and he wrote to Lazare to thank him for sending him his brochure on anti-Semitism: "No need to say how fully I agree with you on the anti-Semitic movement and how glad I am to see a Semite defending my ideas so eloquently; besides, there was only one knowledgeable anarchist Jew

who could raise his voice with authority."[18] He suggested
to Lazare that his daughter-in-law Esther Bensusan could
translate the book and that it could be published in a re-
view edited by her brother. Lazare replied that he would
be delighted and would not ask to be remunerated if the
review was low on funds.

Unfortunately, this project was never realized.
Throughout this period Pissarro became a passionate
reader of the press, and he sent cuttings of articles in
L'Aurore by Clémenceau and Zola to Lucien and his wife,
keeping them up to date on the discouraging shift in pub-
lic opinion. "The bulk of the public is against Dreyfus,
despite the bad faith shown in the Esterhazy case."[19] He
regretted that he couldn't do more to serve justice, but
he needed to work: "Despite the serious events going on
in Paris, I really must, in spite of my concerns, work at
my window as if nothing was happening. . . . Let us hope
it doesn't stop me from working, that would be a shame
because I am well underway."[20] Julie disagreed, thinking
he was letting himself be consumed by the Dreyfus affair
and couldn't even find time to write to her. "The Zola af-
fair is probably taking up all your time so you can't write
to me, you're more interested in it than in your family!
You don't have time to think of us / well good for you."[21]
We don't know whether he replied to this furious letter
or if he let the storm pass, as he usually did. What we do
know, though, is how concerned he was about the mood at
Durand-Ruel's gallery.

His old friend Guillaumin, with whom he'd painted win-
dow blinds in the lean years, thought Zola "an ambitious

prankster." Pissarro told his son Georges that he happened to be in the gallery when the same Guillaumin "in front of Casburn [Durand-Ruel's cashier, who had become his right-hand man] and Durand's employees, who with one exception agreed with him, said that if Dreyfus had been shot after his trial, there would not have been this mess whipped up by people who have no proof at all; but, I replied, they don't need to provide any proof, all they needed to do was base their arguments on the evidence that condemned the accused and that evidence was false!" The ever-equable Pissarro still did not end his friendship with Guillaumin. Their long-standing ties survived political passions.

Cézanne and Degas, on the other hand, knew no moderation: the Dreyfus affair and its fallout transformed them, albeit to different degrees. Cézanne's anti-Dreyfusard opinions were common knowledge, but he clung so furiously to his solitude that he wouldn't allow such matters to distract him from his work and did not indulge in impassioned declarations. He refused to be "under the influence of events... in this Dreyfus affair."[22] It seems very unlikely he would have refused to greet Pissarro or would have reconsidered his admiration for his work. By contrast, Degas allowed himself to be consumed by his anti-Semitism and adopted views that were as absurd as they were extreme. This elegant artist who had been so dazzling in society turned into a cranky old grouch. While he ate his solitary meals, his elderly servant Zoé read him *La Libre Parole*, the publication that had been launched by the anti-Semitic polemicist Edouard Drumont

and had now become Degas's only source of information. During a soirée at the home of Ambroise Vollard (who liked to think that one could get rid of the Dreyfusards by rounding them up and dumping them on a desert island as the city of Constantinople had done with its stray dogs), Degas lashed out at Pissarro and pronounced his painting idiotic.[23] The person he was talking to pointed out that only recently he had found some of Pissarro's paintings "very good," and Degas retorted, "Yes, but that was before the Dreyfus affair."[24] Signac wondered, "What is it that goes on in the brains of such intelligent men for them to become so stupid?"[25]

Accepting the folly of his times, Pissarro doesn't appear to have been unduly offended. It didn't occur to him to judge Degas the artist through the filter of politics. That same year, he wrote to Lucien's wife, Esther, that he had seen an album of reproductions of Degas drawings: "It is terrific. In it you can see that Degas is truly a master, it's more beautiful than Ingres's work, and my word, it's modern!"[26] He simply advised Lucien not to send Degas his own book. "He's prickly as horsehair at the moment."[27] And he commented to Signac that, since all the anti-Semitic incidents, both Degas and Renoir had avoided him. In fact, he would never see Degas again.

Neither Renoir nor Cézanne would deny their friendships with Pissarro or retract their admiration for his work, and in 1906, Cézanne would even sign one of his works *student of Pissarro*. Degas's case was very different and illustrates the folly of the period. He became so ferociously anti-Semitic that even Julie Manet was shocked.

A sufficiently committed anti-Dreyfusard and nationalist to subscribe to a campaign in *La Libre Parole* to repatriate Jews to Jerusalem, she had however never stopped treating Pissarro and the Dreyfusard Mallarmé with almost daughterly affection. Degas's attitude was different. She recalls in her journal that she and her cousin once went to invite him to dinner, "but we found him in such a state against the Jews that we left without asking him to anything."[28] And so the increasingly irascible and solitary Degas broke with his oldest friends—particularly the Halévys, his "adoptive" family—because of their Dreyfusard leanings. He didn't see Ludovic Halévy again until this childhood friend was on his deathbed. He couldn't even bring himself to attend Pissarro's funeral. Granted, he had the courtesy to apologize to Lucien for this, citing his own ill health as the reason and ending the letter with these words: "We hadn't seen each other for a long time, but what memories I have of that old friend."[29] Notwithstanding such memories, he was unable to overcome his more recent loathing of Jews.

This inability to see beyond political differences, which tainted artistic judgment and led to the obliteration of old friendships, was one of the most repulsive aspects of the period. Happily for Pissarro, Durand-Ruel to his credit never yielded to his political passions. Had he joined the chorus of anti-Dreyfusards, the artist's position would have been untenable. Durand-Ruel abstained. At the risk of being seen as a renegade in his social circle, he remained steadfastly loyal to his painters whatever their opinions or origins. He had already proved his independence during

the Commune, when he refused to abandon Courbet. And nearly thirty years later, the same man—who was still a reactionary, still anti-Semitic, still gave his unconditional support to the army and was resolutely anti-Dreyfusard—set up an exhibition that brought together the nucleus of Impressionist artists and gave the place of honor to the Jewish Pissarro, whose entire series of *Vues de l'Opéra* he had bought.

The dealer thus enforced a truce by holding this exhibition in May 1898, and he absolutely refused to be drawn into the melee. He invited Bernard Lazare and Zola to the reception for the opening. He continued to work with other dealers who were Jewish, such as Bernheim in France and Paul Cassirer in Germany, to sell to Jewish collectors, and to support Pissarro as he had done in the past. The latter was very happy with the results: "My avenue de l'Opéra canvases have been hung. I have a large exhibition room all to myself; . . . Durand is very satisfied; it looks very subtle. In the neighboring rooms there is a series of admirable Renoirs and another of superb Monets, and yet another of Sisleys, and the last little room has Puvis de Chavannes."[30]

Pissarro was especially gratified because it had taken all his strength of will and his passion as an artist to overcome the ordeals, sorrows, and anxieties that had disrupted his life in the previous year.

12

Paris from My Window

Pissarro had always managed to cope with terrible difficulties thanks to his incomparable ability to concentrate. Work had never failed to save him from depression, anxiety, and despondency. The Dreyfus affair did not completely consume him; besides, the end of the century would bring far more painful personal ordeals for him. If Pissarro had not consistently proved he was a tender, sympathetic father, always ready to devote himself to his children, it could have seemed that—beneath his imperturbable steadfastness—there lurked a degree of indifference that would explain how he weathered the misfortunes that befell his family in the year leading up to his big exhibition in 1898. I think it would be better interpreted as a sort of fatalism that led him to accept the inevitable without pointless lamentations. Not that this stopped him from taking action and fighting when the need arose.

In May 1897 Lucien collapsed with a stroke that left him temporarily paralyzed. Camille dropped everything to be by his side, knowing what comfort his son would take

from his presence and support. He stayed in England for several weeks, and during this extended visit he formed an affectionate relationship with his granddaughter, Orovida. Naturally, he encouraged her to paint and draw. From then on, the child would send him her work, which delighted him. He kept track of her progress. In 1902 he would write to Lucien that he had just received the child's drawings: "The big horse is absolutely remarkable, Rosa Bonheur beware... she has a sense of shape. I'll write her myself to offer my compliments."[1] Orovida would indeed go on to become a renowned artist, but let's not get ahead of ourselves.

Before the end of the year, when Lucien had just recovered, another tragedy struck the family. Félix, Camille's third son, who also lived in England, had contracted tuberculosis. Camille learned in November that he would not survive, but he hesitated to leave home again. He sent this explanation to Georges, who was helping his dying brother: "It will have to be either me who comes or your mother. I would have come long ago but I must keep battling to pay your subsistence and I can't really see how I would work over there in Kew in winter. Still, if needed, I will come. You mustn't let your imagination run away with you and lose your head, you'll need a little courage and don't let yourself go."[2] He also wrote to the English doctor to check that Georges ran no risk of infection: "In that case, Mrs. Pissarro or I would manage to be near our unfortunate son, would you tell us also if we have time to arrange our business here."[3]

He and Julie agreed on a plan on November 18, 1897. It would be better, she decided, for him to stay at home

working and taking care of the younger children. Not least because the condition of his eye was becoming worrying. She would go to London alone. In moments of grave crisis, Julie always proved brave and full of good sense. "If you went, what would we do about your work and the money that needs to come in?"[4] It can't have been easy for her to go to England in such heartbreaking circumstances, and yet she set sail the very next day. Camille, who was in Paris for an eye treatment, returned to Eragny to look after his children but continued to be very involved in developments in the situation.

As ever, he tried above all to keep his wife and children calm. Concerned about how deeply upset Lucien was by Félix's deterioration, he recommended that Julie be gentle with their eldest and not tell him too bluntly that there was no hope. He was equally worried about the effects of this ordeal on Julie, and asked Georges not to let her exhaust herself, to insist she get some rest, and to ask the doctor for some medication to afford her some relief.[5] He approached Lucien, asking him to prevail upon his wife, Esther, to prevent any altercations with Julie: "Let's hope the women, both of them, manage to be reasonable, because we have enough sadness and misfortune as it is."[6] Relations between daughter-in-law and mother-in-law do not appear to have improved. Lastly, Pissarro reassured Julie about the state of the household: "The children are doing very well. Cocotte is very sweet and does her little bits of housework admirably. Paul is very obliging and helps her a lot. Even Rodo's not being too uncooperative."[7]

Poor Félix died on November 27, a week after his mother arrived. Three days later, she was back in Eragny, and Lucien was finally informed. The letter that Camille sent him amply communicates his state of mind. "In such disastrous circumstances we must resign ourselves and think of those around us; giving in to despair would be terribly grave, and we must overcome that which we cannot control; amid our sorrow, I had an opportunity to see just how well Georges coped with the situation, it took great strength of character on his part to stop your mother making herself ill."[8] And he ends the letter on a note of vigorous optimism: "I forgot to tell you that I have a room at the Grand Hôtel du Louvre with a superb view on the avenue de l'Opéra and place du Palais Royal!—It's very beautiful to paint. It may not be aesthetic, but I'm delighted to have a chance to try painting these Paris streets that people usually say are ugly, but which are so silvery, so full of light and life, completely different from the boulevards—it's just so modern!"[9]

Given that he can't be accused of insensitivity toward his children, it is likely that he hoped this fervor would inspire in Lucien an urge to return to work. He himself didn't waste a moment. What better proof could there be of his vitality than Signac's 1898 account:

> I went to see old Pissarro at the Hôtel du Louvre, where he has taken a room to paint the avenue de l'Opéra and the place du Théâtre Français from the windows. I was expecting to find him stricken by Félix's death and Lucien's illness. He is admirably philosophical and shows

a serene resignation. He's more vigorous than ever, is working enthusiastically, and heatedly discusses the Zola affair. When you compare this artist's old age, full of activity and work, with the grim and doddery dwindling of old rentiers and retirees, what rewards we reap from art![10]

Thadée Natanson, the founder of *La Revue Blanche* and an important art critic, also noted the impression Pissarro gave of youthfulness, a moral youthfulness derived from his ardor for work and his passion for justice. "Is it because he was infallible? Because he was infinitely just and infinitely good? Or because his prominent nose was hooked, and his beard very white and very long? But for those who knew him during the 90s, he really was something like a kindly God. At least an Eternal Father with warts, which made him all the more human."[11]

An Eternal Father who was nevertheless not spared human misery: grief, inevitable family and financial worries, and the no less inevitable affronts of old age. True, he made the most of advantageous sales to buy himself dentures, which meant he could eat better (he'd had to stop eating meat), but his eye still hurt. As the condition worsened, he considered how worthwhile it might be to have an operation. He received differing advice, which left him confused and more worried than ever. In the end he decided on some injections while he waited to go ahead with a minor operation on the lacrimal sac. "I will probably have fewer abscesses now, which will mean I can work a little. Besides, I'm getting used to the idea of having only one eye to work.

It will still be better than nothing!"[12] And he took comfort from the fact that Degas achieved such good results when, like him, he had only one good eye. In fact, the effects of old age were taking a toll on Degas's good eye: he complained to his sister that it was as if he were looking through a strainer and recommended that she use huge writing in her letters, but it is true that he continued to paint.[13]

The absolute refusal to give in to any form of infirmity was equally strong in Monet, who would go on to suffer from cataracts affecting his sense of color; and we find it again in Renoir, who never stopped working despite terrible rheumatic pain. Manet took his passion for art to such an extreme that he was painting flowers on his deathbed. Pissarro had not yet come to that, but he was constantly aware of the possibility of decline. Two letters to his son Georges illustrate both his trials and his attitude: "The eye is not good. I'm having a small operation tomorrow which will not amuse me, well never mind, it has to be!" Two days later he wrote: "I had two sessions having the bone in the corner and the bottom of the eye cleaned, and today I need to have the last part of this little procedure, which is anything but pleasant. Once it's over, it will take just a few days to heal.... Mind you, I have to keep the eye under thick bandaging. The only pain is not being able to do anything."[14] He was allowed out of doors only in very fine weather and even then he had to be wary of gusts of wind, so he mostly had to work inside—but at a window because he was not a portraitist and his buyers didn't like interiors. Still, cityscapes viewed from an elevated position provided him with appealing and varied new subjects.

Although he was first and foremost a landscape artist and a chronicler of rural life, Pissarro was fascinated by city views, be they in Paris, Rouen, Le Havre, or Dieppe. And, like Monet, he addressed them in series, painting the same view at different times of day and working on several canvases at once because the weather could be so changeable, particularly in Normandy. Within the space of a single day, sunshine, rain, and fog could alternate at a few hours' interval. This made it particularly tough for anyone like him who was interested in the play of light. He battled with the endlessly shifting effects of overcast and foggy weather and sometimes worked on ten paintings at once. That is no exaggeration. Monet also sometimes worked on "fifteen paintings by turns, dropping them only to go back to them" as he tried to capture the many changes in the light on a snowy, foggy day in London.[15] It's not hard to imagine the clutter in a hotel room and how difficult it would have been to lay hands on the right canvas to make the most of a beam of sunlight or a reflection in the rain. "I'm going to bed," Pissarro wrote to Lucien one evening: "I've been working on three canvases of thirty centimeters and one of fifteen today, it was exhausting because of the gymnastics I have to do to see the subjects."[16] Capturing effects in such circumstances required astounding vitality and physical energy. He explained his technique to his son Rodolphe: "When you do one or two sessions, you have to make sure everything is to hand; it takes me six or seven sessions for an eight-centimeter canvas, the same as for a fifteen. If I want to do it in one go, I have to make bold changes to the way I work, trying to get the air and the

light."[17] And there is no denying the huge psychological
effort this required: "The changing weather is giving me a
lot of trouble and I'm paralyzed by anxiety."[18]

Each painting was both an independent work and part of
an ensemble. This meant that the notion of the series was
both crucial and ephemeral. Crucial because this desire to
represent different effects of the light was irresistible to
an artist fascinated by shifting patches of light and shade,
and by the fragility of clouds and smoke; ephemeral be-
cause the series was bound to be broken up. It was unreal-
istic to think that a private buyer would buy a whole series
of twelve or fifteen paintings. Clémenceau, who was a
close friend of Monet's, quite rightly doubted that the art-
ist would find a millionaire who could scoop up all of the
Cathedrals or the *Haystacks* like a package of shares. In his
own lifetime, Pissarro saw only one of his series—the fif-
teen paintings of the avenue de l'Opéra—exhibited in its
entirety, and this was in the 1898 exhibition at Durand-
Ruel's gallery. Nevertheless, the concept of a sequence was
essential. When Pissarro saw Monet's *Cathedrals* series at
Durand-Ruel's gallery, he immediately told Lucien to come
to Paris before the end of the exhibition: "His *Cathedrals*
are going to be scattered in all directions, and [the series]
really should be viewed as a whole."[19]

Pissarro's urban series kept him busy in the last ten years
of his life from 1893 to 1903. Granted, he had spent time

in Rouen in 1883 and then in 1886, but it was only with his views of Saint-Lazare station in 1893 and of the boulevard Montmartre in 1898 that his output concentrated on city scenes and he started painting series. He was not the first cityscape artist in the group. Paris had attracted Monet as early as 1873, as evidenced by his *Boulevard des Capucines* and his enthusiasm for Saint-Lazare station; Caillebotte's two Parisian views—*Le Pont de l'Europe* and *Rue de Paris: temps de pluie*—had been well received at the third Impressionist exhibition in 1877. Even earlier, in the 1860s, Renoir had painted various Paris bridges. But Pissarro's undertaking was more extensive. He didn't want to paint a monument or a street scene, he wanted to provide an image of the city in all its feverish activity, giving as much importance to the movement of passersby and carriages as to the outlines of buildings. The result was an extraordinary series of streets, squares, and boulevards— extraordinary in both their quality and their quantity. There are more than three hundred city views by Pissarro.

Camille's first Parisian series featured the place de la Gare Saint-Lazare bustling with intense traffic rather than the station itself that had so interested Monet. In 1893 he completed four paintings from his hotel room window. His 1897 series was more substantial, and it immediately appealed to Durand-Ruel, who recommended that he should paint views of boulevards. He chose boulevard Montmartre and quickly set to work with no illusions about how hard the task would be: "I've started my series," he wrote

Georges. "I have a wonderful subject which I shall have to interpret by every possible effect, to my left I have another subject but it's terribly difficult, it's almost seen from the vantage of a flying bird, carriages, omnibuses, people between large trees, big houses that need to be shown perfectly straight, it's tough!"[20]

Among the different effects, it is worth lingering over a view of the boulevard by night. Pissarro had never rejected the technical advances that so infuriated Degas and Renoir, and this nocturnal scene allowed him to incorporate the effects of artificial light and to play on the contrast between the white light of electric streetlamps and the softer tones of gaslights in shopfronts and oil lamps on hansom cabs. This painting shows how Pissarro took advantage of new inventions. He painted no other night scenes in Paris, and even moonlit landscapes, such as his 1870 view of St. Stephen's Church in England, are very rare for him.

The following year, 1898, he changed neighborhoods and, as he reported to Lucien, set himself up at the Hôtel du Louvre for four months to paint a series intended for Durand-Ruel's planned exhibition. One of the characteristic features of Pissarro's cityscapes is the figures milling about, people captured in a few impeccably accurate touches. Pissarro had always introduced human figures into his landscapes, sometimes so small or hidden in shadows that they are not immediately obvious; in his cityscapes men, women, and children become essential elements of the scene, although at first glance they constitute mere dabs of color. If we surrender to the illusion

conjured by longer viewing, however, they come to life, walking and gesticulating.

What interested him was the confusion of carriages and pedestrians, and these people were often so individualized that it's possible to guess their occupation: laborers are shown going about their work, nannies holding children's hands, women in hats standing by shopwindows, soldiers in uniform, a man walking along reading his newspaper. Pissarro goes so far as to sketch in umbrellas and baskets, even the different peaked caps worn by coachmen. The diversity of the crowd is there for all to see. Everyone is in a hurry, in motion; everyone is contending fearlessly with the unpredictable traffic, avoiding omnibuses, weaving between cabs and barrows, and taking refuge around fountains and streetlamps. These snapshots amply illustrate Pissarro's conviction that the arts are intimately bound to their era. He was fascinated by the hubbub of carriages and people and displayed astonishing mastery and equally astonishing speed in capturing all this movement when the weather allowed. It shouldn't be "done bit by bit; do it all together...the eye mustn't concentrate on any particular point but must see everything."[21] This meant he had to work quickly, and in a letter to Julie he congratulated himself for finishing a snow scene in just one sitting: "The canvas was ready, but I painted it over from one end to the other in one go!!...So I'm having a break."[22] Durand-Ruel came to see him in March, thought the series a great success, and bought twelve of the fifteen paintings, which allowed Pissarro to return to Eragny and catch his breath.

Pissarro was an inclusive man. He may have enjoyed observing the turbulence, asperities, and innovations of modern life in Paris, but this doesn't mean he rejected the traditional and immutable rustic life of his retreat in Normandy. He said he was "very happy to be able to breathe a bit of air here and to see greenery and flowers." Then he added a characteristic note: "And so I have set to work so that I don't lose the habit."[23] His zeal for work never faltered: "I can't help digging away at it, it's become second nature."[24] And his self-discipline was unwavering: he woke at five in the morning, worked until midday, and then from two until five. His friend Mirbeau pointed out that then, "come nightfall, he had finished his work unwearied and could think of nothing but the next day's task...he put away his canvases, cleaned his palette and brushes, and made meticulous preparations for the morning's session."[25] It is also worth noting that he endlessly urged his sons to rise early—by which he meant at five o'clock in the morning—in summer and winter alike.

The 1898 exhibition was a great success for Pissarro. Making the most of a slight improvement in his finances, he undertook a three-week trip to the east of France with Julie. Almost immediately after this he settled in Rouen in order to paint another series, most of which would be bought by Durand-Ruel. "I can't always work in Eragny so I have to travel to good places where I find appealing or intriguing subjects and that is expensive, very expensive. I found a really beautiful spot yesterday, from there I could

paint the rue de L'Epicerie and even the very unusual market that's held every Friday."[26]

His choice of places to stay and paint was often dictated by how easy it would be to travel back to Paris to see his eye specialist. These trips away were crucially important to him in his final years because he had a very strong feeling that Eragny wasn't allowing him to evolve (although springtime in his orchard still dazzled him). He therefore chose accessible destinations: Rouen, Dieppe, Le Havre, and particularly Paris, where he stayed for extended periods.

It usually took Pissarro four months to complete a series. Four months was tough for Julie, who ended up isolated in Eragny with her teenage children, and a long time for Camille, who was unhappy away from his family. He especially liked Rouen, which he knew well, having stayed there in 1883 and twice in 1896 before returning in 1898. On the first of those trips, he had still been in his prime and painted *en plein air*, even if that meant being stared at by passersby, as described in this letter from Gauguin: "I laughed this morning when I read the passage in your letter about the crowd gathered around the painter who sets out his cups along the quayside like some lowly prestidigitator. Obviously, it must make you very self-conscious."[27] Working from a window protected him from ridicule and from the comments—and even advice—of passersby, but he was far from comfortable in rooms that were often cramped and inadequately heated. The 1896 trip had been brightened by an unexpected meeting: one evening, he was surprised to see Julie Manet, Berthe Morisot's

daughter, arrive on a visit to the region with two cousins. The young woman mentions the meeting in her journal: "In [the hotel's] dining room we found the beautiful old man with a white beard that is Mr. Pissarro. He was astonished to see us. We spent a delightful evening with him." Entertainment was provided the following evening by one of the young ladies—Jeannie Gobillard, the future wife of the poet Paul Valéry—who, to Pissarro's absolute delight, sat down at the piano and gave an impromptu concert. The young ladies left after what was in Pissarro's words too short a stay: "Heavens above," he told them, "for someone like me who lunches and dines alone every day." Before they left, he showed them the paintings he had done, and they asked whether he would hold an exhibition the following winter: "No," he said, "all this will go into Durand-Ruel's cellars to mature like wine."[28]

During his last visit, in 1898, his sons Georges and Rodolphe and then Julie came to visit him. He finished his Rouen series in mid-October and—as proof of his energy and curiosity, and encouraged by Durand-Ruel—he set off for the Netherlands with Rodolphe to establish some contacts but, more important, to explore museums. "I haven't had time to write you about how I felt when I saw Rembrandt's masterpieces: it's admirable, and the thought that came to me after seeing not only the Rembrandts but also the Franz Hals, the van der Meers and so many other great artists, is that we modern painters are damnably right to experiment, or rather to feel things differently because we are different and besides it's a form of art that's so very specific to an era that it's absurd to try walking that path."[29]

This trip was a sign of growing affluence. Perhaps more indicative of this is the fact that Pissarro was planning to spend the winter in Paris with Julie, Cocotte, and Paul (Rodolphe and Georges would move into a studio in Montmartre). In 1899 he could finally afford this extra expense. "I hope this means that your mother, Cocotte, and Paul won't be as bored as if they stayed alone in Eragny, which really isn't very cheery in winter."[30] Besides, he was concerned about the effects of the damp in the countryside on his canvases. It only remained for him to find a suitable apartment. Camille and Julie searched actively for somewhere that would be right for them, but it wasn't easy reconciling their preferences. "It will be difficult to keep your mother and my work happy," he wrote to Lucien without elaborating on Julie's wish list.[31] He eventually found what was needed on the rue de Rivoli, "opposite the Tuileries, with a superb view of the gardens, the Louvre to the left, houses in the background, the riverbank behind the trees in the garden, the dome of Les Invalides to the right, the belltowers of Sainte-Clotilde behind the banks of horse chestnuts, it really is beautiful."[32] The Tuileries Gardens is a place where nature—albeit a very controlled version hemmed in by buildings and monuments—becomes part of the urban landscape and would allow Pissarro to play on contrasting forms. Here there were no carriages and no traffic jams but a haven of calm that was hardly affected by the changing seasons and was made all the more cheerful by children playing. The apartment was not huge: one large room that served as a bedroom, living room, and studio; a smaller bedroom; and a tiny study. Being able

to work in this more convenient space translated into increased output: the Tuileries series comprises two groups of fourteen canvases, the first completed in 1899, the second in 1900.

That winter in Paris marked a period of respite and was an opportunity to contemplate what the Pissarros' life might have been had they not been strangled by financial hardship throughout their time together. Pissarro worked enthusiastically on his Tuileries series. One of the many advantages of the apartment was that he could alter his vantage point by moving from one window to another. He also had enough room to store large canvases, and it was easier to lay his hands on the right one at any given time.

Music was another pleasure that was available in Paris. He loved music and had been keen for all his children to play an instrument, but since moving away from Paris, he had had very few opportunities to go to concerts. As soon as they were settled on the rue de Rivoli, he organized a concert in the apartment with the best performers from the Orchestre Colonne, who played pieces by Bach, Mendelssohn, and Rameau. "We'd put the piano into the living room that I use as my studio, it's a huge room and has pretty good acoustics," he reported to Lucien.[33] And he was delighted that "Paul is keeping up with the piano under the instruction of the pianist who played so remarkably in the concert. She comes here three times a week! Although he's not very advanced because he had only inadequate lessons in Eragny, he's making progress under Mlle Lavallo's direction." Paul, who also played the clarinet, appears to have been the most gifted in this field, but the family orchestra

also included Cocotte on the piano and Rodolphe on the violin. (In the past, Félix had also played the violin.)

As he had in Eragny, Pissarro always watched patiently over the two youngest children at work. He had hoped to guide Cocotte toward an artistic career and always made time to look at her drawings and take her to exhibitions. He gave her plenty of advice, particularly emphasizing that she must always make studies from nature "even if it's less accurate, it's better, tracing is bad practice, it is not honest."[34] But Julie confined Cocotte to household chores, and Camille didn't have the strength to prize her away from this influence. They reached a degree of compromise and several portraits of Cocotte painted by her father show her doing needlework. She was never happier than when stitching tapestries based on Lucien's designs; she was quick to voice her opinion and particularly wanted "the silks, while being more colorful, to be harmonious as well."[35] A request that must surely have pleased her father. Paul had oriented himself toward painting and had always enjoyed accompanying his father around Eragny, helping him push his easel, watching him, and doing his own work. Julie could now see that Camille was going to nudge him along this path and resigned herself to it, but she was not prepared to let go of Cocotte.

The older children sometimes tested their father's patience. It was not that Lucien and Georges didn't work, but they weren't earning a living, and Camille was irked by their carefree attitude. Lucien's wife always ran out of money before the end of the month but wouldn't contemplate coming to France without a maid to look after her

young daughter. Outraged by this pointless expenditure and angered by what he saw as a lack of trust in Julie and himself, Camille didn't mince his words in a letter to Lucien:

> It's obviously a peculiar idea and not at all practical, particularly an English maid....So you would trust her more than you would us....Hasn't it occurred to you that we could look after her for the few days that you're in Paris, in this inferno where we breathe nothing but dust, in a city invaded by swarms of people from the four corners of the earth? It's simply madness, my dear, and I do hope you won't commit this colossal error...be practical, and it will cost you a lot less! Without a maid you'll be able to eat wherever you want; with a child and a maid, it's quite an encumbrance.[36]

Of course, the grandfather's protestations were ignored and Esther brought her maid.

Meanwhile, Georges exasperated his parents for a more serious reason. Since 1899 he had been living with a young painter called Amicie Brécy. Camille and Julie knew about this and didn't seem at all concerned about the relationship but were surprised by the birth of a little girl in April 1900 and, a month later, by Georges and Amicie's wedding on the island of Jersey. Like Lucien, Georges was on the wrong side of the French authorities because he had refused to perform his military service and therefore could not be married in France. Camille congratulated him on the baby's arrival while expressing surprise at the

choice of name, Athée (atheist), although it should have pleased him given his convictions, but it is likely that—in this—he was echoing Julie's opinion. He did not raise the issue of the marriage, but there was a marked coolness between father and son, and Georges didn't even inform him before he came to Paris and settled with his wife and child in Moret near Fontainebleau. Rodolphe, who had traveled to Jersey with his brother, stayed there for the time being. News of the marriage caused considerable turmoil in the family, but it is not entirely clear why, except that Julie disapproved. Camille didn't explain it very clearly in a letter to Lucien:

> You've received the announcement of Georges's marriage; that was another very tiresome business and was followed by quarrelling and tantrums; naturally your mother was not at all receptive to this decision of Georges's.... If you ask me and *between ourselves* there was as much to blame on each side. For my part, I'm in favor of people being free to live together but master Georges has not made things easy.... The result has been never-ending gossip, swearing, tantrums, it hasn't helped him much.... Even very recently I had to intervene between the two camps, both fuming.[37]

To make matters worse, Rodolphe entered the fray and irritated his mother by defending Georges. As usual, Camille tried to calm Julie and persuade her to "overlook lots of little things [for] the sake of family unity" while encouraging his children to be more diplomatic.[38] This quarrel is

incomprehensible, as family quarrels often are. Julie, who
had had several children with Camille before they were
married, appears to have been peculiarly rigorist. But per-
haps her irascibility derived from the fact that her adult
children were still dependent on help from their father,
who continued, unruffled, to pay them their allowances.
He never demeaned himself by insisting that these pay-
ments depend on their behavior. In a letter to Rodolphe,
for example, he expressed concern about his son's non-
chalance: "Are you rising early enough for your work? I
doubt it, because you don't usually have the enthusiasm
for work that people have in their youth. It's the only way
to achieve anything."[39] But he concludes by announcing
that he would send him one hundred francs.

This generosity was not synonymous with insouci-
ance or laxness. Pissarro was always very accurate in his
accounting, be it with Durand-Ruel or his children. This
would become clear when his notary, Mr. Teissier, urged
him to put his affairs in order. One of the potential prob-
lems that his estate might cause was the disparity between
the sums he had given to Lucien over the years and, to a
lesser extent, to Georges (although Georges's son Tommy's
education was entirely financed by Camille) and those he
had granted to the younger children. The notary—and
Julie agreed with him—was afraid that this inequality
could cause friction among the children in future. In fact,
Pissarro had kept very precise records of his spending, and
when he wrote his will in 1902, he bequeathed half of his
paintings to Julie and shared the second half equally be-
tween Julie and the children. To avoid disadvantaging the

youngest two, he specified that 52,100 francs should be deducted from Lucien's share, 23,794 from Georges's, and 7,462 from Rodolphe's. Few could fail to admire the accuracy of these figures. As soon as Pissarro had more funds, in 1899, Teissier also encouraged him to put a small sum aside for Julie and to give Cocotte a dowry. The anarchist in Pissarro yielded to the notary's reasoning and invested in the railroads . . . and became a (small-time) capitalist.

Of course, Pissarro continued to take a lively interest in politics, although there is surprisingly little mention of the Dreyfus affair in his correspondence. But it would have been pointless to comment on a matter that everyone was discussing when writing to French correspondents, and it is highly likely that Lucien followed the developments closely himself. Some letters may also have been lost. In August 1899 Camille mentions the trial in Rennes but only to fret about the economic repercussions of the affair. The 1899 trial, Dreyfus's second after the 1894 ruling was quashed, was held from August 7 to September 9 in Rennes, to avoid violent demonstrations in Paris, and it ended with the accused being sentenced to ten years' imprisonment. Dreyfus accepted the pardon offered by the French president, though only reluctantly because accepting it meant professing to be guilty, but he was utterly drained after five years of cruel detention on Devil's Island. He would not be exonerated until 1906, when the second trial was overturned. Strangely, just when things seemed calmer in November 1899, Pissarro mentions the

possibility that Jews might be deported—a comment that is symptomatic of the lasting effects that the Dreyfus affair had on Jews but one that is all the more startling because the most ardent Dreyfusards made much of how the climate had changed after Emile Loubet's election as president. Joseph Reinach, author of a monumental history of the Dreyfus affair, concluded that the republicans were back on their feet.[40] A crowd of five hundred thousand sympathizers was able to parade through place de la Nation without incident to celebrate the erection of the sculpture *Le Triomphe de la République.*

Pissarro himself was feeling sanguine and thought that the World's Fair—"that great, that dreadful bazaar"—would keep Parisians busy and calm them down.[41] The transformation of Paris would certainly either fill the population with wonder or infuriate it. Many buildings and monuments had been built or rebuilt for the occasion: the Grand Palais, the Petit Palais, three railroad stations (the Gare d'Orsay, the Gare des Invalides and the Gare de Lyon), and the Alexandre III bridge. The Big Wheel said to have a one-hundred-meter diameter was constructed on the site of the present-day Village Suisse on the avenue de Suffren and attracted thousands of visitors. Sixty thousand gas lamps were used to illuminate the Eiffel Tower, the dome of Les Invalides, and the Trocadéro Gardens. Needless to say, Pissarro didn't enjoy all the upheaval but could see its benefits.

International events were of at least as much interest to him as French affairs. He subscribed to the *Herald Tribune* not only to keep abreast of sales of paintings but also to

keep a close eye on American politics. The Boer War sent him into a state of constant exasperation: he was violently critical of the English government, as was all European left-wing opinion, and he made several contributions to support Afrikaners in the Transvaal and the Orange Free State. His letters to Lucien demonstrate how sensitive he still was to the lunacy and ferocity demonstrated by nation-states: "Unless I'm mistaken, England is playing a very dangerous game, whether she wins or loses in the Transvaal, she will have played a very bad hand that will cost her dear both morally and materially. It's a major calamity for civilization, particularly as it comes from a country that set an example of the highest values. Oh! The madmen or rather the miserable wretches."[42] Two days later he was back on the offensive but with a different insult: "Well, the English are doing well!!! What a downfall! and if, by putting in enough money and effort, they end up suppressing those peasants, what future is there for the civilized world! Oh! They're so bourgeois!"[43] He also mentions that in the smallest of villages, even in Eragny, people were contributing to the Boers' defense. But Pissarro was too honest not to realize that injustice was rife all over the world and that not all the English supported the war. "I can understand that the English people of good heart are ashamed of this cowardly act, but when you think what's happening right here, in Madagascar, in China, Spain, Russia, Austria, wherever power dominates, in free America, Aguinaldo ambushed, nothing surprises anymore."[44]

One sees that Pissarro was by no means turning inward and that he refused to let his obsession with art cut him off from global events. Besides, an interest in international

politics didn't stop him from thinking about how best to display works of art. He had dreams of a museum that would be the absolute opposite of the World's Fairs and Salons. He therefore gave a lengthy answer to a correspondent who asked about the ideal layout of the Louvre Museum: "Without aiming too high, we could do a lot worse than to follow the example set by the English, who have managed to lay out a museum [the National Gallery] displaying only works by old masters, with rooms that are neither too tall nor too small nor too large, where the paintings are hung at an appropriate height and are well lit, where visitors find chairs available for their use and affable attendants and if they so wish they can spend a long time in a restaurant to refresh themselves."[45] This reply is characteristic of a man as balanced as Pissarro, an artist who fully appreciated that art lovers needed a degree of comfort to enjoy and linger over a masterpiece. He doesn't deem it necessary to point out that free entry is essential. When he heard of plans to charge a fee for entry to the Louvre, he had erupted furiously: "[The government] is going to make us pay for the right to gaze at Botticelli at the Louvre, ah! the blackguards, the brutes three times over; it really is enough to make you crack your head against a wall." The argument about free entry lasted nearly forty years. In the end, in 1921, entry tickets became compulsory except on Sundays and on Thursday afternoons, when children were out of school.[46]

When he had completed his series of the Tuileries, Pissarro looked for new Parisian subjects, and this meant moving to another apartment. He found one on place Dauphine

in late 1900. He worried about the inevitable dampness on the Ile de la Cité because, like many landscape artists, he suffered from rheumatism. But he carried on regardless, lured by the triple view from the window: to the left the Hôtel de la Monnaie and the dome of the Institute of France; in the center the Square du Vert-Galant dropped in the middle of the river Seine and, in the background, the Pont des Arts and the Louvre; and to the right glimpses of the Pont-Neuf and the stores at la Samaritaine. He spent three long spells here between October 1901 and May 1903, punctuated by periods of work in Moret-sur-Loing, Dieppe, and Eragny. He completed more than sixty works in this apartment, the greatest number of paintings in one site. But before starting this series he was boosted by a great success in January 1901.

Durand-Ruel organized a solo exhibition for him, the first since 1898, and he displayed more than forty works, views of Rouen and the Tuileries and landscapes of Eragny and the area around Dieppe. The critics were captivated. Pissarro was at the height of his craft, wrote Antonin Proust, and collectors were fighting over his work. Word of this widespread enthusiasm appeared even in the *New York Herald Tribune*, and Pissarro also enjoyed success in Berlin. During a Georges Feydeau sale at the Hôtel Drouot in February 1901, a Pissarro sold for ten thousand francs, a record for him. In May he learned that an American had bought one of his paintings for fifteen thousand francs. "The Americans are doing well!" he wrote exuberantly to his son Georges.[47] Of course, taking a break was out of the question; he promptly set off to find somewhere to work

in the summer and visited several towns, accompanied by Rodolphe. "We went to Rouen to take the train to Trouville," he wrote to Lucien:

> As you can imagine, I found the route from Rouen to Trouville absolutely horrible, we took it into our heads to stop at Lisieux, of which you've spoken highly. And the place did indeed strike us as very interesting with its old streets and its churches. From Trouville we went to see Villers-sur-Mer, which seemed to us even uglier than Trouville, ghastly chalets and nondescript landscapes. Finally, I did think Caen was worth visiting....After all those trips, I did not find anything that might suit me. Lisieux and Caen are too far from Paris, because I must be able to see Parenteau [his eye specialist] if the need arises; as for Villers-sur-Mer, which the Bernheims highly recommended, I wouldn't want to spend twenty-four hours there.[48]

In the end, he settled on Dieppe, where he moved into a modest hotel room opposite Saint-Jacques church, and he rented a large cottage with a pony and trap in the nearby holiday resort of Berneval for Julie and the children. But even though he was now spending a little more money for the comfort and entertainment of his family, his new affluence didn't go to his head. He was too conscious of being at the mercy of a possible health problem. In July he had a kidney infection for the first time, and the state of his eyes was still a constant source of concern. He was also well aware that the art market was unstable, and

that dealers and *amateurs* weren't always reliable. Despite excellent sales, he was a little suspicious of Durand-Ruel, "who seems to be playing a nasty trick on me," he wrote to Lucien: "He wasn't entirely correct after my exhibition and as business isn't good in Paris, it wouldn't surprise me."[49] And memories of the lean years were still very clear in his mind and would torment him until his dying day. When Lucien wanted to borrow a large sum from him to buy a house, Camille reminded him that he didn't have such reserves and he himself balked at borrowing: "I would have to pay interest for a number of years, I wouldn't be at peace! It's not like the loan I had from Monet, who didn't ask me for any interest, and you can surely imagine the anxieties I had paying back that sum. No, really, I can't go through that again."[50] What he wanted was to work in peace.

13

The Light Fades

Working in peace didn't mean insisting on being alone. It is impossible to overstate the fact that, despite quarrels and tensions, the Pissarro family was united by a shared obsession with art and the intense admiration that all the children had for their father. The pleasure Camille took in having them around never waned. He traveled often with one or another of them. Thanks to them, he kept in touch with the new generation: it is interesting to observe how, during these last years, Pissarro, the aging Impressionist, reacted to new trends. We have seen that he distanced himself from Gauguin when the latter veered toward Symbolism. Despite his hostility to the Nabis, he was still sufficiently curious to go to their exhibitions, particularly in Vollard's gallery. He loathed Pierre Bonnard's work (although he admired his illustrations of Verlaine) and expressed his opinion in a letter to Lucien with a vigor that shocks today: "All self-respecting painters, Puvis, Degas, Renoir, Monet, your servant are unanimous in thinking his exhibition at Durand's gallery hideous ... this symbolist is called Bonnard.... Besides,

it's a complete fiasco."[1] Unfortunately, he doesn't explain why he so violently rejects the younger man's art. He is no more taken with Francis Picabia, whom he met through Georges, who had befriended the young artist during a trip to the south of France and had then seen him again in Moret. It was probably there that Camille met him in 1901.

He was hardly impressed. Georges had told his father that Picabia had painted three fifteen-centimeter canvases in a day and believed "you succeeded only by doing quantities of them and flooding the market."[2] It is easy to imagine Pissarro's contempt for this theory and for the technique of a young man who painted studies from nature making no allowances for the air or the light and "who is starting his Salon painting: a two-meter canvas, having used the medium of photography to get a subject to suit him! Wonderful! What!!! And for that he'll receive a medal and be dubbed a great painter."[3] Equally scornful of Picasso, whose Blue Period canvases he most likely saw at a Vollard exhibition in 1901, he wrote in an undated letter to one of his protégés, Eugène Durenne, that Picasso's work had "neither candor nor sincerity and he's twenty years old."[4] By contrast, he warmly welcomed Matisse, who was two years older than his son Georges, and received him several times in Paris. One of Camille's most endearing characteristics is that very availability. He liked listening to and having discussions with younger people. The painter Charles Angrand, a contemporary of Lucien and a friend of Seurat, Signac, and Van Gogh, had often visited him during the final summer

spent in Dieppe, and in a letter to Fénéon he recalled how approachable the older man was. When friends and acquaintances met in cafés in the evening, he was "the soul of the conversation and he was always youthful, enthusiastic, and smiling [...he took pleasure in] extending a kindly hand to the young. He was the only one of that illustrious group to show such benevolence. Monet quickly cuts conversations short. Degas and Renoir are rather unapproachable."[5]

We can't be sure that Matisse showed Pissarro any drawings, at least Matisse doesn't mention this in memories he evoked more than forty years later. However, he did stress the older man's kindness—saying he seemed "extremely likable"—and how interesting his conversation was. On one of his visits, Matisse asked Pissarro what an Impressionist was. "An Impressionist is the artist who paints a different picture every time, a painter who never produces the same picture twice," Pissarro replied. "Sisley for example. Cézanne isn't an Impressionist. He's a classical painter who has only ever done grays. He has painted the same painting his whole life. He didn't do sunshine. He only did gray weather. He always did the same thing." Matisse never forgot these comments but concluded that Pissarro himself did not remain an Impressionist according to his own definition: "I think that Pissarro is no longer, was no longer an Impressionist, because there is a stability in his paintings, a peacefulness that is the product of contemplation."[6] Such a pertinent observation makes it all

the more disappointing that we don't know what Pissarro thought of this very perceptive artist.

But it is clear that in his final years Pissarro was primarily interested in his sons' artistic development, and this interest was reciprocated. The young men were very familiar with their father's oeuvre, and he proved he had faith in them by frequently asking their advice about which works to exhibit. All the indispensable physical work had become difficult for him, and he was grateful that his sons took charge of packaging and transport and helped with hanging the work. Still more important, Lucien went to great lengths to organize an exhibition of his father's engravings in London and wanted to produce a catalogue raisonné to go with it. The sons' admiration for their father never diminished. How not to be moved by this letter from a forty-year-old Lucien to his father: "What I want more than anything else is to do a bit of work with you, without you Eragny wouldn't show me the way. Perhaps you think I should work alone: all that's very nice for someone working as a painter but in my case I need help pulling myself together and I have a feeling that working with you would make a huge contribution to that."[7] Georges, although more independent, was still happy to welcome his father when he came to paint alongside him in Moret, and his enthusiasm for his father's work remained intact. He wrote to his brother Lucien from Dieppe in August 1902: "I was in Dieppe to see Tom and all the family who are spending the vacation bickering at the seaside. One

way of passing the time. Papa, though, worked hard, he did some wonderful painting: the harbor with all the bustle of the crowd and of boats coming and going, the smoke trails etc...etc...it's terrific, it's more beautiful than last year's churches."[8] There is less written evidence of Rodolphe's admiration for his father—their letters are often about Rodolphe's work—but he proved it beautifully by devoting several years of his life putting together the catalogue raisonné of Camille's work, an indispensable resource for any study of his oeuvre.

With his prices remaining high, Pissarro spent the summers of 1901 and 1902 in Dieppe. In July 1901 he took a room in the Hôtel du Commerce, which meant he was close to the family who had returned to Berneval. "I shall have a room overlooking the market, to the left I have the doors of the Saint-Jacques church."[9] This solution guaranteed the peace he needed to work while allowing him a break from solitude when he stopped briefly. His room was small but within a week of moving in he already had several paintings underway. Unlike Monet, he didn't concentrate solely on the façade of the church but enjoyed contrasting the movement of the crowd, the temporary shacks of a fair set up on the square, and the weekly market stalls with the powerful immutability of the Gothic building whose details and bold presence always earned his admiration. These paintings bring together his taste for Gothic style and his long-standing predilection for markets. He completed nine paintings, six of which Durand-Ruel would

buy, as well as a large number of gouaches that the Bern-
heims, who were entertaining the idea of mounting an ex-
hibition of them, had asked him to paint.

He spent the winter at place Dauphine, where he
painted twenty-six canvases that constitute his second
Vert-Galant series. In February 1902, a joint Monet-
Pissarro exhibition at Bernheim's enjoyed great critical ac-
claim, which was all the more heartening to him because
Monet had overtaken him some time ago in attracting
buyers and, above all, securing much higher prices. In July
1902 Pissarro returned to Dieppe a third time and slipped
back into what was now a routine. This time he abandoned
the church in favor of the harbor. "Dieppe is an admirable
place for a painter who likes life, movement, and color. I
have friends here and I know the subjects that I would like
to paint."[10] He returned to the Hôtel du Commerce because
he was satisfied with it, and he liked its good, uncompli-
cated food, but he took a second room under the Arcades
de la Poissonnerie, in the first place to have a different
view—the 1902 series focuses on the outer harbor, the
harbor itself, and the fish market—and also to have a little
more space when the family came to spend the July 14
holiday with him. A photograph shows him outside Saint-
Jacques Church surrounded by family members: Georges
with a cigar in his mouth and a canvas under his arm, and
Rodolphe very elegant in his vest, white tie, and boater.
The young men look relaxed, unlike Julie and Alice Isaac-
son (who came with Georges's young son Tommy)—a pair
of sullen matrons dressed entirely in black. Jeanne, on the
other hand, is very chic in a pretty white hat. No one looks

particularly cheerful, and not one member of the family is making any effort to stand out by adopting an artist's style. This was most likely Julie's influence; appearances were no trifling matter to her. Once the family had left, Pissarro went back to the grindstone and worked tirelessly until the end of September.

A shadow was cast over his return to Paris by the terrible news that Zola had died, asphyxiated by carbon monoxide from a blocked chimney. He was buried on October 3, 1902, but Camille did not feel strong enough to follow the procession only a day after returning, so Georges represented him. And then Pissarro's perennial anxieties started up again: refusing to be intoxicated by his success, he was worried about exceeding his credit with Durand-Ruel before his series was sold. In fact, Lucien's October allowance emptied his account, and he told the children they would have to reduce their spending. He explained to Lucien that he didn't anticipate any good news: "Durand and Bernheim have an agreement, and therein lies the danger that I so feared when they both kept urging me to sell to them. If I can stand firm, I will.... As for *amateurs*, they are annoying me; even friends are the first to want to push down my prices, I'm having to stand up to all of them."[11]

Georges's financial affairs were in an awful mess and, even though Camille promised he wouldn't leave him with no money at all, he did point out that this was a very critical time "and the funds [that he] could keep safely aside would have to be shared out extremely sparingly."[12] He wrote to Lucien again: "I have such responsibilities that

this will be difficult for all of us. Obviously, Durand needs me, otherwise he wouldn't twist and turn so much before cutting me off in five secs without any hesitation. I can hardly rely on private buyers either." And he picked apart the mechanism of which he was a victim: "I might have a glimmer of hope from Germany where, apparently, I'm very well known, but on the other hand I know that I'm up against Durand's enemies, who do everything they can to minimize my popularity by offering my work at low prices, like back in the day when some big Paris dealers sold paintings at a loss to establish their own position and sink Durand."[13]

His friend Dr. Elias, a Berlin art critic and translator of Ibsen, confirmed this notion. Elias had very close ties with the major Berlin dealer Cassirer, and he told Pissarro of a conversation the latter had had with Georges Durand-Ruel: "At the moment, trade in Monets is running low because you can't get hold of exceptional quality Monet paintings. Mr. Durand, both father and son, believe that Pissarro's paintings will go up in the foreseeable future...the time will soon come when the Durands raise the price on your work and they think the prices...will more or less reach Sisley's [level]. Those are Georges D's actual words.... Here's my opinion: Durand senior kept you waiting to make you cooperate and to secure favorable prices for himself."[14] Elias also implied that Cassirer and Durand had an agreement, and it would be wise not to be too open with the former.[15] These letters demonstrate that, on the one hand, Pissarro had a strong grasp of the workings and the complexity of the art market and, on the

other, continued to contemplate financial difficulties with equanimity.

In spite of these problems, two of his paintings were sold at the Louvre, but this was not enough to reassure him. Pissarro continued to support and spoil his children, never significantly cutting their allowances, and taking pleasure in sending Rodolphe a pâté de foie gras when he was in Nice for the New Year celebrations.[16] More tellingly, he was sufficiently confident to refuse the prices Durand-Ruel offered for his Dieppe series. One solution was to turn to the young dealer Félix Gérard, who was taking over his father's business. Encouraged by Gérard's overtures, Pissarro held out: "Durand and Bernheim having refused to take my paintings at prices I named, and my having received a visit from a new dealer asking to buy from me, I seized the opportunity and sold the whole series for a good sum. What particularly made up my mind was the chance that this provided for me to get out of Durand's clutches when he was not only insisting on a monopoly for his own advantage but also insisting on his prices, claiming that my work was unsalable."[17]

Until his death, Pissarro was torn between not wanting to rely exclusively on Durand-Ruel and wanting to achieve enough security to abandon himself to his art with perfect freedom. The two men explain their views clearly: Pissarro was infuriated that Durand-Ruel had sold one of the *Place du Théâtre-Français* series for four thousand francs, having bought it from him for fifteen hundred, and wrote him to say that this seemed unfair; Durand-Ruel defended his actions, saying that he could sell only one in twenty of

Pissarro's paintings and that it was only the steady sales of old masters or artists of the 1830 School that allowed him to buy work that he might be able to sell some time in the future. "I can assure you," he concluded, "that it takes courage to keep doing what I do rather than following the example of dealers who buy only what is fashionable and therefore easy to sell."[18] They continued like this, not listening to each other, right up until Pissarro's final days. His last exchange with Durand-Ruel was distressingly cold. Goaded by his notary, who had little understanding of the dynamics of the art market, Pissarro still wouldn't back down on his prices. The last letter sent to Durand-Ruel indicates a definitive break: "Dear Monsieur Durand-Ruel, I do not accept the prices that you offer in your letter of 16 inst. / I regret this endlessly. / Your devoted."[19] He informed Elias of his decision and was thrilled to be getting back to work. "How hard and absurd life is," he confided.[20] These never-ending discussions exhausted him and stole the time he needed for painting.

And so he returned to work, renting a hotel room on the quai Voltaire between the bridges Pont du Carrousel and Pont-Royal to give some variety to his views of the riverbanks and of the Louvre for his spring 1903 series. Once the series was finished, he started worrying about his summer series and wanted to return to the coast in Normandy. When Lucien asked him why, he replied: "Quite simply because I prefer Normandy, it's a short hop from Paris and Eragny and I need to think about satisfying my *amateurs*. You know that the subjects are completely secondary to me: what I think about is the atmosphere,

and the effects. Anything at all will do for me. If I had my own way, I'd stay in the same town or village for years on end, unlike plenty of other painters. In the same place I end up finding effects I didn't know about and hadn't attempted or achieved successfully."[21] A long article in *Le Temps* returned to his evolution:

> Pissarro was unpopular for a long time. His unpopularity was all the more persistent because of his way of dividing up colors, accentuated by the harshness of tone and the harshness and lack of grace of his figures. No one did justice to his great draftsmanship and the sincerity of his interpretation. Fashion has changed since then. We have developed a taste for the truth, and this has turned attention back to him. Now he too is seen as a master.... The interest he has aroused with his recent work will not be contradicted by the pieces he is currently exhibiting, pieces that continue the series with more authority: the Pont-Neuf, the banks of the Seine along the Louvre, in the fog, under gray skies, in the rain; views of Dieppe in particular are astonishingly high in color, overflowing with life, and churning with the bustle of a multicolored crowd. Fine work from an artist and someone who knows his trade.[22]

This is all very true but doesn't explain why a Pissarro is a Pissarro and why his views can't be mistaken for those of his fellow artists. The subject of the painting—the aspect that jumps out at any observer—is not what mattered most to Pissarro. The key for him, and herein lay the

difficulty, was to establish the connection between the different elements: sky, terrain, water, walls, and human figures. There had to be a connection between them, but it needed to be found and then portrayed. He persisted with this research even when he changed his style, as his son Lucien pointed out in 1903: "It is astonishing how it all holds together. The early paintings, the Pontoise series, the paintings that are systematically pointillist, and the recent pieces, when you see them all together, they form a whole.... Whatever way and under whatever influence your paintings are done, they always have that search for closely associated values which is the great fundamental characteristic of your art."[23]

In the end, Pissarro chose Le Havre. He confessed that he would have been just as happy staying in Eragny, but the house was full of children: "I wouldn't have had a bed and then there is the cooking pot for which I'm responsible. And a cooking pot is not to be taken lightly."[24] He was therefore in Le Havre, alone, to celebrate his seventy-third birthday, and he admitted in a letter to Rodolphe that he was feeling his age: "I really wanted to do some trees, houses, lost villages, but it's difficult to get set up. I'm too old to go far in search of what I want. I'll stay here, I'll paint the comings and goings of ships...the harbor at Le Havre isn't very aesthetic, but you get used to it and end up seeing it has a lot of character."[25] This doesn't betray his usual enthusiasm, but then he was disappointed—outraged even—by a short stay at the Hôtel Saint-Siméon in Honfleur, an establishment with a glorious past that had inspired Boudin, Corot, Cals, Daubigny, Monet, and

Jongkind. "It's hideously spruced up," he reported to Lucien, "with straight sandy alleys, you can see the sea only from the dining room...in a word it's laid out for the English who flock here."[26] And so he set up his easel at the Hôtel Continental, a large comfortable establishment on the quay. It's difficult for biographers to overlook what lies ahead. We know that Pissarro was coming to the end of his life and this stay at Le Havre—as Joachim Pissarro, his great-grandson, pointed out with acuity—brought him full circle, because it was in fact in Le Havre that the eleven-year-old Pissarro had landed from Saint Thomas to complete his education in France. He had not traveled on one of the steamers that busied back and forth in the cove in 1903 but on a sailing ship. As if to emphasize this convergence, a terrifying storm swept through the harbor during Camille's final stay, reminding him of the hurricanes on the island where he was born.

He chose a room with a balcony from which he could see the jetty and the pilot boats' cove and simply study the variations of light playing on the outer harbor. Passersby sometimes spotted him at his open window wearing his cap, his gray cotton smock, and his leather sandals. When the weather was really too bad for him to work, he would go out, and people admired this fine-looking old man whose beard "was silvered like a stream in April."[27] His work in Le Havre engrossed him. As usual, he had several paintings underway, some for gray rainy weather, others for sunshine. He had brought two chests with sliding drawers to his room to store his canvases, and he stayed glued to the spot, forced to be on the lookout to capture abrupt changes in visual

effects. He thought he might manage to finish a dozen paintings in six weeks. He actually completed eighteen. He was concerned about the major building projects being carried out: the old port was being demolished with pickaxes and explosives and modernized, but he was interested in everything that would be lost—the bastions, breakwaters, and jetties—and raced to preserve their image. The historical and documentary aspects of these paintings was so clear that he sold some to the museum in Le Havre, which wanted evidence of the past; unfortunately, he sold them at a discount, but thought they could possibly attract other buyers. He realized he might have done better not to rush to sell, but he was so short of money he couldn't afford to turn down offers.

The season came to an end, and he prepared to move into 1 boulevard Morland, near the Bassin de l'Arsenal in Paris, having thoroughly exhausted subjects around the place Dauphine. He left Le Havre on September 26 with little confidence for the future after a visit from Georges Bernheim, who had complained that business was bleak. He announced his return to Julie in a brief letter of September 24. It was to be the last known letter of his long correspondence. The previous year he had been unable to follow Zola's funeral cortège. This year he attended a meeting for friends of Zola organized at the writer's home in Médan by Maurice Leblond, a journalist for *L'Aurore* who would go on to marry Zola's daughter in 1908. The reception was held on September 29 in the villa's garden, and we are indebted to Leblond for this fine last image of Pissarro, which the journalist wrote in his obituary:

I shall always remember [Camille Pissarro], in Zola's garden, conversing amid a large group of friends, smiling gently, standing fair and square in his huge Rembrandt-style felt hat, its wide brim shading his face. Nothing in his apparent sturdiness could have led anyone to suspect the illness which, a few weeks later, would definitively prevail over his vigor. People pointed out the stately physiognomy of this splendid old man whose beard flowed dazzling and snowy, but what impressed above all were his eyes, his shining eyes which had remained youthful, their liquid blackness twinkling beneath formidable eyebrows that had grown out like bushes.[28]

Two days later, on October 1, Pissarro felt unwell. He was in the Hôtel Garnier at the time, waiting to move. The homeopathic doctor Léon Simon, who had cared for him and his entire family since 1882, initially thought he had influenza, but his condition deteriorated very rapidly. On October 10, Julie added a few lines to a letter from Rodolphe to Lucien, providing alarming details although she remained optimistic. "Your poor father has just had a terrible week, suffering like a condemned wretch with pain in his bladder. Doctor Simon feared a tumor or stones. . . . A specialist came today and said there was nothing dangerous, he's very calm and has stopped crying out since being examined."[29]

Dr. Simon's incompetence bordered on the criminal. He didn't even lift the blankets to examine the poor patient, whose pain returned. Several factors contributed

to the catastrophe: his children's inability to take decisive action, Julie's panic, and the confusion caused by the move to boulevard Morland, where Pissarro was taken on October 27. The pain became unbearable: when he hadn't fainted, Camille screamed from pain. In this state of delirium, he was still tormented by anxieties about lack of money and worried about the sale of his Le Havre series. He was also still haunted by the loan he had taken from Monet to buy his house—a debt that had long since been repaid—and somehow found the strength to write him a note on the subject. Monet was made aware of how serious the situation was and replied, reassuring Camille with his characteristic kindness. We can't be sure that Pissarro was even able to read this letter. Boulevard Morland was a scene of turmoil; no one had sufficient authority to make decisions and hold to them. A procession of doctors visited. The oculist Dr. Parenteau brought in a specialist, Dr. Estraban, who identified an inflammation of the prostate gland; the Bernheims recommended a Dr. Guyon, who diagnosed cystitis. But Dr. Simon, who was still in charge, continued his tergiversations and consulted with his fellow doctors but kept the family out of these muttered conversations. A letter from Rodolphe to his brother Lucien gives a gauge of their distress and uncertainty: "What to do? Should we change doctors?" He hesitated to ask Lucien to come for fear of disturbing and worrying the patient until Parenteau recommended that he do so. Eventually a surgeon came and drained an abscess on November 11. Too late, the infection had spread. Lucien arrived that same day. And, surrounded

by his whole family, Camille Pissarro died two days later, on Friday, November 13, 1903.

The funeral took place two days later, on the Sunday, a civil ceremony, it goes without saying, during which no speeches were made. There was a long procession that included old friends and comrades: Monet and Renoir; his dealers the Bernheims, Georges Durand-Ruel, and Vollard; the sculptor Paul Paulin, who posthumously made his bust; his writer and critic friends, Octave Mirbeau, Théodore Duret, and Félix Fénéon; his *amateurs* from the early days, the dentist Georges Viau, the baritone Jean-Baptiste Faure, Gustave Kahn, and many others besides. There may have been no speeches, but there were a great many articles in the Paris press as well as regional newspapers. Signac couldn't bring himself to write an article for the anarchist newspaper *Les Temps Nouveau* in time: "I'm really too overcome by the death of poor 'père Pissarro' to write with a cool head about this splendid man and great painter, in the very week of his funeral."[30] There was a spate of homages in England, Germany, Austria, and the United States. The Durand-Ruel gallery in New York exhibited some forty of Pissarro's paintings in his honor.

Thanks to Camille's and his notary's foresight, his estate provoked no recriminations. It was to be divided, as planned, into two equal parts: the first would go to Julie and the second would be divided into six shares between Julie and the five children. These shares would be distributed by drawing lots. The valuing of his paintings—a

task that was both sensitive and vital—covered not only Pissarro's own work but the art in his collection, which included several Cézannes, a Corot, three Manets, and various works by Jongkind, Monet, Renoir, Degas, Morisot, Cassatt, and Van Gogh. In order to avoid conflicts of interest, the family did not retain Durand-Ruel and the Bernheims, the experts whom Pissarro had chosen, but asked his loyal friend Monet to determine the contents of each share. The older sons would clearly have liked to convert these assets into money as quickly as possible, but Monet advised them to be extremely cautious. He wrote to Lucien:

> I think it would be very dangerous, now that each of you has his share, his share of your father's paintings, if you sought either loans or sales and I'm very afraid that by so doing you will diminish their value.... Evidently, I do not intend to put your mother's share up for sale.... If you make this division and each of you sells separately, I would be afraid of a substantial depreciation. I say all this extremely frankly. I am not a businessman, so I could be wrong to beg you in the name of all of your best interests to think carefully and consult your father's notary.[31]

At the end of the year, he informed Julie about the overall state of affairs. He suggested making the most of a widespread craze for Cézanne by selling any of his work but without backing down on price, and not to go any further with plans for a sale of Pissarros without talking

to Durand-Ruel. He was always friendly toward her and shrewd, offering very good advice. He remained loyal to her to her death (they both died in 1926), expressing his distress in a 1917 letter to Lucien that she was so isolated and, in 1922, sending her his own doctor when he was concerned about the care she was receiving.

Above all, Monet busied himself with the major retrospective that the family arranged at Durand-Ruel's gallery; it brought together 134 oils and more than 40 gouaches, pastels, and drawings. Although Paul Durand-Ruel stood aside from the organization of this tribute, yielding his place to Pissarro's sons, he not only put his premises at their disposal but also loaned them some fifty works that he owned. The late parting of ways between Durand-Ruel and Pissarro and the cooling of relations between him and Julie and her sons did nothing to stop his continued energetic support of the man he had represented for so many years and from whom he had bought one-third of his output. When the artist died, one-half of his stock at the gallery remained unsold, but Durand-Ruel and his sons continued buying everything that came on the market. They acquired some 170 works after 1903 and continued to lend to various exhibitions. They mounted six solo exhibitions in Paris between 1908 and 1961 and ten in New York. So this collaboration continued after Pissarro's death, and few would be left unmoved by the touching revelation an elderly Durand-Ruel later made to the writer Georges Lecomte: "I have always imagined the paradise that I believe in—as you know, my dear friend—as having the sweetness of a landscape by Corot or Pissarro."[32]

Epilogue

Dead forever? At the end of the biography of an artist, how can one avoid thinking of this question that Proust's Narrator asks himself upon the death of the writer Bergotte? How to not answer in the negative, thinking of the destiny of Pissarro's oeuvre and of his posterity? Painting and bringing up his children constituted the two poles of his existence. Thanks to his astonishing energy and willingness to make himself available, he never sacrificed either one for the other, and the positive result of his hard work didn't dwindle after his death. What success he had enjoyed in his lifetime never stopped growing, and although his children, grandchildren, and great grandchildren never achieved the same renown, they continued to make his name shine in the world of the arts.

The elder sons pursued their own careers. Lucien, who was closest to his father, built a commendable reputation as a Neo-Impressionist painter while still working as an engraver and publisher. An exhibition of his books was held at the Grolier Club in New York in 2007. Georges, who was known as Manzana, took more of an interest in the

decorative arts but never stopped painting successfully and being included in major exhibitions. Ludovic-Rodolphe exhibited with the Fauves and devoted many years to preparing his father's catalogue raisonné. The youngest, Paul, was just twenty when his father died, and the blow was hard on him. Although he had always been close to his father, he was too young to have benefited from his advice and criticism as his older brothers had and would have been left to fend for himself had he not been able to turn to his guardian, Claude Monet, who always encouraged and advised him affectionately. He in turn achieved success under the name Paulémile and as early as 1905 was shown in the Salon des Indépendants and was successful in the United States. He remained very attached to the memory of Monet. Paul's grandson Joachim remembers two photographs in different rooms in his grandfather's house—one of Pissarro and the other of Monet—and as a small boy he'd been convinced that both of them were his great-grandfathers. A passion for painting was still evident in the generation of Camille's grandchildren: in Lucien's daughter Orovida, in Paulémile's son H. Claude, and in Jeanne's son Claude Bonin-Pissarro. The fourth generation kept up the tradition with Jeanne's grandson Fréderic Pissarro and Paulémile's granddaughter Leila (whose first teacher was her grandfather Paulémile); and then Leila's daughter Lyora represents the fifth generation of Pissarros to be devoted to a career in art.

But so far, true glory has remained the preserve of their forebear. Certainly, Pissarro isn't an easy painter; his art requires prolonged and attentive viewing. It takes a

practiced eye to spot the silhouettes huddled in the shade of a wood, to appreciate the variations in light filtering through the rain or foliage or, conversely, dazzling in full sun, to discover the unexpected subtlety in the surface of a painting made up of a magma of colors and textures, or grasp at once the overall effect of a landscape in which every individual element is important. This process also requires a lot of concentration from the viewer. To use his expression, a passerby giving a cursory glance couldn't appreciate him. Besides, the complexities of an oeuvre that he kept developing and fine-tuning often disconcerted buyers. Among the general public, there is a sort of unofficial classification of Impressionist painters in which Pissarro's popularity usually comes in below Degas's, Cézanne's, Renoir's, and Monet's. An inept classification, according to Cézanne, who said: "We may all come from Pissarro.... Yes, he was the first impressionist."[1] That is the man I have tried to bring to life.

Acknowledgments

I am immensely grateful to Joachim Pissarro, who responded to my project with great generosity, and over several virtual exchanges answered all my questions with patience and precision.

I am very fortunate to have Judith Gurewich as both my publisher and my editor. Her sharp comments are invaluable, and her enthusiastic support of this project the best stimulant. Georges Borchardt, my agent of many years standing, has been equally encouraging.

Many thanks to Susan Galassi, Colin Bailey, and Alan Wintermute for their interest and suggestions.

Thank you, Stacey Plaskett, delegate to the United States House of Representatives from the United States Virgin Islands, who shared generously her knowledge of Saint Thomas's past.

The manuscript would not have turned into a book without the help and the attentiveness of Janice Goldklang, Yvonne Cárdenas, Iisha Stevens, Alexandra Poreda, and Gage Desser. My warmest thanks to the whole team.

I am also grateful to Dominique Bourgois, one of my first readers, who offered many interesting insights.

And thank you to my children and stepchildren, Anne Bazin, Adam Begley, Robert and Stéphane Dujarric, who read the manuscript and urged me to forge ahead. Thank you also to my granddaughter, Isabella, who listened and questioned during our long COVID walks.

As for my husband, Louis Begley, he cheerfully read, and reread, and read yet again, corrected, and improved. To him I dedicate this book, which would not have been written without his loving support.

Chronology

1830
Birth of Camille Pissarro on July 10 at Charlotte Amalie, the capital of Saint Thomas, an island in the Danish Virgin Islands, second son of Frédéric Pissarro and Rachel Pomié Manzana. Rachel had two daughters, Delphine and Emma, from a previous marriage.

1842–1847
Pissarro and his brother Alfred in France, boarding at the Institut Savary in Passy.

1847
Pissarro returns to Saint Thomas, where he works in his father's business.
The abolition of slavery in the Danish Virgin Islands.

1848
Revolution in France.
The fall of the July Monarchy and establishment of the Second Republic.

1851
Louis-Napoléon Bonaparte coup.
Author Victor Hugo is exiled.

1852–1854
Pissarro's trip to Venezuela.
Establishment of the French Second Empire.

1855
Pissarro leaves for Paris, where the entire Pissarro family gathers.
French Exposition Universelle (World's Fair).

1856
Pissarro meets Corot.

1857
Flaubert's trial for outrage to public morality.
Publication of *Les Fleurs du mal* and Baudelaire's trial.

1859
Pissarro exhibits at the Salon.
He befriends Claude Monet and Ludovic Piette, and then Paul
 Cézanne and Armand Guillaumin.

1860
Pissarro falls in love with Julie Vellay.

1862
Pissarro becomes friends with Frédéric Bazille, Auguste Renoir,
 Alfred Sisley, and Emile Zola, and then with Edgar Degas. He
 sets up home with Julie Vellay against his parents' wishes.

1863
Birth of Pissarro's first son, Lucien.
Pissarro moves to La Varenne-Saint-Maur.
He participates in the Salon des Refusés, where Manet's *Le Déjeuner
 sur l'herbe* causes a scandal.
Death of Delacroix.

1864
Pissarro exhibits at the Salon.

1865

Death of Pissarro's father, Frédéric.

Birth of his first daughter, Jeanne.

He exhibits at the Salon.

He works *en plein air* with Renoir and Sisley.

Richard Wagner composes *Tristan and Isolde*.

1866

Pissarro settles in Pontoise.

He joins in gatherings at the Café Guerbois and meets Edouard Manet.

He starts planning an exhibition for the group.

1868

Death of Pissarro's sister Emma. He travels to London for the funeral.

1869

Pissarro moves to Louveciennes.

He works *en plein air* with Monet and Renoir.

1870

Franco-Prussian War.

Fall of the Second Empire and proclamation of the Third Republic.

Pissarro, his partner, and children take refuge with Piette in Brittany.

Birth and death of his third child, Adèle-Emma.

He goes into exile in England, where he joins his mother and brother.

Bazille dies on the battlefield.

1871

Pissarro marries Julie Vellay.

He meets Paul Durand-Ruel.

Armistice on January 28.

The Treaty of Frankfurt brings an end to war on May 10.

Insurrection of the Commune (March–May).

Pissarro returns to France in September.

Birth of his fourth child, Georges.

1872

Start of Pissarro's collaboration with Durand-Ruel.

He returns to Pontoise.

Cézanne works with him and other painters (Béliard and Guillaumin).

1874

Death of Pissarro's daughter, Jeanne.

First Impressionist exhibition.

Birth of his fifth child, Félix, known as Titi.

1876

Second Impressionist exhibition.

1877

Third Impressionist exhibition.

Death of Gustave Courbet.

1878

Birth of Pissarro's sixth child, Ludovic-Rodolphe.

1879

Fourth Impressionist exhibition.

Paul Gauguin comes to paint with Pissarro.

Death of Honoré Daumier.

1880

Fifth Impressionist exhibition.

Pissarro collaborates with Degas and Mary Cassatt on engravings.

Boer War.

1881

Sixth Impressionist exhibition.

Cézanne, Gauguin, and Guillaumin work alongside Pissarro for the summer.

Birth of his third daughter, Jeanne, known as Cocotte.

1882

Seventh Impressionist exhibition.

Cézanne's last summer working alongside Pissarro.

Foundation of the Union des Arts Décoratifs.

Opening of the Ecole du Louvre.

1883

Pissarro's first solo exhibition held by Durand-Ruel.

His eldest son, Lucien, leaves for London.

Pissarro works in Rouen through October and November.

Death of Manet.

1884

Pissarro moves to Eragny-sur-Epte.

Birth of his eighth and last child, Paul-Emile.

Serious cholera epidemic in Paris.

He subscribes to the socialist newspaper *Le Prolétaire*, an "organ for social demands."

1885

Start of the Impressionists' dinners.

Pissarro meets Paul Signac, then Georges Seurat.

First studies using pointillism.

He befriends the anarchist Jean Grave and subscribes to his newspaper, *Le Révolté*.

Death of Victor Hugo.

1886

Eighth and last Impressionist exhibition. Only Pissarro and Degas exhibited in all eight exhibitions.

Durand-Ruel opens his first exhibition in the United States.

Pissarro meets Vincent van Gogh and Octave Mirbeau.

Publication of Zola's *L'Œuvre* (*The Masterpiece*).

1887

Exhibition at Georges Petit's gallery.

Durand-Ruel sets up a subsidiary in New York.

Theo van Gogh becomes interested in Pissarro.

1888

Pissarro moves away from pointillism.

His first eye infection.

Death of his mother.

1890

Pissarro completes the series of drawings *Les Turpitudes sociales*.

Death of Vincent van Gogh.

1891

Death of Theo van Gogh.

Death of Seurat.

Nine people are killed and thirty-five wounded when troops fire on
 workers during demonstrations in Fourmies on May 1.

1892

Pissarro's first retrospective exhibition at Durand-Ruel's gallery.

Lucien marries Esther Bensusan.

Georges marries his cousin Esther Isaacson.

Edouard Drumont launches *La France juive*, an anti-Semitic nation-
 alist newspaper.

Anarchist bombings. Ravachol is guillotined.

French miners' strike.

1893

Birth of Georges's son Tommy, whose mother, Esther, dies two days
 later.

Birth of Lucien's daughter Orovida.

First series of *La Place de la Gare Saint-Lazare*.

1894

Exhibition at Durand-Ruel's gallery.

Pissarro meets Ambroise Vollard and encourages him to exhibit
 Cézanne.

June: after the assassination of Sadi Carnot, Pissarro leaves France
 for Belgium. He returns in September.

September: Beginning of the Dreyfus affair. Captain Alfred Dreyfus is found guilty of treason in December.

Death of Gustave Caillebotte who bequeathed his collection to the French nation.

1895

Exhibition of Monet's series *Les Cathédrales de Rouen*.

Alfred Dreyfus publicly stripped of his rank and deported to the penal colony on Devil's Island.

Gauguin travels to Tahiti.

Death of Berthe Morisot.

1896

Two extended trips to Rouen.

March: A telegram (*le petit bleu*) from the Prussian military attaché Schwartzkoppen to Ferdinand Esterhazy is intercepted.

August: Lieutenant Colonel Georges Piquart establishes similarities between Esterhazy's handwriting and the writing on the letter that condemned Dreyfus.

November: Bernard Lazare sends his pamphlet *Une Erreur judiciaire: la vérité sur l'affaire Dreyfus* (A legal mistake: the truth about the Dreyfus affair) to thirty-five hundred people.

1897

Pissarro completes his second series of *La Place de la Gare Saint-Lazare* and his *Boulevard Montmartre* series.

May–July: Lucien is unwell, and Pissarro spends this time in England.

November: Death of his son Félix.

1898

Pissarro works on the *L'Avenue de l'Opéra* series and the *La Place du Palais-Royal* series, and the former is exhibited at Durand-Ruel's gallery in June.

Extended trip to Rouen.

January: Zola publishes *J'accuse* in the daily *L'Aurore*. Pissarro gives him his support.

January: Zola's first trial.

July: After his second trial, Zola goes into exile in England.

August: Colonel Henry admits authorship of the false document that condemned Dreyfus and dies by suicide.

September: Esterhazy flees first to Belgium, then to the United Kingdom.

1899

Pissarro rents an apartment on rue de Rivoli and paints his *Le Jardin des Tuileries* series.

Death of Sisley.

June: The Cour de Cassation (court of appeal) overturns the verdict of Dreyfus's 1894 trial, and Dreyfus is summoned to appear before a Council of War in Rennes.

June: Zola returns to France.

July: Dreyfus returns to France.

September: Dreyfus is found guilty with attenuating circumstances by the Council of War. He is sentenced to ten years' imprisonment and accepts the pardon offered by the French president.

1900

Pissarro spends the summer in Dieppe.

He leaves rue de Rivoli for place Dauphine at the end of the year.

April–October: Exposition Centennale (World's Fair).

1901

Pissarro returns to Dieppe.

In Paris, he paints the first series of *Le Square du Vert-Galant* and of *Le Pont-Neuf.*

February: Exhibition of women painters and sculptors at the Grand-Palais.

1902

Pissarro returns to Dieppe for the third time.

He refuses to sell to Durand-Ruel, not satisfied with the prices he is offering.

He continues his series of views of the place Dauphine.

September: Death of Zola.

1903

Pissarro spends the summer in Le Havre.

He has to leave place Dauphine for boulevard Morland in early
 November.

He attends the reception for the anniversary of Zola's death.

He falls ill on November 2.

He dies on November 13.

1926

Death of Julie Pissarro.

Endnotes

Introduction

1 *Correspondence de Camille Pissarro*, ed. Janine Bailly-Herzberg (Presses Universitaires de France, 1980), I, p. 252 (hereafter cited as *Corr.* with volume number and page).

2 *Corr.* II, p. 270.

3 The first volume, *1865–1885*, was published by Presses Universitaires de France; the four subsequent volumes by Editions Valhermeil.

4 *Corr.* II, p. 270.

5 *Corr.* I, p. 387.

6 Emile Zola, *Le Messager de l'Europe* (1876).

I: Saint Thomas–Paris–Saint Thomas Round Trip

1 Thodoor de Booy and John T. Farris, *The Virgin Islands; Our New Possessions and the British Islands* (Philadelphia and London, 1918), p. 54, quoted by Isaac Dookhan, *A History of the Virgin Islands of the United States* (Caribbean Universities Press, 1974).

2 For Saint Croix, see Dookhan, *A History of the Virgin Islands*, p. 44.

3 *Digital Encyclopedia of European History* (Université de la Sorbonne).

4 Jean-Pierre Poussou, *Les Étrangers à Bordeaux à l'époque moderne, Annales de Bretagne et des Pays de l'Ouest*, 2010.

5 National Register of Historic Places Program: St. Thomas synagogue—Beracha Veshalom Vegemiluth Hasadim, Charlotte Amalie, Virgin Islands.

6 Joachim Pissarro and Stephanie Rachum, *Camille Pissarro: Impressionist Innovator* (The Israel Museum, 1995), p. 21.

7 After the brief British occupation that ended in 1815, English became the dominant language on the island where Danish, French, Spanish, Italian, Gaelic, Dutch, and a hybrid language, Dutch Creole, were in common usage.

8 Anne Thorold, ed., *The Letters of Lucien to Camille Pissarro, 1883–1903* (Cambridge University Press, 1993), p. 26.

2: Rudderless Adventure in Venezuela

1 *Corr.* I, p. 123.

2 *Corr.* V, p. 29.

3 *Corr.* IV, p. 503.

3: Paris: One-Way Ticket

1 Ralph E. Shikes and Paula Harper, *Pissarro: His Life and Work* (Horizon Press, 1980), p. 35.

2 *Corr.* I, p. 79.

3 *Corr.* III, p. 368.

4 Unpublished letter of November 20, 1901, cited in Joachim Pissarro and Claire Durand-Ruel Snollaerts, *Pissarro: Critical Catalogue of Paintings*, 3 vols. (Skira Wildenstein Plattner Institute, 2005; hereafter cited as *Pissarro, Catalogue raisonné*), III, p. 857.

5 *Corr.* III, p. 251.

6 Paul Durand-Ruel, *Mémoires* (Flammarion, 2014), p. 19.

7 Shikes and Harper, *Pissarro: His Life and Work*, p. 39n.

8 *Corr.* III, p. 434.

9 *Corr.* III, p. 200.

4: A Mother, a Wife, and a Rather Different Family

1 She had had two slaves in Saint Thomas.

2 *Corr.* I, 288.

3 *Corr.* I, p. 61.

4 *Corr.* V, p. 297.

5 Shikes and Harper, *Pissarro: His Life and Work*, p. 60.

6 *Corr.* II, p. 245.

7 *Pissarro, Catalogue raisonné*, I, p. 119.

8 Letter of May 18, 1883, in Thorold, *Letters of Lucien to Camille Pissarro*, p. 22.

9 Henri Matisse, *Bavardages: les entretiens égarés* (Skira, 2017), p. 151.

10 *Corr.* I, p. 197.

11 Julie Manet, *Journal, 1893–1899* (Mercure de France, 2017), 1898 entry, p. 280.

12 Richard Brettell, *Pissarro's People* (Fine Arts Museums of San Francisco and the Sterling and Francine Clark Art Institute, 2011), p. 36.

5: The Group

1 *Corr.* III, p. 30.

2 *Corr.* I, p. 275.

3 François Thiébault-Sisson, "Claude Monet. Les Années d'épreuves," *Le Temps*, November 26, 1900, p. 3.

4 Letter to Baptistin Baille, June 1861, in Emile Zola, *Correspondance* (Les Presses de l'Université de Montréal, éditions du CNRS, 1978).

5 Edmond and Jules Goncourt, *Journal*, 3 vols. (Robert Laffont, 1989), I, p. 621.

6 Claude Monet, *Mon histoire* (L'Echoppe, 1998), p. 17.

7 Letter from Cézanne to Emile Bernard, 1905, cited by Denis Coutagne in Société Paul Cézanne, https://www.societe-cezanne.fr

8 *Corr.* IV, p. 504.

9 "Salon des Refusés," https://en.wikipedia.org/wiki/Salon_des_Refusés.

10 Barbara Ehrlich White, *Renoir* (Thames & Hudson, 2017), p. 26.

11 Frédéric Bazille, *Correspondance* (Les Presses du Languedoc, 1992), p. 136.

12 Letter from Bazille to his mother [late February 1867], in Michel Schulman, *Frédéric Bazille, 1841–1870, Catalogue raisonné* (éditions de l'Amateur, éditions des Catalogues raisonnés, Paris, 1995), letter 158, p. 354.

13 Zola, *Correspondance* (Université de Montréal et Editions du CNRS, 1978–80) I, p. 462.

14 Comments documented by Thiébault-Sisson, published in *Le Temps*, November 26, 1900, cited in Marc Elder, *Á Giverny, chez Claude Monet* (Paris, Bernheim-Jeune, 1924), pp. 48–49.

15 *L'Evénement*, May 20, 1866.

16 *Corr.* I, pp. 118–19.

17 *Corr.* III, p. 309.

18 Letter to Fantin-Latour, in Stanley Weintraub, *Whistler, a Biography* (Da Capo Press, 2001 [1974]), cited in Shikes and Harper, *Pissarro: His Life and Work*, p. 78.

19 *Corr.* IV, p. 55.

20 Letter from Bazille to his mother, dated April 2, 1867, cited in Société Paul Cézanne, https://www.societe-cezanne.fr.

21 Schulman, *Frédéric Bazille*, p. 356.

22 Unpublished letter cited by Shikes and Harper, *Pissarro: His Life and Work*, p. 69.

23 Paul Gachet, *Deux amis des impressionnistes, le docteur Gachet et Murer* (Paris, éditions des Musées nationaux, 1956), p. 1.

24 Zola, "Cahiers naturalistes" (1868), http.//item.ens.fr/les-cahiers-naturalistes

25 Théodore Duret, "Quelques lettres de Manet et de Sisley," *Revue Blanche*, vol. 18, March 15, 1899, *Corr.* I, p. 65.

26 *Corr.* I, p. 62.

27 *Corr.* I, p. 60.

28 P. Gsell, "La Tradition artistique française, I, L'Impressionnisme," *Revue Bleue*, March 20, 1892, p. 404. Cited in *Studies on Camille Pissarro*, ed. Christopher Lloyd (Routledge and Kegan Paul, 1986).

29 Renoir cited in Pascal Bonafoux, *Monet* (Tempus, 2010), p. 151.

30 The eldest, Pierre, appears to have died very young. To his honor, Renoir continued to take an interest in his daughter, Jeanne; he dealt with finding her an adoptive family and never stopped giving her financial support, but he never admitted her existence to the three sons he had later on with his wife, Aline. They found out about their half sister's existence at the reading of their father's will.

31 Théodore Duret, *Les Peintres impressionnistes, Claude Monet, Sisley, C. Pissarro, Renoir, Berthe Morisot*, (Forgotten Books, 2017), p. 24.

6: War, Exile, and a Fortuitous Meeting

1 Letter from Rachel Pissarro, dictated to her granddaughter Amélie Isaacson, cited in Société Paul Cézanne, https://www.societe-cezanne.fr. Rachel, whose spelling was shaky, often dictated letters.

2 *Corr.* I, p. 31.

3 *Corr.* I, p. 78.

4 Letter cited in extenso in Société Paul Cézanne, https://www.societe-cezanne.fr.

5 Frédéric Bazille, *La Jeunesse de l'Impressionnisme* (Flammarion, 2016), p. 196.

6 Denis Maurice, *Journal*, vol. 2, *1905–1920* (Paris, La Colombe, éditions du Vieux Colombier, 1957), p. 34. Cited in Société Paul Cézanne.

7 *Corr.* V, p. 283.

8 Paul Signac, *D'Eugène Delacroix au Neo-impressionnisme* (Paris 1921), p. 48.

9 *Corr.* V, p. 417.

10 P. Gsell, "La Tradition artistique française, I, L'Impressionnisme," *Revue Bleue*, March 20, 1892, p. 404.

11 *Corr.* I, p. 64.

12 Letter from Duret to Pissarro, Institut Néerlandais, Fondation Custodia, cited in Charles C. Frankiss, "Camille Pissarro, Théodore Duret and Jules Berthel in London in 1871," *Burlington Magazine* 146 (July 2004), pp. 470–72.

13 Paul Durand-Ruel, *Le Pari de l'Impressionnisme*, Catalogue for the exhibition at the Musée du Luxembourg, (Réunion des musées nationaux, 2014), p. 136.

14 Cited by Pierre Assouline, *Grâces lui soient rendues: Paul Durand-Ruel, le marchand des impressionnistes*, (Plon, 2002), p. 111.

15 Durand-Ruel, *Pari de l'Impressionnisme*, p. 37.

16 Assouline, *Grâces lui soient rendues*, p. 116.

17 Assouline, *Grâces lui soient rendues*, p. 117.

18 Cited in Société Paul Cézanne, 1871.

19 Letter from Mr. and Mrs. Eugène Ollivon to the Pissarros, dated "Louveciennes, this March 27, 1871," cited in Société Paul Cézanne.

20 *Corr.* I, p. 70; the original spelling can be seen in Société Paul Cézanne. For clarity, it is worth transcribing the letter: "you can come back to Paris quite safely, it's very calm, there aren't any riots, nothing, and best of all, food is now back to what it was before the war, except your house is uninhabitable."

21 *Corr.* I p. 68.

22 In a letter to Octave Mirbeau dated February 12, 1892, he refers to two hundred paintings believed to be in the hands

of the composer Victorin Joncières, but this appears to have been fanciful. See *Corr.* III, p. 200.

23 *Corr.* I, p. 70.

24 Piette, *Mon cher Pissarro* (Editions Valhermeil, 1985), p. 71.

25 Letter from Duret to Pissarro, Institut Néerlandais, Fondation Custodia, cited in Charles C. Frankiss, "Camille Pissarro, Théodore Duret and Jules Berthel in London in 1871," *Burlington Magazine* 146 (July 2004), pp. 470–72.

26 Piette, *Mon cher Pissarro*, p. 63.

27 Octave Mirbeau was an influential journalist, an art critic who defended the avant-garde, a renowned pamphleteer, and a novelist whose most widely known work is *The Diary of a Chambermaid*. He was also an unconditional champion of Camille Pissarro.

28 The first war reparations had been demanded by France after the defeat of Prussia in 1807. In 1815, now defeated in turn, France was condemned to pay seven hundred million gold francs to the Holy Alliance.

29 Octave Mirbeau, "Degas," in "Notes sur l'art," *La France*, November 15, 1884, p. 35.

30 *Corr.* I, 71.

31 Guillemet, letter of September 3, 1872, cited in Société Paul Cézanne, https://www.societe-cezanne.fr.

32 Piette, *Mon cher Pissarro*, p. 74.

7: An Open-Air School: Work and Friendship

1 *Corr.* I, p. 75.

2 Société Paul Cézanne, https://www.societe-cezanne.fr, 1873.

3 Letter from Emperaire to a friend, March 17, 1872, in John Rewald, *Paul Cézanne, Correspondance* (Grasset, 1978), p. 141.

4 The house appears in a painting by Louis Van Ryssel (Paul Gachet, the doctor's son): *Maison habitée par Cézanne à Auvers en 1873*, dated "06." It is still recognizable at its present-day address, 66, rue Rémy. Gachet, *Deux amis des Impressionnistes*, pp. 51, 93, and figure 33.

5 *Corr.* IV, p. 128.

6 Zola, *Correspondance*, June 1861.

7 Georges Rivière, *Le Maître Paul Cézanne* (Paris, H. Floury éditeur, 1932), pp. 53–54.

8 Ambroise Vollard, *Renoir* (Les Editions G. Crès et cie, 1920), p. 98.

9 Bernheim de Villers Gaston [Gaston Berheim-Jeune], *Un ami de Cézanne* (éditions Bernheim-Jeune, Paris, 1954), p. 14.

10 J. Borély, "Cézanne à Aix," *Revue du Midi*, no. 7, July 15, 1906, pp. 433–40.

11 *Corr.* I, p. 77.

12 Société Paul Cézanne, https://www.societe-cezanne.fr, 1873.

13 "Mon cher papa, Mamman te fait dire que la porte est cassee que tu viene vite parce que les voleur peuve venir." Société Paul Cézanne, https://www.societe-cezanne.fr, 1873.

14 See *Pissarro, Catalogue raisonné*, II, p. 307.

15 Letter from Lucien Pissarro to Paul-Emile Pissarro, undated [1912] (Ashmolean Museum, Oxford). This was, in fact, the painting *Louveciennes*, painted in 1871, which is now in the Musée d'Orsay.

16 *Corr.* IV, p 121.

17 Exhibition at the Museum of Modern Art in New York, run jointly with the Los Angeles County Museum and the Musée d'Orsay in Paris.

18 See citation in *Musée d'Orsay Cézanne et Pissarro: une amitié picturale*.

19 Paul Gachet, *Deux amis des Impressionnistes*, p. 55.

20 Coquiot Gustave, *Paul Cézanne* (Paris, Librairie Paul Ollendorff, 1919), pp. 51–54.

21 "L'Exil de Courbet," http://www.gustave-courbet.net/fr/biographie/exil.13.html

22 "Echos. À travers Paris," *Le Figaro*, Thursday, February 8, 1894.

23 *Corr.* I, p. 81.

24 *Corr.* I, p. 203.

25 Cited in *Pissarro, Catalogue raisonné*, I, p. 227.

26 Shikes and Harper, *Pissarro: His Life and Work*, p. 112.

27 *Corr.* I, p. 96.

28 *Corr.* I, p. 126.

8: Upheavals, Poverty, and Unexpected Changes

1 *Corr.* I, p. 90.

2 Merete Bodelsen, "Early Impressionists Sales," *Burlington Magazine* 16 (June 1968), p. 343.

3 Renoir, words cited by René Gimpel, "Cagnes, mars 1918," in *Journal d'un collectionneur* (Paris, Calmann-Lévy), p. 28.

4 *Corr.* I, p. 79.

5 *Corr.* I, p. 208.

6 Shikes and Harper, 132.

7 *Le Figaro*, April 3, 1876.

8 Paul Gachet, *Lettres impressionnistes, au Dr. Gachet et à Muret* (Grasset, 1957), p. 55.

9 Ambroise Vollard, *En écoutant Cézanne, Degas, Renoir* (les Cahiers Rouges, Grasset, 2005), p. 255.

10 *Corr.* I, p. 125.

11 *Corr.* I, p. 115.

12 Durand-Ruel, *Mémoires*, p. 147.

13 *Corr.* I, p. 117.

14 *Corr.* II, p. 221.

15 *Corr.* I, p. 119.

16 *Corr.* I, p. 122.

17 *Corr.* I, p. 120.

18 Durand-Ruel, *Mémoires*, p. 144.

19 *Corr.* I, p 113.

20 *Corr.* I, p. 120.

21 *Corr.* I, p. 126.

22 *Corr.* I, p. 123.

23 Bonafoux, *Monet*, p. 126.

24 *Corr.* I, p. 110.

25 Bonafoux, *Monet*, p. 217.

26 *Corr.* I, p 133.

27 Isabelle Cahn, *Cadres de peintres* (Hermann, éditeurs des sciences et des arts, Réunion des musées nationaux, 1989), p, 25.

28 Isabelle Cahn's *Cadres de peintres* was invaluable to me in researching this topic.

29 Letter cited in Ira M. Horowitz, "Whistler's Frames," *Art Journal 39*, no. 2 (1979–1980), pp. 124–31.

30 Joris-Karl Huysmans, *Ecrits sur l'art* (Flammarion, 2008), p. 216.

31 *Corr.* I, p. 178.

32 Achille Segard, *Mary Cassatt, un peintre des enfants et des mères* (Paris 1913), p. 8.

33 Berthe Morisot, letter to Edma Morisot, March 18, 1869, cited in Theodore Reff, *Degas, the Artist's Mind*, (The Belknap

Press of Harvard University Press, Cambridge and London, 1987), p. 157.

34 See Richard R. Brettell and Anne-Brigitte Fonsmark, *Gauguin and Impressionism* (Yale University Press, 2005).

35 Edmond Duranty, *La Chronique des Arts*, April 19, 1879, pp. 127–28, cited in Merete Bodelsen, "Gauguin the Collector," *Burlington Magazine* 112 (September 1970), p. 590.

36 *Corr.* I, p. 245.

37 *Corr.* I, pp. 15–16.

38 *Corr.* III, p. 25.

39 *Corr.* III, p. 66.

40 *Corr.* III, p. 82.

41 *Corr.* III, p. 400.

42 *Corr.* III, p. 8.

43 *Corr.* III, p. 46.

44 *Corr.* I, p. 142.

45 Huysmans, *Ecrits sur l'art*, p. 228.

46 *Corr.* I, p. 158.

47 Degas, *Letters*, I, 254.

48 Letter to Evariste de Valernes, October 26, 1890, in *The Letters of Edgar Degas,* bilingual edition, ed. Theodore Reff (Wildenstein Plattner Institute, 2020) II, p. 29.

49 *Corr.* I, p. 204.

50 *Corr.* III, p. 124.

51 *Corr.* III, p. 82.

52 Jean-Paul Crespelle, *Degas et son monde* (Presses de la Cité, 1972), p. 14.

53 Edgar Degas, *Lettres*, ed. Marcel Guérin (Paris, Grasset, 1945) I, p. 261.

54 *Corr.* I, p. 143.

55 Degas, *Lettres*, I, p. 261.

56 *Corr.* I, p. 141.

57 Segard, *Mary Cassatt*, p. 46.

9: The Family Man

1 *Corr.* I, p. 175.

2 W. S. Meadmore, *Lucien Pissarro* (Knopf, 1962), pp. 32, 34.

3 *Corr.* I, p. 181.

4 *Corr.* II, p. 167.

5 *Corr.* I, p. 183.

6 *Corr.* I, p. 183.
7 *Corr.* I, p. 239.
8 *Corr.* I, p. 221.
9 *Corr.* I, p. 242.
10 Julie Pissarro, *Quatorze lettres* (L'Arbre, 1984).
11 *Corr.* I, p. 287.
12 *Corr.* II, p. 196.
13 *Corr.* II, p. 379.
14 *Corr.* I, p. 233.
15 *Corr.* III, p. 20.
16 *Corr.* II, p. 24.
17 *Corr.* I, p. 191.
18 *Corr.* III, p. 294.
19 *Corr.* IV, p. 85.
20 *Corr.* IV, p. 165.
21 Julie Pissarro, *Quatorze lettres.*
22 *Pissarro, Catalogue raisonné*, I, p. 23.
23 *Corr.* I, p. 266.
24 *Corr.* I, pp. 245–46.
25 *Corr.* I, p. 189.
26 *Corr.* I, p. 260.
27 *Corr.* I, p. 215.
28 *Corr.* I, p. 261.
29 *Corr.* I, p. 291.
30 *Corr.* I, p. 284.
31 *Corr.* I, p. 192.
32 *Corr.* II, p. 332.
33 *Corr.* II, p. 313.
34 *Corr.* II, p. 331.
35 *Corr.* I, p. 278.
36 *Corr.* II, p. 263.
37 *Corr.* II, p. 226.
38 *Corr.* I, p. 159.
39 *Corr.* II, p. 186.
40 *Corr.* II, pp. 173–74.
41 *Corr.* II, p. 348.
42 *Corr.* II, p. 279.
43 *Corr.* II, p. 280.
44 *Corr.* III, p. 97.
45 *Corr.* II, p. 338.

46 *Corr.* I, p. 338.
47 Julie Pissarro, *Quatorze lettres.*
48 *Corr.* II, p. 291.
49 Meadmore, *Lucien Pissarro*, p. 55.
50 *Corr.* III, p. 226.
51 *Corr.* III, p. 236.
52 *Corr.* III, p. 238.
53 *Corr.* III, p. 236.
54 *Corr.* III, p. 248.
55 *Corr.* III, p. 251.
56 *Corr.* III, p. 288.
57 *Corr.* III, pp. 289–90.
58 *Corr.* III, p. 362.
59 *Corr.* III, p. 530.
60 *Corr.* IV, p. 143.

10: A Painter and His Dealers

1 *Corr.* III, p. 158.
2 *Corr.* III, p. 162.
3 *Corr.* III, p. 164. The acclaimed painter Eugène Carrière founded an academy where Matisse and Derain studied. Alexandre Bernheim, with encouragement from Courbet, had opened a gallery in 1863, where he exhibited first the Barbizon painters, then the Impressionists.
4 Boussod and Valadon had taken over the Goupil gallery when its founder, Adolphe Goupil, retired. Vincent van Gogh had worked briefly for the Goupil gallery in his youth. His brother, Theo, made his career there.
5 *Corr.* III, pp. 164–65.
6 *Corr.* IV, pp. 30, 49.
7 *Corr.* IV, p. 515.
8 This incident has been referred to in several iterations although there is no precise source. See Jacques Lefèvre, *Impressionnistes et Symbolistes devant la presse* (Paris 1959), p. 149.
9 Durand-Ruel, *Mémoires*, II, pp. 197–98.
10 Durand-Ruel, *Mémoires*, II, p. 55.
11 *Corr.* I, p. 153.
12 Daniel Wildenstein, *Monet, Catalogue raisonné— Werkverzeichnis*, 5 vols. (Wildenstein Plattner Institute;

hereafter cited as *Monet, Catalogue raisonné*), II, p. 229. Letter dated June 1883.

13 *Corr.* I, p. 216.
14 *Corr.* I, p. 217.
15 *Corr.* II, p. 104.
16 *Pissarro, Catalogue raisonné*, I, p. 20.
17 *Monet, Catalogue raisonné*, II, p. 252.
18 *Corr.* I, pp. 299–300.
19 *Corr.* I, p. 302. Georges Petit, one of Durand-Ruel's most astute competitors, had taken over his father's gallery. He bought more cautiously than Durand-Ruel and had more varied, less vulnerable stock. Petit exhibited Monet in 1885 and became Sisley's official dealer.
20 *Corr.* I, p. 301.
21 *Corr.* I, p. 302.
22 *Corr.* I, p. 316.
23 *Corr.* I, p. 317.
24 *Monet, Catalogue raisonné*, II, p. 251.
25 *Corr.* I, p. 318.
26 *Corr.* II, p. 30.
27 Assouline, *Grâces lui soient rendues*, p. 215.
28 Durand-Ruel, *Pari de l'Impressionnisme*, p. 107.
29 *Corr.* II, p. 60.
30 Cited by Assouline, *Grâces lui soient rendues*, p. 226.
31 Cited by Colin Bailey, "How He Ruled Art," *New York Review of Books*, December 3, 2015.
32 Cited by Amy Linda Boyce in *American Collectors of French Impressionist Art, 1876–1913*, Internet Archive.
33 *Corr.* II, p. 75.
34 *Corr.* II, p. 64.
35 Durand-Ruel, *Mémoires*, II, p. 217, cited in *Corr.* II, p. 39.
36 *Corr.* II, p. 64.
37 *Corr.* II, p. 45.
38 *Corr.* II, p. 45.
39 Anne Therold and Kristen Erickson, *Camille Pissarro and His family* (Ashmolean Museum, Oxford, 1993), p. 13.
40 *Corr.* II, p. 194.
41 *Corr.* II, p. 219.
42 *Corr.* II, p. 251.
43 Cited in Venturi, *Archives de l'Impressionnisme*, I, p. 89.

44 *Corr.* II, p. 254.

45 Letter from Monet cited in *Corr.* II, p. 139.

46 *Pissarro, Catalogue raisonné*, III, pp. 828–29.

47 *Corr.* II, pp. 92–93.

48 *Corr.* II, p. 243.

49 *Corr.* II, pp. 250–51.

50 *Corr.* III, p. 185. Joséphin Péladan was an eccentric Catholic and Royalist who played an important part in the Symbolist movement. Born into a modest family in Lyon, he claimed to be descended from Babylonian royalty several thousand years old and proclaimed himself *Sâr*, an Assyrian title meaning "king." He organized a "Salon of the Rose+Cross," with artists who completely excluded naturalism in favor of an ethereal vision of beauty. The inaugural 1892 salon was held in Durand-Ruel's gallery with fanfares composed by Erik Satie and, despite the ludicrous excess, had a great impact. It goes without saying that the prankster was soon forgotten.

51 *Corr.* III, p. 191.

52 *Monet, Catalogue raisonné*, V (Supplément aux Peintures, Dessins, Pastels, Index, 1991), p. 201.

53 *Corr.* III, p. 190.

54 *Corr.* III, p. 196.

55 *Corr.* III, p. 201.

56 *Corr.* III, p. 278.

57 *Corr.* III, p. 276.

58 *Corr.* III, p. 471.

59 *Corr.* III, p. 498.

60 *Corr.* IV, p. 199. Blanche was the painter Jacques-Emile Blanche.

11: The Irruption of Politics: The Dreyfus Affair, 1894–1906

1 Gustave Geffroy, *Claude Monet, sa vie, son temps, son oeuvre* (Paris, Les éditions G. Crès & Cie, 1922; republished Paris, Macula, 1980), pp. 325–26.

2 Ambroise Vollard, *Souvenirs d'un marchand de tableaux* (Paris, éditions Albin Michel, 1937), p. 95.

3 Ambroise Vollard, "Souvenirs sur Cézanne," *Cahiers d'art* 9–10, 6th year (1931), pp. 394.

4 For the remark from Morisot's mother, see Degas, *Lettres*, I, p. 67.

5 Julie Manet, *Journal, 1893–1899* (Mercure de France, 2017), pp. 247–48.

6 Ambroise Vollard, *En écoutant Cézanne, Degas, Renoir* (Grasset, 1938), p. 105.

7 Misia Sert, *Misia* (Gallimard, 1952), p. 58, cited by Bertrand Tillier, *Les Artistes et l'affaire Dreyfus* (Epoques Champ Vallon, 2009), p. 88.

8 *Corr.* IV, p. 403.

9 Michael M. Marrus, *Les Juifs de France à l'époque de l'affaire Dreyfus* (1972; Bruxelles, Editions Complexe, 1985), p. 33.

10 *Corr.* II, p. 270.

11 *Corr.* I, p. 338.

12 *Monet, Catalogue raisonné*, II, p. 261.

13 Letter from Renoir to Deudon, cited in Colin Bailey, *Renoir's Portrait: Impressions of an Age* (Yale University Press and National Gallery of Canada, 1977), p. 40.

14 *Corr.* IV, p. 441.

15 *Corr.* IV, p. 434.

16 Paul de Cassagnac, "L'Art juif," *L'Autorité*, July 5, 1900, cited in Tillier, *Artistes et l'affaire Dreyfus*, p. 98.

17 Henri Rochefort "A eux la France," *L'Intransigeant*, October 3, 1900, and Cassagnac, "L'Art juif," *L'Autorité*, July 5, 1900, both cited in Tillier, *Artistes et l'affaire Dreyfus*, p. 98.

18 *Corr.* IV, p. 254.

19 *Corr.* IV, p. 429. Esterhazy, who had written the dispatch that condemned Dreyfus, was the true perpetrator. Despite decisive proof, he was protected by the military staff closing ranks and fled to England.

20 *Corr.* IV, p. 435.

21 Julie Pissarro, *Quatorze lettres*.

22 Reported by Ambroise Vollard, *En écoutant Cézanne, Degas, Renoir*, p. 118.

23 Reported by Matisse, *Bavardages*, op. cit., pp. 105–6.

24 Vollard, *Souvenirs d'un marchand de tableaux*, p. 112.

25 John Rewald, "Journal inédit de Paul Signac," *Gazette des Beaux-Arts* (January–June 1952).

26 *Corr.* IV, p. 439.

27 *Corr.* IV, p. 441.

28 Julie Manet, *Journal*, p. 282.

29 Degas, *Lettres*, II, p. 357.

30 *Corr.* IV, p. 486.

12: Paris from My Window

1 *Corr.* V, p. 299. Rosa Bonheur, born 1822, was a painter of animals who enjoyed extraordinary success during her own lifetime. Her masterpiece, *The Horse Fair*, painted between 1852 and 1855, was first bought by the French government. She bought it back to sell it for the then astonishing sum of forty thousand francs to an English publisher. After several successive sales, the painting became the property of Cornelius Vanderbilt in 1887, and he gifted it to the Metropolitan Museum in New York.

2 *Corr.* IV, p. 405.

3 *Corr.* IV p. 407 (English in the original).

4 *Corr.* IV, p. 405.

5 *Corr.* IV, p. 410.

6 *Corr.* IV, p. 410.

7 *Corr.* IV, p. 410.

8 *Corr.* IV, p. 418.

9 *Corr.* IV, p. 418.

10 Signac's unpublished diary cited in *Corr.* IV, p. 454.

11 Thadée Natanson, *Peints à leur tour* (Albin Michel, 1948).

12 *Corr.* III, p. 75.

13 Degas, *Lettres*, II, p. 70.

14 *Corr.* V, p. 167.

15 *Monet, Catalogue raisonné*, V, p. 14.

16 *Corr.* IV, p. 165.

17 *Corr.* V, p. 347.

18 *Corr.* IV, p. 282.

19 *Corr.* IV, p. 75.

20 *Corr.* IV, p. 325.

21 Unpublished notes by the painter Louis Le Bail who was given advice by Pissarro in 1896–1897, cited by Linda Nochlin in "Pissarro's Unassuming Eye," in *Studies on Camille Pissarro*, ed. Christopher Lloyd (Routledge and Kegan Paul, 1986), p. 10.

22 *Corr.* IV, p. 456.

23 *Corr.* IV, p. 478.

24 *Corr.* V, p. 336.

25 Octave Mirbeau's preface to Pissarro's posthumous exhibition, cited in *Corr.* V, p. 396.

26 *Corr.* IV, p. 504.

27 *Pissarro, Catalogue raisonné*, II, p. 481.

28 Julie Manet, *Journal*, pp. 104–8.
29 *Corr.* IV, p. 520. Van der Meers is a curious spelling for Vermeer.
30 *Corr.* IV, p. 518.
31 *Corr.* IV, p. 519.
32 *Corr.* IV, p. 522.
33 *Corr.* V, p. 21.
34 *Corr.* IV, p. 463.
35 *Corr.* V, p. 140.
36 *Corr.* V, p. 105.
37 *Corr.* V, p. 96.
38 *Corr.* V, p. 307.
39 *Corr.* V, p. 100.
40 Joseph Reinach, *L'Affaire Dreyfus* (Eugène Fasquelle, 1901).
41 *Corr.* V, page 66.
42 *Corr.* V, p. 65.
43 *Corr.* V, p. 6.
44 *Corr.* V, p. 224. Emilio Aguinaldo was the hero of the nationalist uprising against the Spanish in the Philippines. He proclaimed the islands a republic and formed an alliance with the Americans before fighting against them when they went on to buy the islands from Spain. He was imprisoned by the Americans in 1901.
45 *Corr.* V, p. 43.
46 *Corr.* III, p. 148. At the time, schoolchildren were out of school on Thursdays and not on Wednesdays as they are today.
47 *Corr.* V, p. 179.
48 *Corr.* V, p. 186.
49 *Corr.* IV, p. 512.
50 *Corr.* V, p. 147.

13: The Light Fades

1 *Corr.* IV, p. 159.
2 *Corr.* V, p. 331.
3 *Corr.* V, p. 284.
4 *Corr.* V, p. 246.
5 *Corr.* V, p. 390.
6 Matisse, *Bavardages*, p. 151.
7 Thorold, *Letters of Lucien to Camille Pissarro*, p. 770.

8 *Corr.* V, p. 258.
9 *Corr.* V, p. 188.
10 Letter to an anonymous correspondent, *Corr.* V, p. 247.
11 *Corr.* V, p. 277.
12 *Corr.* V, p. 278.
13 *Corr.* V, p. 280.
14 *Corr.* V, p. 297.
15 *Corr.* V, p. 328.
16 *Corr.* V, p. 295.
17 *Corr.* V, p. 316.
18 *Pissarro, Catalogue raisonné*, I, p. 44.
19 *Corr.* V, p. 315.
20 *Corr.* V, p. 317.
21 *Corr.* V, p. 352.
22 François Thiébault-Sisson, in *Le Temps*, March 1, 1902, cited
 in *Corr.* V, p. 220.
23 Thorold, *Letters of Lucien to Camille Pissarro*, September 2,
 1903.
24 *Corr.* V, p. 358.
25 *Corr.* V, p. 355.
26 *Corr.* V, p. 356.
27 *Corr.* V, p. 369.
28 *L'Aurore*, November 25, 1903, cited in *Corr.* V, p. 383.
29 *Corr.* V, p. 383.
30 Cited in *Corr.* V, p. 389.
31 *Monet, Catalogue raisonné*, V, p. 365.
32 Georges Lecomte, *Ma traversée* (Robert Laffont, 1949),
 p. 139.

Epilogue

1 Words first reported by Joachim Gasquet in *Cézanne* (Paris,
 1921), ed. P. M. Moran (Paris, Macula, 1978), p. 121.

ANKA MUHLSTEIN is the author of biographies of Queen Victoria, James de Rothschild, and Cavelier de La Salle; studies on Catherine de Médicis, Marie de Médicis, and Anne of Austria; a double biography, *Elizabeth I and Mary Stuart*; *Balzac's Omelette* (Other Press, 2011); *Monsieur Proust's Library* (Other Press, 2015); and *The Pen and the Brush* (Other Press, 2017). She won the Goncourt Prize for her biography of Astolphe de Custine and has received two prizes from the Académie française. She and her husband, Louis Begley, are the authors of *Venice for Lovers*. They live in New York City.

ADRIANA HUNTER studied French and Drama at the University of London. She has translated more than ninety books, including Marc Petitjean's *The Heart: Frida Kahlo in Paris* and Hervé Le Tellier's *The Anomaly* and *Eléctrico W*, winner of the French-American Foundation's 2013 Translation Prize in Fiction. She lives in Kent, England.